HISTORIC PHOTOS OF
ATLANTA

MICHAEL ROSE

ATLANTA HISTORY CENTER

TURNER

PUBLISHING COMPANY

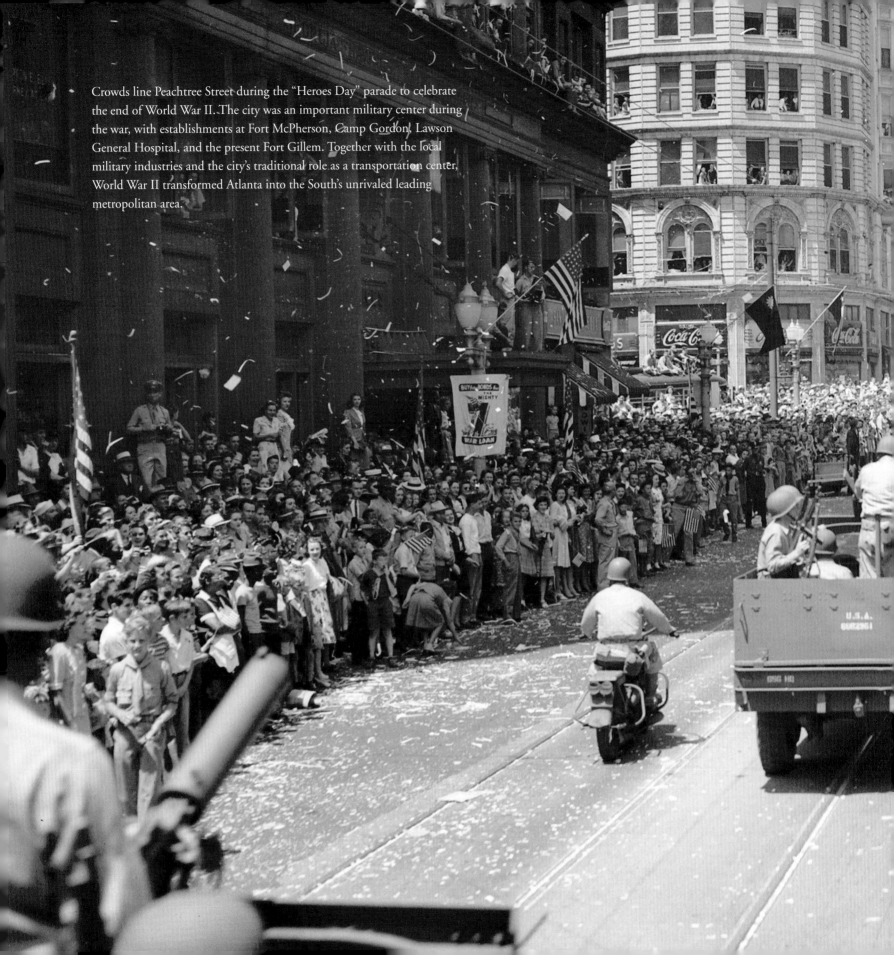

Crowds line Peachtree Street during the "Heroes Day" parade to celebrate the end of World War II. The city was an important military center during the war, with establishments at Fort McPherson, Camp Gordon, Lawson General Hospital, and the present Fort Gillem. Together with the local military industries and the city's traditional role as a transportation center, World War II transformed Atlanta into the South's unrivaled leading metropolitan area.

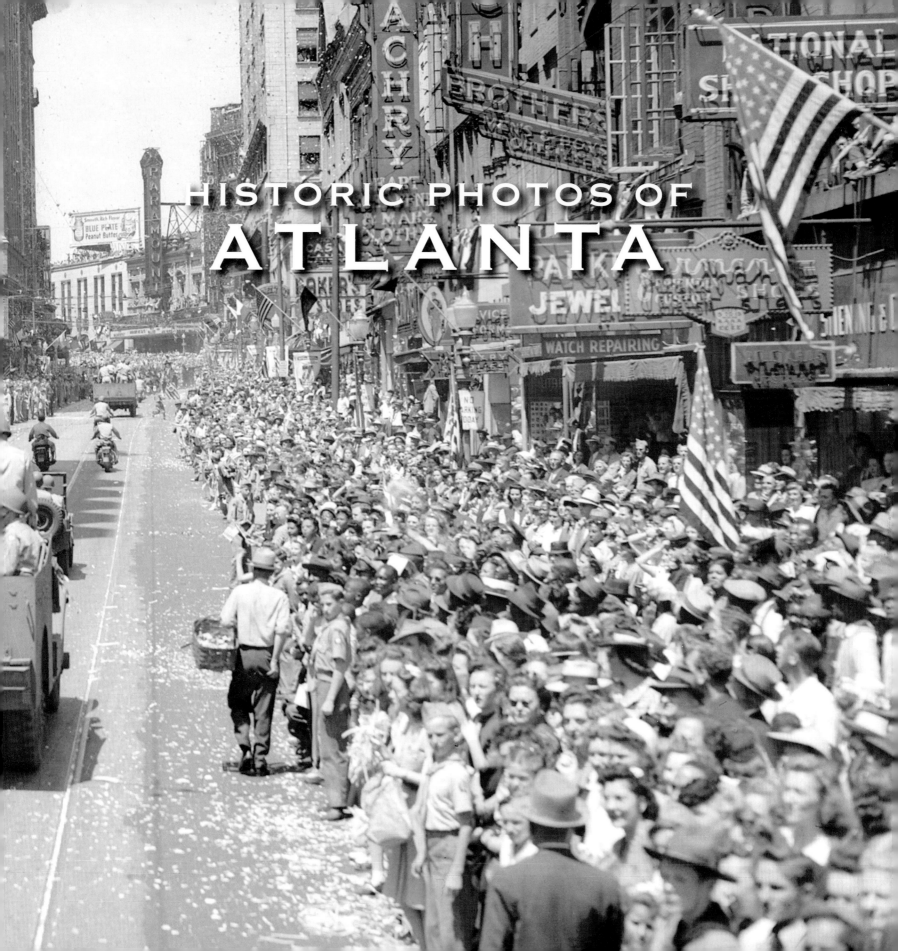

HISTORIC PHOTOS OF
ATLANTA

Turner Publishing Company
200 4th Avenue North • Suite 950 412 Broadway • P.O. Box 3101
Nashville, Tennessee 37219 Paducah, Kentucky 42002-3101
(615) 255-2665 (270) 443-0121

www.turnerpublishing.com

Historic Photos of Atlanta

Copyright © 2007 Turner Publishing Company

Library of Congress Control Number: 2007929605

ISBN-13: 978-1-59652-404-0

Printed in the United States of America

07 08 09 10 11 12 13 14—0 9 8 7 6 5 4 3 2 1

CONTENTS

Dr. and Mrs. Martin Luther King, Jr., and the Reverend and Mrs. Ralph David Abernathy tour Markham Street in one of the city's most impoverished areas in January 1966. Residents in the Vine City neighborhood were protesting poor housing conditions, which Dr. King deemed "a shame on the community." After Dr. King was awarded the Nobel Peace Prize in 1964, the city honored him with the first officially integrated dinner in the city's history.

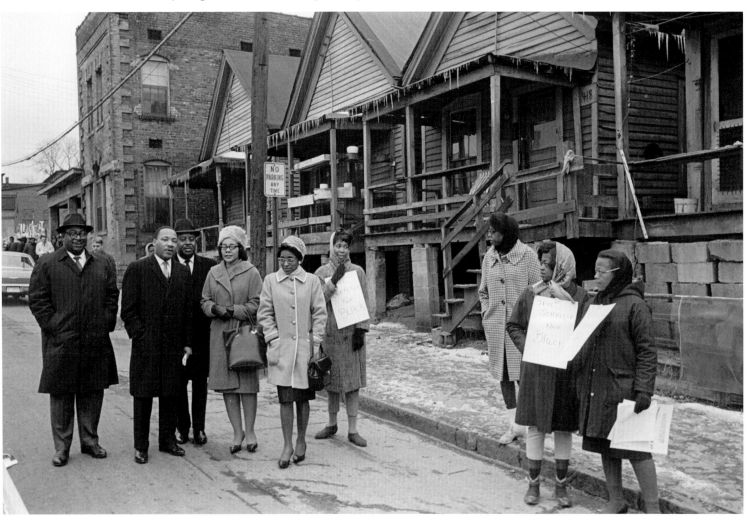

ACKNOWLEDGMENTS

All of the photographs included in *Historic Photos of Atlanta* are from the collection of the Kenan Research Center at the Atlanta History Center.

I would like to acknowledge the individuals and institutions who have generously donated photographs and acquisition funds to the Kenan Research Center and who have made possible the quality and quantity of visual collections that made this book possible.

Thanks, as always, to the staff of the Kenan Research Center for their advice, patience, and understanding. And thanks to Franklin M. Garrett, who led the way.

Above all, thanks go to Betsy Rix, for her understanding of graphic excellence, magic with digital imaging, unlimited patience and perseverance, and unfailing good humor.

—*Michael Rose*

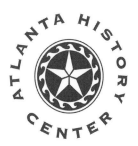

PREFACE

A picture is worth a thousand words, as the saying goes. The idea being that a photograph in itself can express what may require many paragraphs of a book's text to explain. The images collected here offer a glimpse of time through Atlanta's history. Though not a history of the city, they are arranged chronologically from the earliest-known existing photograph taken in the city to those from the later twentieth century. Some images may be familiar, but the collection presented here provides many scenes of Atlanta never seen or never published before.

These photographs are both representational and symbolic. Some present street scenes or views of the city throughout time, others may provide a sense of time and place, evoking a feeling or sentiment from the viewer. Some images are iconic—many photographs of Dr. Martin Luther King, Jr., convey the concepts of justice and equality for which he stood, of the civil rights movement and the struggle for racial equality.

Photographers for many of the photographs are known, ranging from George N. Barnard, who traveled with General William T. Sherman's army, to modern photojournalists such as Kenneth G. Rogers, Bill Wilson, and Floyd Jillson of the city's large newspapers, or Boyd Lewis, who worked in Atlanta's counterculture alternative press. The earliest image is a daguerreotype of an Atlanta home in 1850. For the next number of years, the images in the book are the work of professional studio photographers and most of the building views and street scenes are commercial work executed by them. It is not until the early twentieth century that amateur photography appears, presenting Atlantans in informal poses, riding in cars, and smiling. As the twentieth century progresses, the photojournalism of professional news photographers appears as newspapers document a changing city.

Although the image presents the visual record, some words contain a visual legend that in them brings photographs and images to mind. Peachtree, Scarlett, and Sherman are three words that in many ways defined the public's perception of Atlanta for decades—a timeless reflection of Civil War Atlanta reinforced by the novel *Gone With the Wind.* Add to them Coca-Cola, CNN, Delta, and the Olympic Games, and the impression that comes to

mind is the emerging Atlanta of the twentieth century—the home of the "Atlanta Spirit," in which business and promotion characterize the city.

Atlanta is a city of words and images, presented here to give the viewer a sketch of time, both distant and close. The city has lost much of its physical past—it is missing the first City Hall and all of the antebellum town, each of its four historic passenger train depots (all of them razed), as well as many of the homes and businesses that once lined the streets throughout the city. *Historic Photos of Atlanta* remembers many of these places as well as the people who have lived, worked, and played in a city born in a southern forest, founded by a train engineer who one day drove a stake in the ground where he thought it should be.

In 1847, Richard Peters purchased this house and its two-acre lot at the corner of Mitchell and Forsyth streets from Samuel G. Jones for $1,400. This half-plate daguerreotype of the house, made around 1850, is the earliest-known existing photograph of Atlanta. Peters served as principal assistant to Joseph E. Thomson, chief engineer of the Georgia Railroad. Thomson is credited with coining the term "Atlanta" to replace the town's older name, Marthasville.

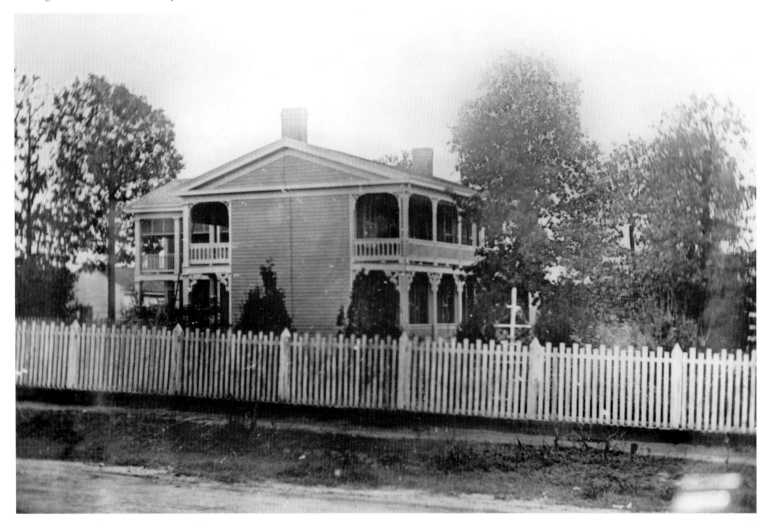

A Stake in the Wilderness: From Birth to Destruction

(1837–1864)

Atlanta was founded as a frontier railroad town and for many years was as rough and tumble as the words bring to mind. The State of Georgia sought a railroad running north and south through the Piedmont and by driving a stake in the backwoods, Stephen H. Long selected the southern end of that rail line. When he did, he picked the spot around which Atlanta would emerge.

Major Long, a civil engineer for the Western & Atlantic Railroad, and the area's few white pioneers were not the first inhabitants. The Creeks hunted here, settling nearby at Sandtown and Buzzard's Roost along the Chattahoochee River. They also had a village, where Long chose to cross the river with a railroad bridge. The village was called Standing Peachtree.

The town that sprang from Long's stake was variously called Terminus, Thrasherville—for general-store owner John Thrasher—and White Hall, for a local tavern. It wasn't until 1843 that the town was officially named Marthasville, and then very quickly changed to Atlanta. Parts of town had evocative names, such as the notorious Murrell's Row, poverty-stricken Slabtown, and the degraded Snake Nation. And not until 1851 did the Moral Party defeat the Rowdy Party in an election.

By that time, the first train had run from Atlanta to Chattanooga along the Western & Atlantic line for which the town had been sited. Atlanta also became home to other rail lines—the Georgia Railroad from Augusta, the Macon & Western connecting south, and the Atlanta & West Point linking the city to the west. By 1857, Atlanta claimed the title "Gate City of the South" for strategic railroad connections north, south, east, and west.

With the advent of the Civil War, those connections created the Confederacy's central rail depot downtown. Troops, munitions, food, and supplies moving from the western theater of war to the eastern in Virginia passed through the city's station. With it, Atlanta became an arsenal and factory, producing war materiel such as rails, munitions, clothing, cannon, and coffins.

The Atlanta war machine would become Sherman's target. In five months he moved from Chattanooga—ironically, the Western & Atlantic Railroad was his supply lifeline—into Atlanta. After bombarding the city, he entered in September 1864, evicted its residents, and destroyed much of the city before leaving in mid November. In less than three decades, a rough and tumble spot in the woods had become a primary target in America's battle for national unity.

Passengers wait on a flatboat on the Chattahoochee River at the Mayson-Turner Ferry, which crossed the river at the site of the present Bankhead Highway. Atlanta was situated for its rail lines and not for convenience to a main waterway. Nevertheless, ferry crossings along the Chattahoochee River supplied the city with historic street names, including Paces Ferry, Montgomery Ferry, Powers Ferry, and Johnson Ferry. Ironically, Atlanta's first ferry crossing was located at a site named Shallowford.

Like ferry crossings, the area's saw and grist mills provided place names throughout Atlanta, including Moores Mill, Howell Mill, Akers Mill, Terrell Mill, and Tilly Mill. In late August 1864, following a month-long siege of Atlanta, Union general William T. Sherman attempted to cut the city's railroad supply lines south of town. His victory on September 1 in the Battle of Jonesboro near Jester's Old Mill forced Confederate troops to finally evacuate Atlanta.

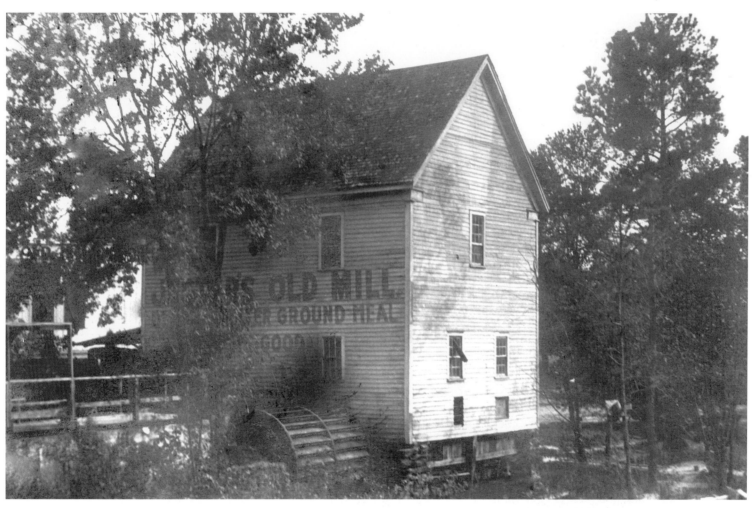

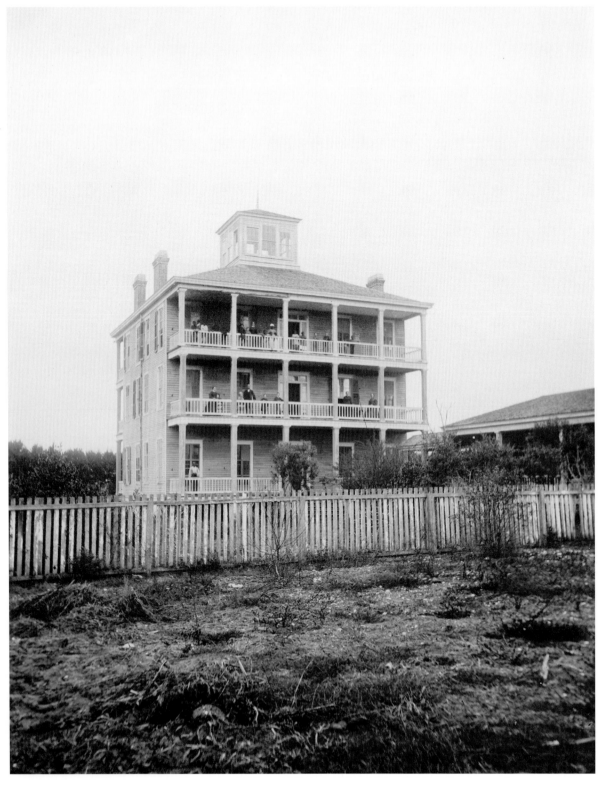

Unlike the plantation South where cotton was king, Atlanta's early economy was based on commerce and the railroads. Though the site of this house is unknown, photographer George N. Barnard noted its location as Atlanta. One of the area's largest antebellum plantations belonged to James H. Kirkpatrick, who moved to DeKalb County in 1827. At the time of his death in 1853, Kirkpatrick owned 1,000 acres, much of which was later developed into the Kirkwood neighborhood.

This unidentified street scene depicts the way much of antebellum Atlanta would have appeared—dirt roads and all. In 1860, the city was home to fewer than 10,000 residents. As the war evolved over the next few years, the population grew to nearly 22,000. This quiet city street would have been filled with Confederate soldiers and the citizens who worked in factories, hospitals, warehouses, and other war-related activities.

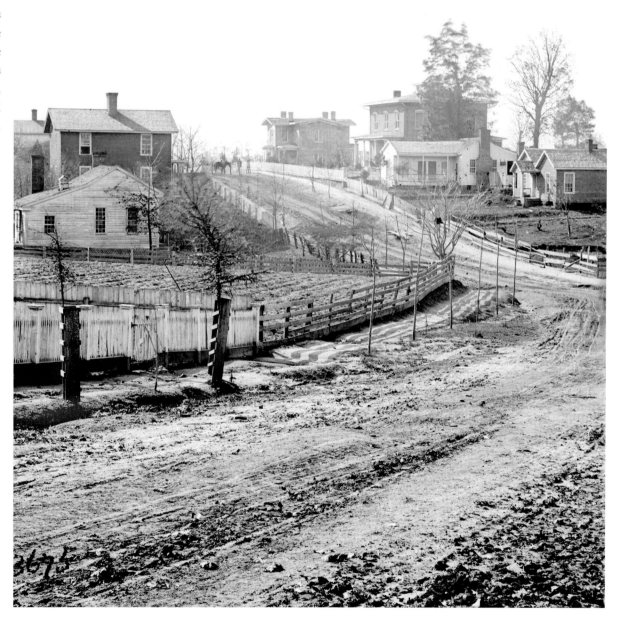

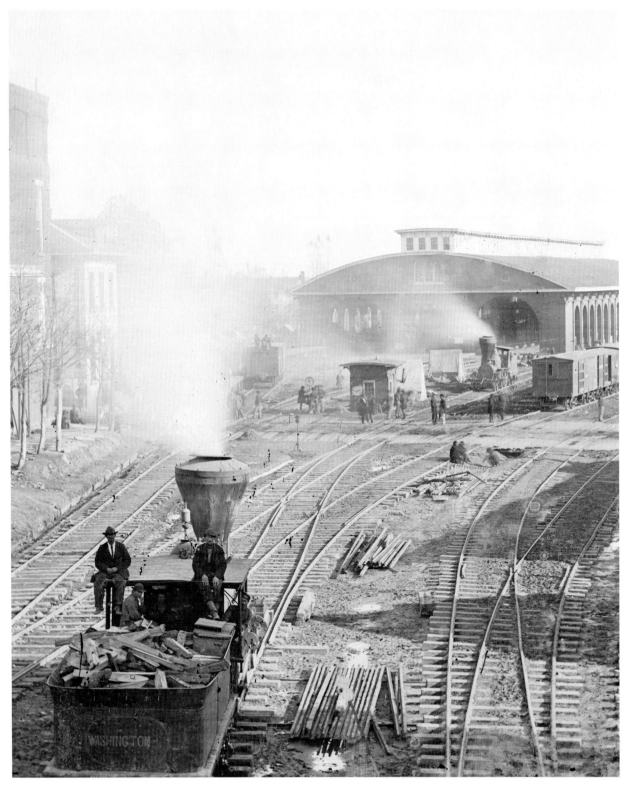

Completed in 1854, Atlanta's Passenger Depot sat at the very heart of the city near the Zero-Mile Post, designating the southern terminus of the Western & Atlantic Railroad. The depot served four rail lines that linked the Southeast, creating the transportation and manufacturing hub that would become General Sherman's target. The depot is seen from the first bridge to be built over the tracks, making it safer to cross from one side of the city to the other.

The large top hat on the right side of the street advertises J. M. Holbrook's store on Whitehall Street. Holbrook offered men's hats, caps, straw goods, and trunks, as well as canes and umbrellas. From early Atlanta to the mid twentieth century, Whitehall Street served as the city's central business district. As a result of its commercial importance, everything in this photograph was destroyed before the Union army's departure from Atlanta.

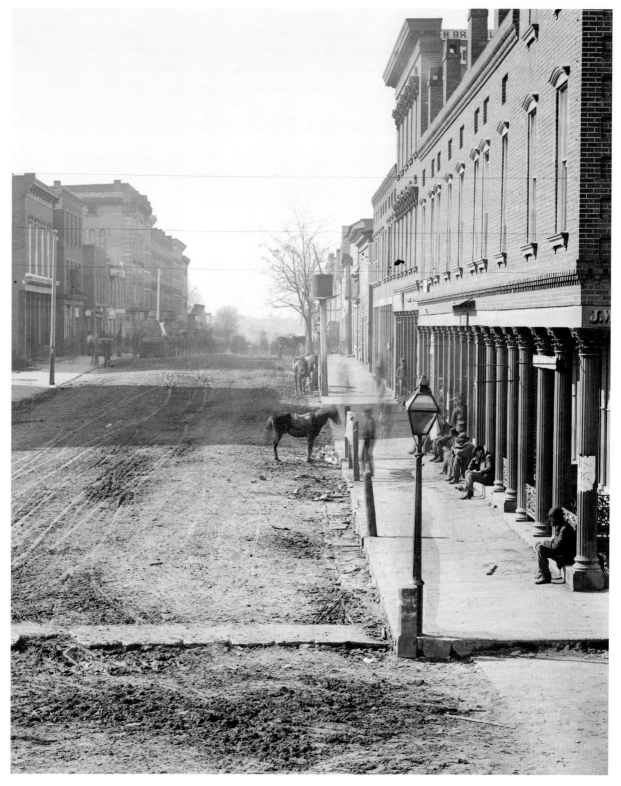

Bulloch Hall in nearby Roswell personifies the white-columned manor many people associate with Atlanta as a result of Margaret Mitchell's novel *Gone With the Wind*. Completed in 1839, the Greek Revival house was built by Major James Stephens Bulloch. In 1853, Bulloch's daughter, Mittie, married Theodore Roosevelt, Sr., of New York City in the house's dining room. Their son, President Theodore Roosevelt, visited the house more than fifty years later on a tour of the South.

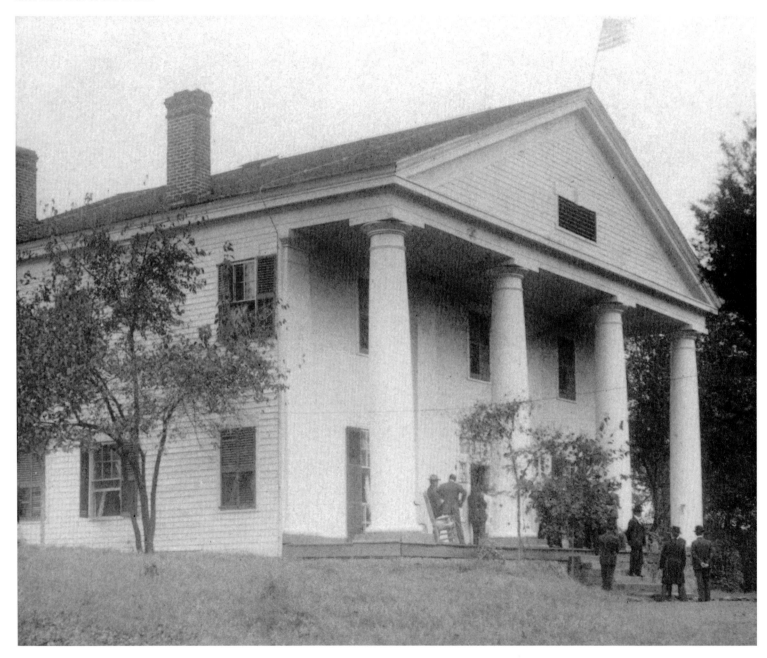

The plantation plain style home of Robert Smith is representative of the homes of Piedmont Georgia farmers of the antebellum. Built in DeKalb County in the 1840s, the house was occupied by Smith family descendants until the late 1960s. Relocated to the Atlanta History Center, the house and its original detached kitchen are now the centerpiece of an interpretive farm that includes a period barn, smokehouse, blacksmith shop, and corncrib.

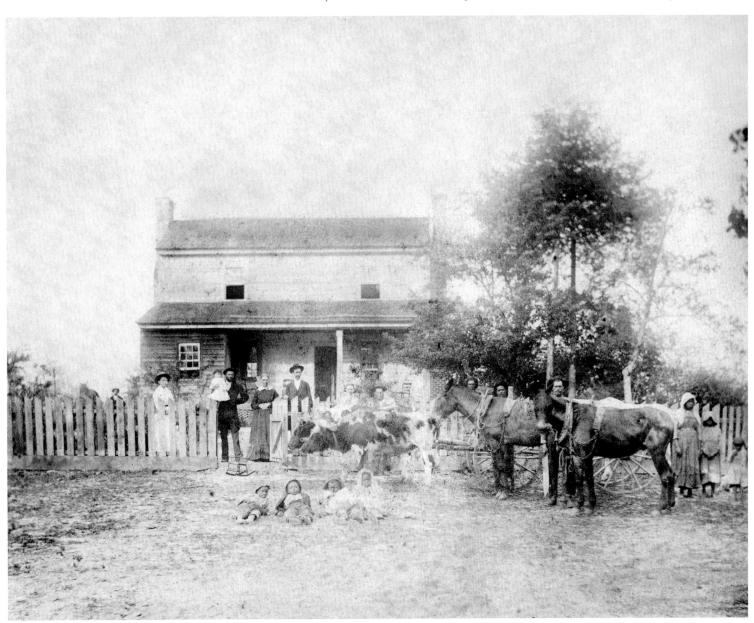

When completed in 1859, the home of John Neal was the height of antebellum splendor. All brick, with a majestic columned portico and surmounted by a standard for fashionable homes, a cupola. Neal's house stood at the corner of Washington and Mitchell streets, across the street from Atlanta City Hall, in one of the foremost residential sections of the city. For that reason, the house served as General Sherman's headquarters during the occupation.

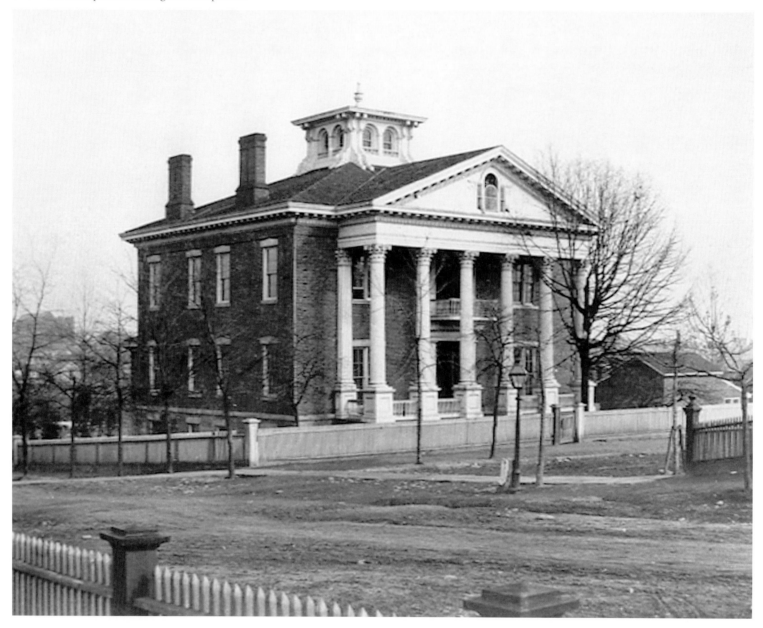

Atlanta City Hall, completed in 1854, sat on the site of the current Georgia State Capitol. The city had originally allocated a lot next to the train depot for a city hall until Richard Peters sold property to the city council on higher ground nearby. The area immediately surrounding city hall acted as the command center of the Federal occupation of Atlanta, with both Sherman and the Federal army's post headquarters occupying residences across the street.

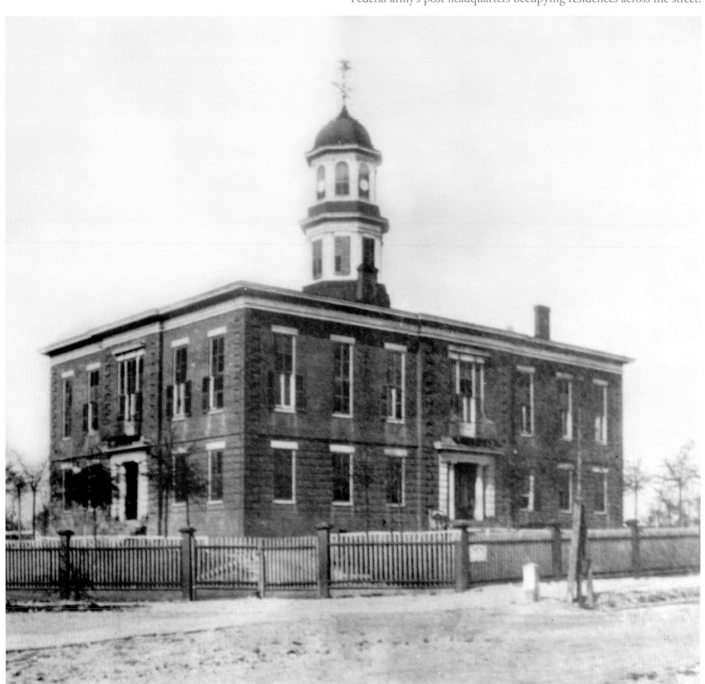

This and the following two images are from a panorama of Atlanta, taken from the cupola of the Atlanta Female Institute by photographer George N. Barnard during the Federal occupation of the city, September-November 1864. This view presents the city from the Atlanta Medical College to the southeast (the domed building at upper-left) to residences along present Courtland Street. The female seminary was dismantled by Union troops, who used the bricks for winter shelters that went uninhabited that winter.

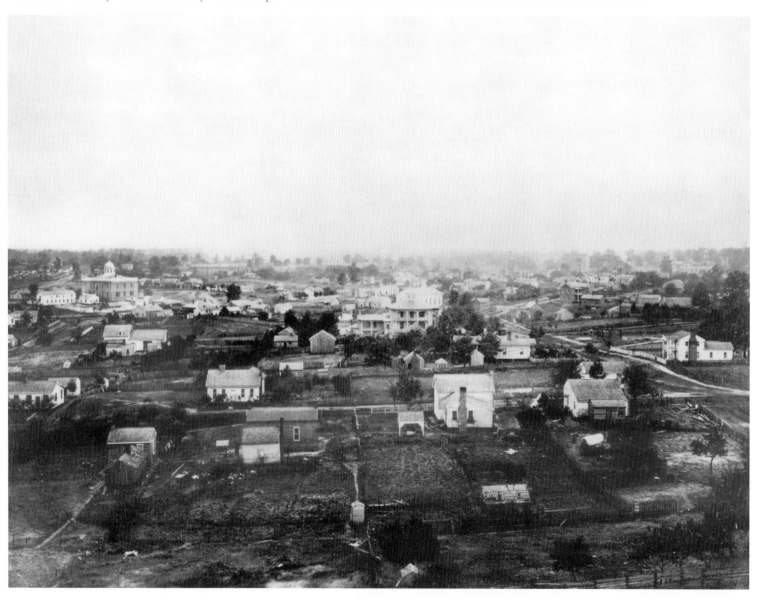

Though photographed during the war, this scene presents not only the look of antebellum Atlanta, but the appearance of this part of the city after Sherman left on the March to the Sea. All of the houses and outbuildings in this view remained, with the exception of the Passenger Depot (at the horizon, middle-left) and a few buildings in Atlanta's commercial district that are discernible in the distance.

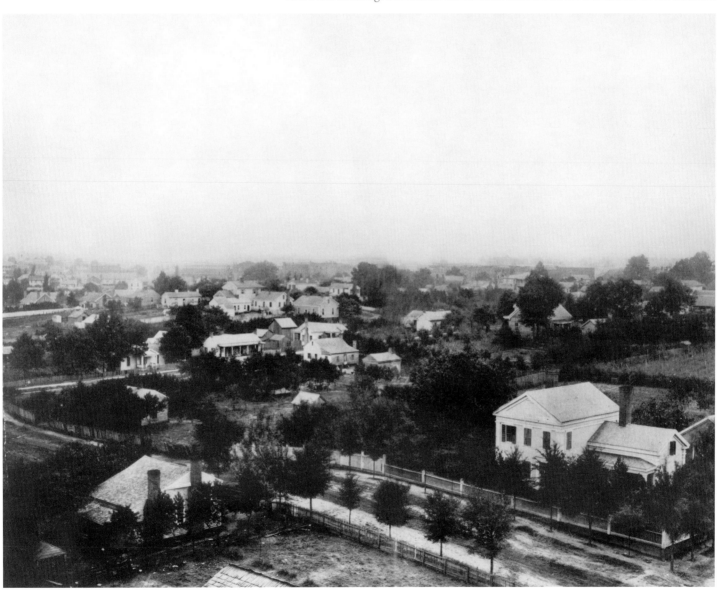

Following Sherman's order expelling most of the civilian population, the streets and yards in this scene are empty. The street running into the distance is Ellis, crossing present Peachtree Center Avenue in the middle and cresting at the ridge line, which marks Peachtree Street. The columned house right of center along Peachtree is the Herring-Leyden House, which served as Union general George H. Thomas' headquarters during the occupation.

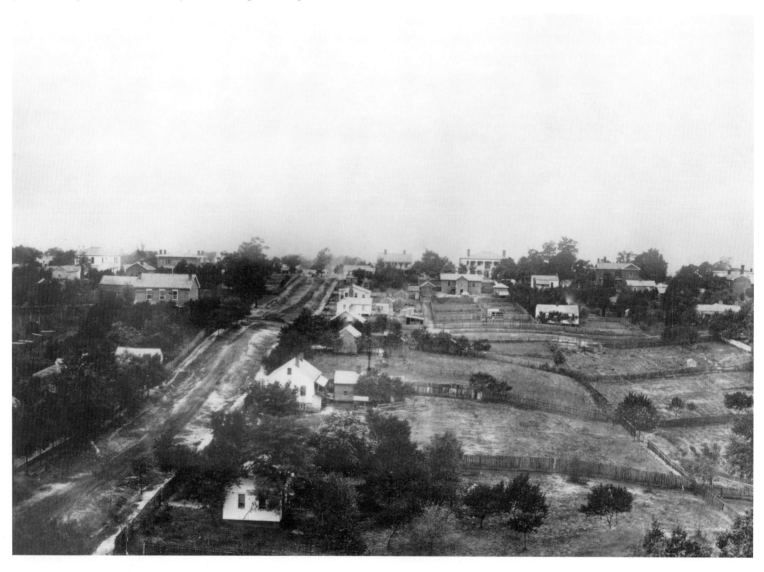

After occupying Atlanta, Sherman ordered a line of fortifications in the event of a resurgent Confederate attack. The forts were constructed southeast of the city's center, creating a concentrated, compact defensive perimeter. Federal Fort No. 19 lay astride the rail line of the Georgia Railroad running east to Augusta. The scene looks northwest toward the city across the tracks; the cupola of the Atlanta Medical College rises just beyond the tree at left.

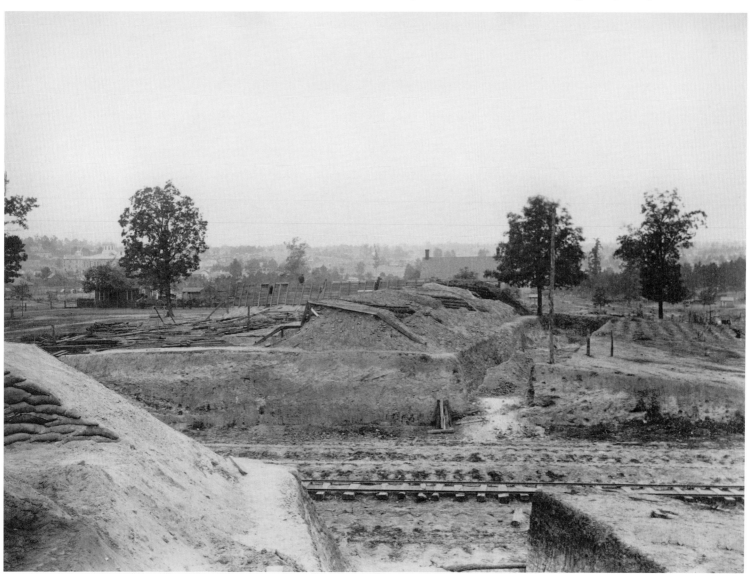

A fort along the Confederate line faces the present Georgia Tech campus from the site of the Administration Building. Part of Atlanta's defense was to clear timber for a distance of 1,000 yards in front of earthwork fortifications. In December 1864, a report on the area's destruction noted that "for miles around, scarcely a tree is standing." Faced with this landscape, Sherman laid siege to the city, bombarding Atlanta throughout the month of August.

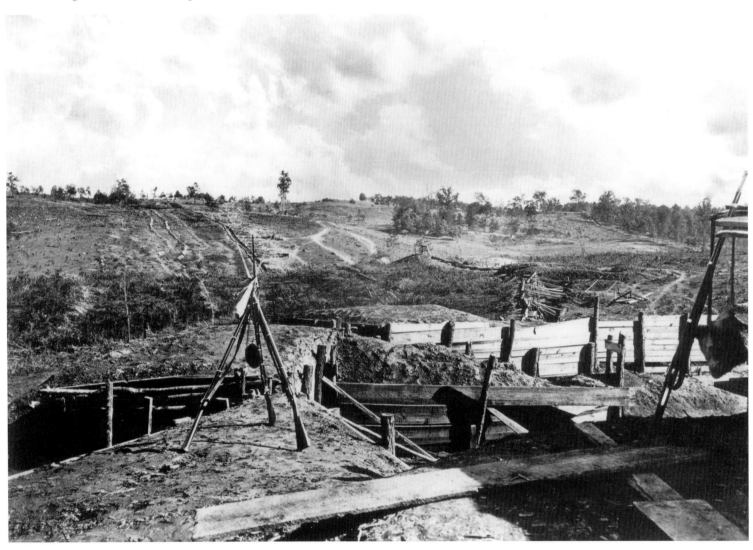

Fort Hood, the northern-most redoubt in the city's defenses, overlooks fortifications erected on the property of planter and slave trader Ephraim G. Ponder. Ponder had moved to Atlanta in 1857, when he built the house in the distance on the edge of what is now the Georgia Tech campus. The house served as a Confederate sharpshooter's position until heavily shelled by Sherman's artillery, which was bombarding the city from the woods near present-day Eighth Street.

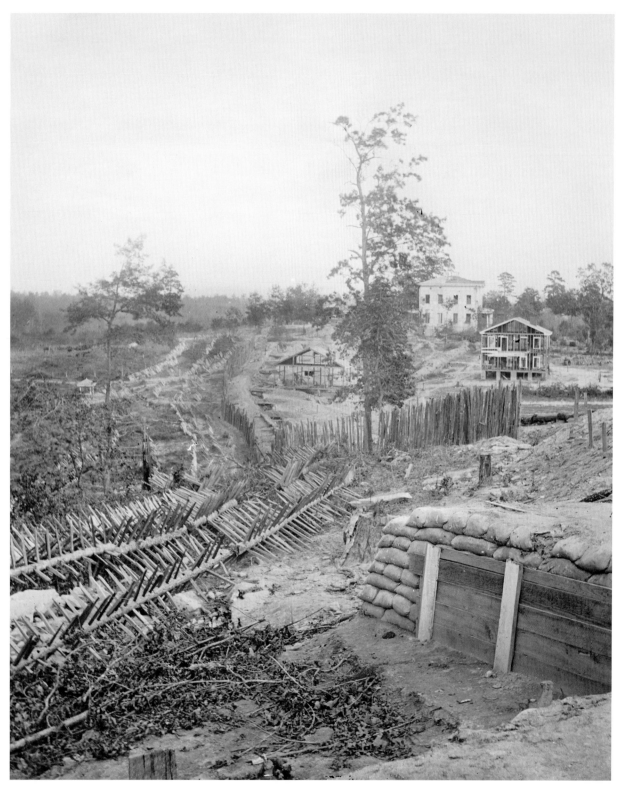

A Federal soldier sits atop the sand-bagged cannon redoubt of the captured Confederate
Fort Hood overlooking the Marietta road. A line of rifle pits extends into the distance,
screened by sharpened, interlocking logs called chevaux-de-frise. "It is astonishing to see
what fortifications they had every side of the city," a Union soldier wrote from Atlanta.
"All in vain for them," he concluded, "but quite convenient for us."

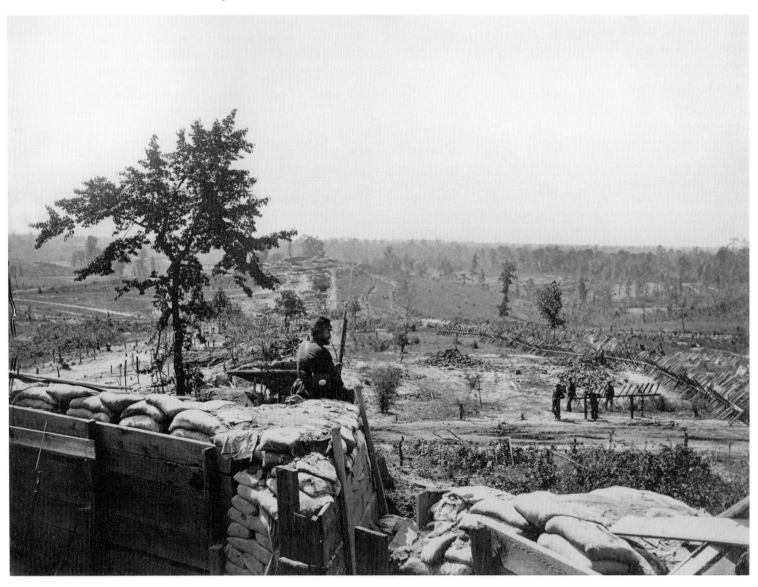

General William T. Sherman poses with his staff in Federal Fort No. 7, which had been the westernmost redoubt in the Confederate defensive line. The position stood on high ground located on the edge of the present Clark Atlanta University campus at the corner of Fair Street and the present Joseph E. Lowery Boulevard. Federal troops entered the city on September 3, 1864, and remained until departing for the March to the Sea on November 15.

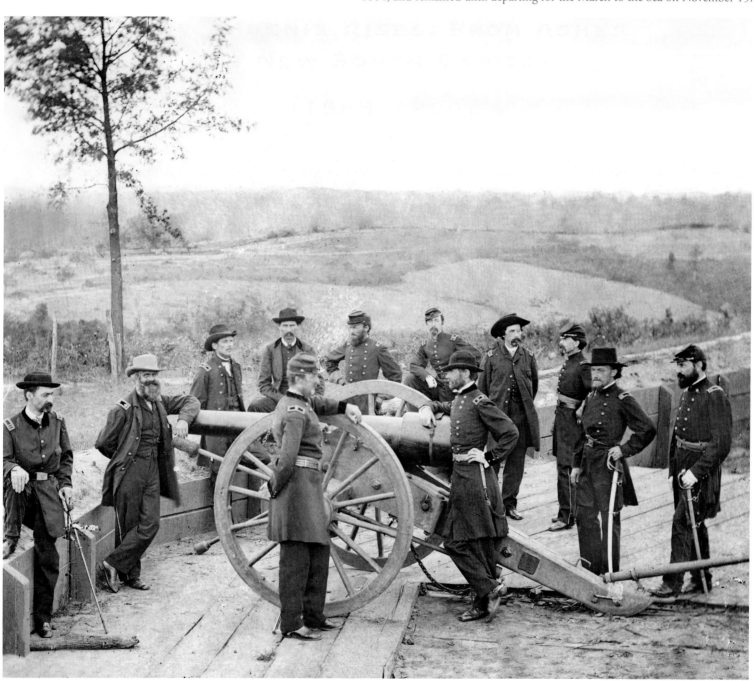

In this view north on Washington Street, the house at left built by John Neal before the war was the home of state Supreme Court judge Richard F. Lyon by 1864. Beyond are the Second Baptist and Central Presbyterian churches, and the home of Atlanta's mayor, James M. Calhoun, in the distance. Calhoun surrendered the city to Union forces on the northern edge of the city's fortifications, near the Ponder house.

The facilities of the Western & Atlantic Railroad stood north of downtown Atlanta, near the present site of CNN headquarters. These buildings were left in ruins after Federal troops destroyed most of the city's transportation facilities in mid November 1864. "We have been utterly destroying everything in the city of any use to the armies of the South," an Indiana soldier wrote. "General Sherman is credited with saying 'War is Hell.' I think that it is."

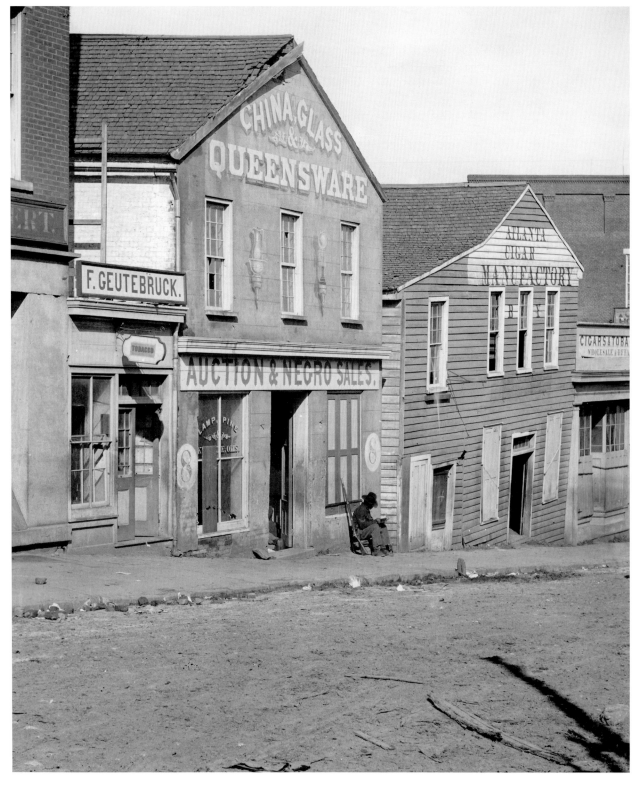

The Crawford, Frazer & Co. slave market was located at No. 8 Whitehall Street (now Peachtree Street), one block uphill from the rail line. Atlantan L. C. Butler remembered the benches surrounding the room on which slaves were seated. "Here," he said, "the prospective buyers made their selections just as they would have a horse or mule at a stockyard." The site of the slave market is now the entrance to the city's Five Point MARTA station.

This view looks down Alabama Street from the corner of Whitehall Street (now Peachtree Street) toward the Georgia Railroad locomotive house. The area is now the heart of Underground Atlanta. One of the civilian casualties of Sherman's bombardment, Solomon Luckie was killed when he was struck by shell fragments at this corner. Luckie was one of the city's free African Americans and ran a barbershop and bathing salon at the nearby Atlanta Hotel.

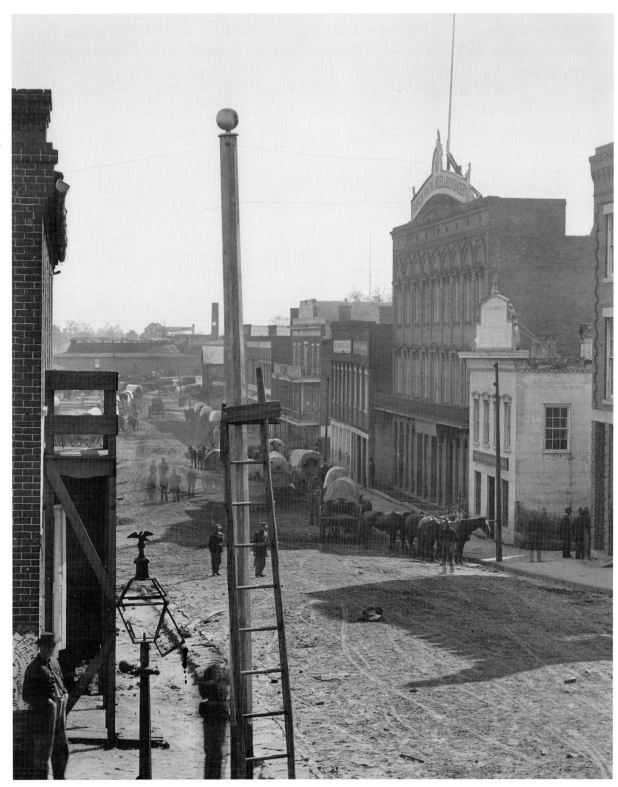

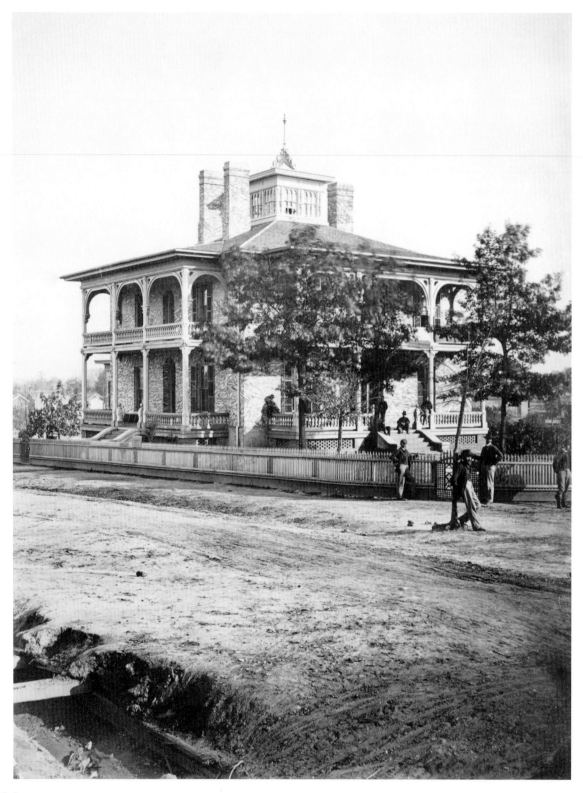

The Calico House was headquarters of Sherman's chief engineer, Captain Orlando M. Poe. Poe directed the destruction of Atlanta's commercial, military, and transportation infrastructure before the March to the Sea. Built for attorney Marcus Aurelius Bell in 1860, the house stood at the corner of present Auburn Avenue and Courtland Street. The residence was marbled in shades of blue, yellow, and red. Atlantans believed the simulated effect looked more like calico fabric than classic marble, thus the nickname.

Federal officers relax on the steps of the home of Er Lawshé, located on Peachtree Street between Cain and Harris streets. After the war, this house was requisitioned as headquarters for the commander of the Post of Atlanta, Prince Felix Salm-Salm, a brigadier general from Prussia. Though this was an imposing two-story residence with trellised and columned porches, the wife of the commander, Agnes Leclerq Salm-Salm, described it as "a very nice little cottage."

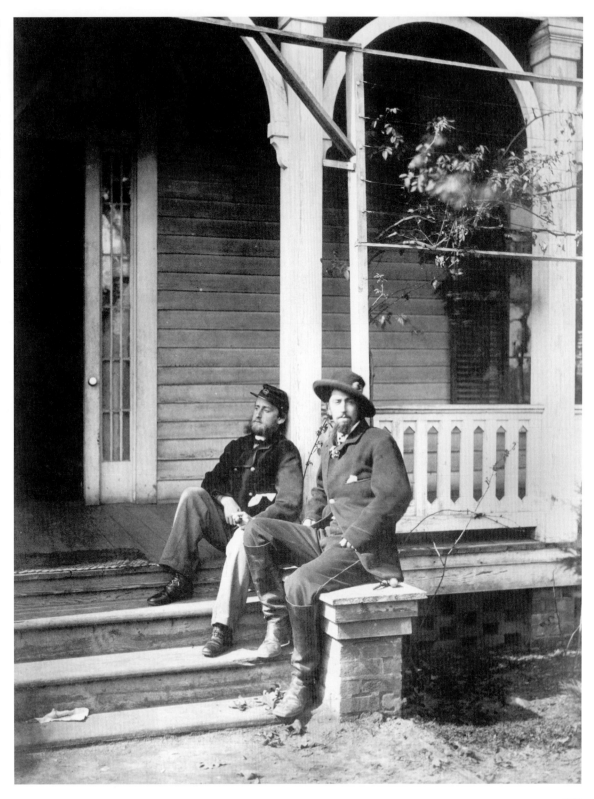

This house on Peachtree Street shows damage both under the roofline and to the chimney at right—probably from shelling during the Federal bombardment of the city during August. The siege was horrifying for residents of the city. Sherman himself wrote to Confederate general John B. Hood, criticizing him for defending the city "on a line so close to town that every cannon shot and many musket shots . . . went into the habitations of women and children."

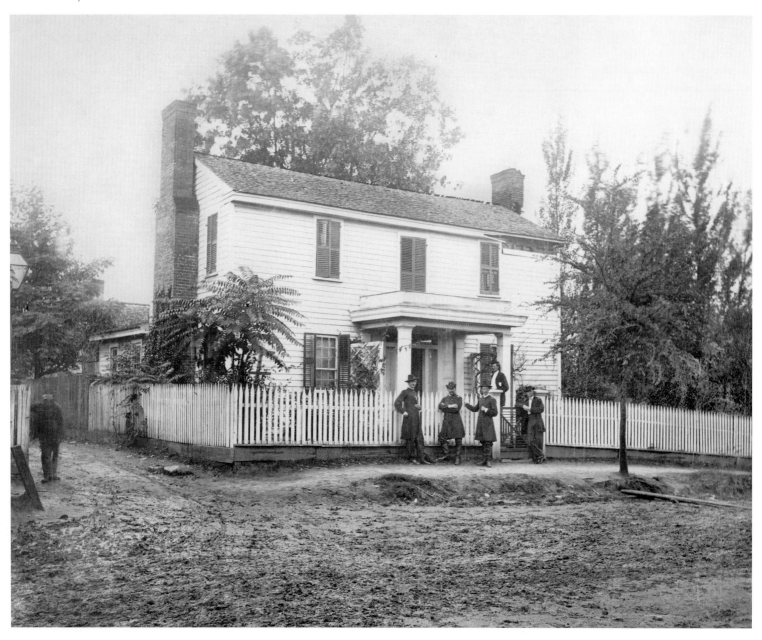

Officers and troops of the Union Army of the Cumberland pose on the porch of an unidentified house located on what was known as "Upper" Peachtree Street, the section between Ellis and Butler streets. Major General George H. Thomas' headquarters was located in the Herring-Leyden House near the intersection of Ellis and Peachtree streets. Subsequently, many of the homes in the area were appropriated by officers of his army.

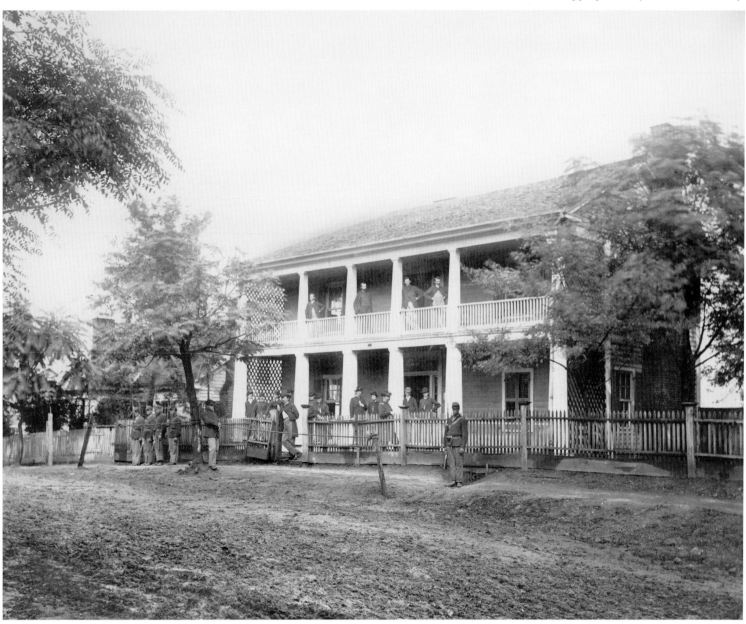

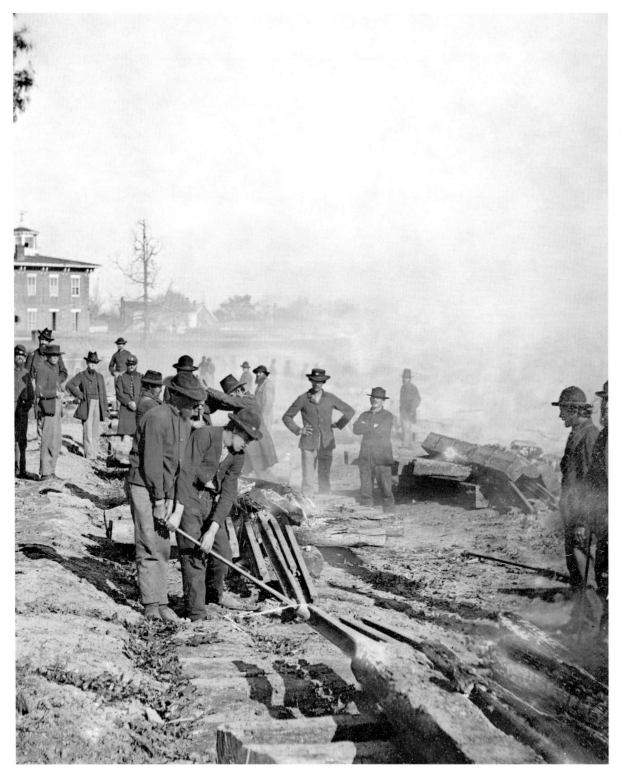

Federal troops dismantled and destroyed the city's railroad network in the last days of the Federal occupation of Atlanta in November 1864. The destruction of Atlanta's military capabilities had been Sherman's goal and the subsequent damage to surrounding homes and private property ruined a significant section of downtown Atlanta.

The center of Atlanta and the basis for its existence, the depot and rail lines had transformed a city in the forest into a major transportation and commercial center. Yet the Union Passenger Depot, commonly called the "Car Shed," lay in ruins when Sherman departed on the March to the Sea. "The devastation of the city was so widespread," a Union private wrote, "that I don't think any people will want to try and live there now."

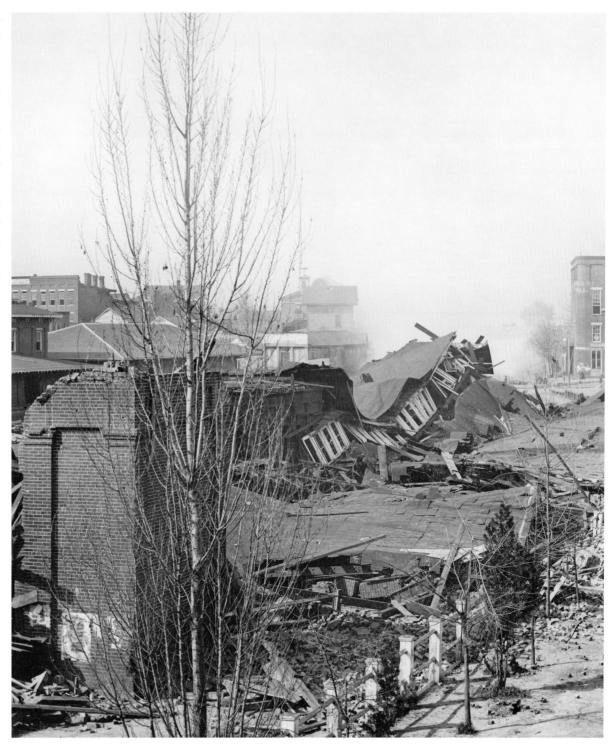

Seen from the Broad Street Bridge, Union Station was completed in 1871. The Kimball House to the left opened in 1870. With 240 rooms, the hotel was painted yellow with brown trim and provided elevators and central heat. Rising six stories, it was considered by many Atlantans to be "too large for the community," and its builder, Hannibal Kimball, was in financial trouble before it was completed. Yet the hotel was a source of city pride until destroyed by fire in 1883.

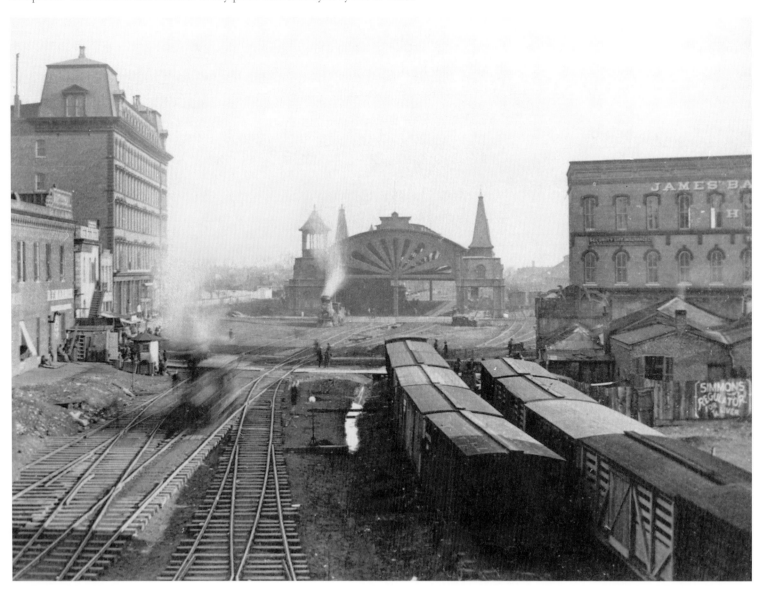

The Phoenix Rises: From Ashes to New South Capital

(1865–1899)

Nearly as soon as Sherman left Atlanta, the city set about to rebuild what he had destroyed. A small wood shed replaced the ruins of the passenger depot and the rail lines were quickly restored. With them came commerce and trade and the return of prosperity that ran on the rails. Throughout the remainder of the century, the city became a center of business and investment as well as the hub of an emerging southeastern rail network.

Embracing the mythological Phoenix—a firebird reborn from its ashes—and adopting the motto Atlanta Resurgens for "rising again," the city established itself as the capital of Georgia and the self-proclaimed first city of the South. The first was achieved in 1868 in the state's post–Civil War constitution; the second was a matter of promotion and strategy.

Henry W. Grady, editor of the *Atlanta Constitution,* was a spokesman for the New South, a vision of the region's future composed of an agrarian system combined with an industrialized southern economy. With the aid of northern capitalists, the New South would join in the nation's prosperity through reconciliation with the north, diversification, and manufacturing. At the same time, the image of the New South included racial segregation and white supremacy.

Even so, Atlanta's growth throughout the late nineteenth century included a significant, emergent African American community. Between the close of the Civil War and the turn of the century, the city became home to several of the nation's most important historically black colleges and universities, including Atlanta University, Clark University, Morehouse College, and Spelman College. By 1900, Atlanta's population included 35,000 African Americans, constituting 40 percent of the city's residents.

During the period, Atlanta's boosterism was put on display in a series of grand expositions that sought to set the city apart from its southern competitors. Presenting the commercial economy of the New South, the expositions promoted southern industry, including cotton textile mills, and the variety of produce and natural resources available from the region. From 1881 to 1895, the city staged three expositions: the International Cotton, Piedmont, and Cotton States and International. By the close of the last, Atlanta had confirmed its role as first city of the South.

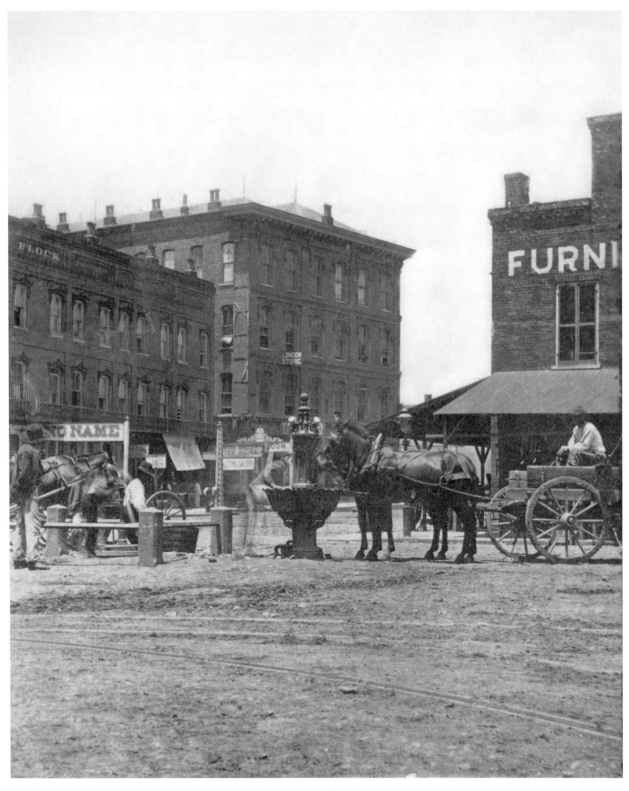

In the 1870s, this fountain on Marietta Street provided public watering for horses. In early Atlanta, Walton Springs was located nearby in the vicinity of present Carnegie Way and Andrew Young International Boulevard. The area of the spring had been popular for strolling in antebellum Atlanta and became home to bombproofs dug into the hillsides during the war. Spring Street is named for the spring and Walton Street for its owner, Anderson W. Walton.

A horse-drawn trolley moves past hitching rails along the city's first length of street rails on Alabama Street. The cupola at the end of the street is the Georgia Railroad Freight Depot; the cupola at right is Atlanta City Hall. The small cupola at center-left is Fire Engine House No. 2, which like city hall survived Sherman's destruction. This section of Alabama is south of present Peachtree Street and part of Underground Atlanta.

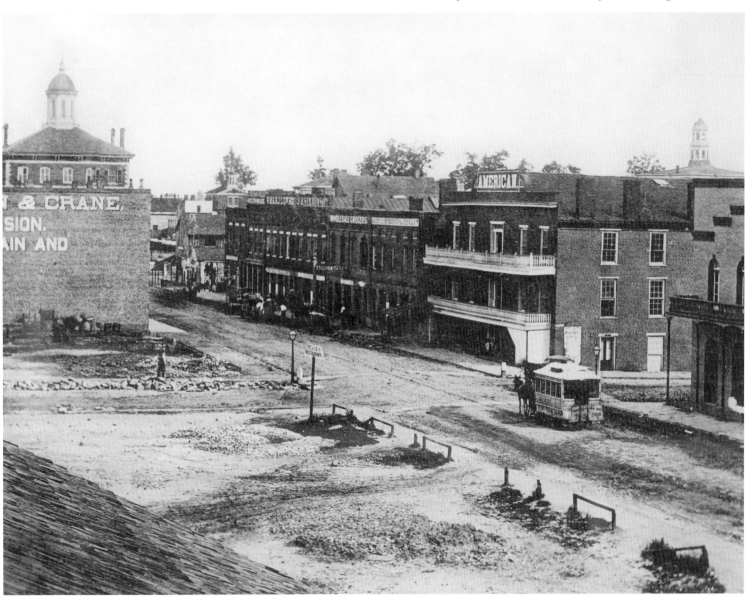

A buggy, blurred by its motion, passes the trolley along a section of Alabama Street north of Broad Street. The building at the end of the street is the Georgia Railroad Freight Depot, completed in April 1869. Following a fire in 1935, the top two stories of the depot were removed. The building's first floor and attached freight bays, however, still stand next to Underground Atlanta and it remains the oldest surviving building in downtown Atlanta.

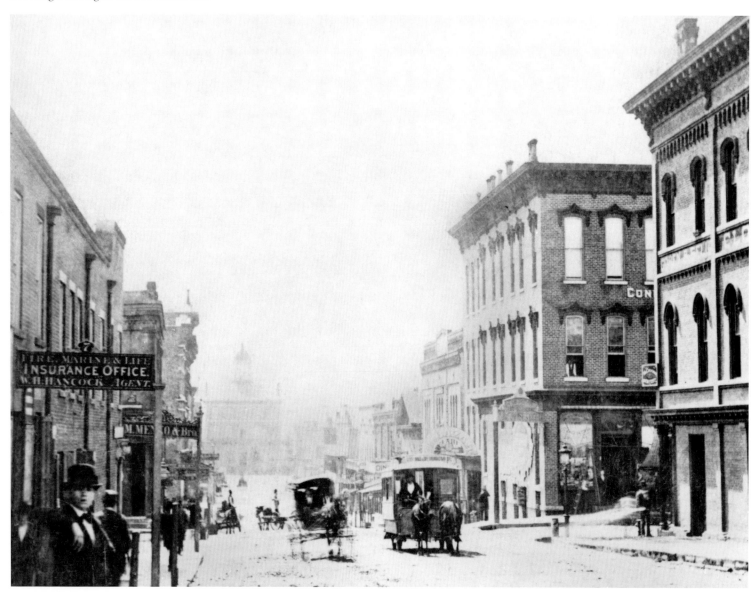

The signpost for the bookseller M. Lynch and Company appears in the foreground, in this view down Whitehall Street (present Peachtree Street) beyond Alabama Street. A trolley car heads toward the photographer, with a second seen in the distance, not too far behind. Frequent trolleys along this section of the city suggest heavy traffic, which would have been likely, given the many dry goods and merchandise stores located here.

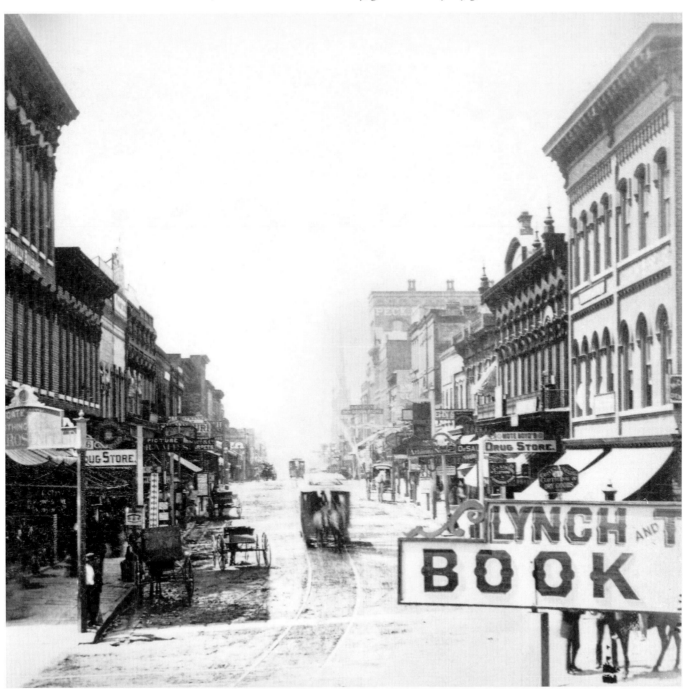

The Tallulah Fire Company No. 3 was organized in February 1859 following the city's first fire-related deaths earlier that winter. The volunteer company adopted uniforms—orange jackets with black pants and red caps trimmed in blue, along with the motto "We Strive to Save." The company's brick firehouse stood on present Broad Street between Marietta and Walton streets. The city's all-volunteer fire companies served until the fire department was authorized in 1882.

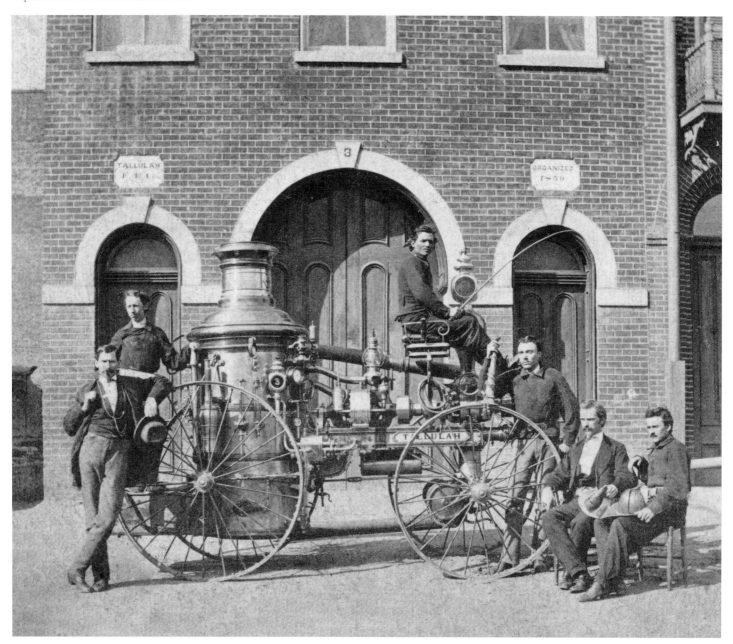

Atlanta's Presbyterian Church was founded in 1848 after the new schoolmaster, Dr. William N. White, arrived in town to discover "there are but two Presbyterians besides myself in the place." Organized with nineteen initial congregants, the group held services in a combined nondenominational church and schoolhouse at Peachtree and Pryor streets. Their own church building was dedicated July 4, 1852, and stood along the west side of Marietta Street until the late 1870s.

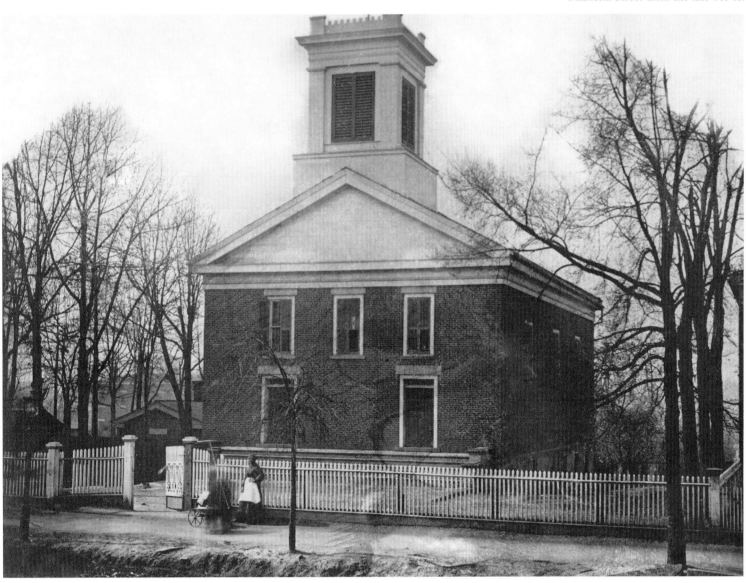

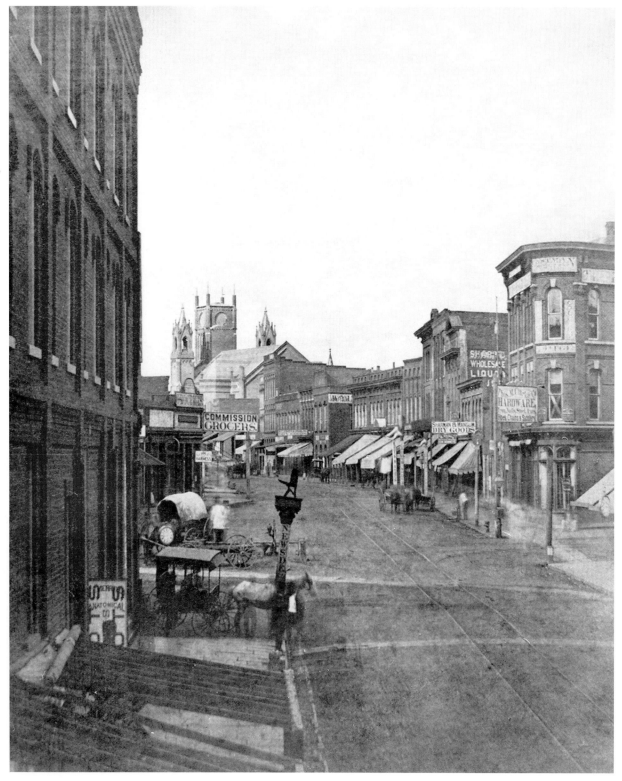

The First Methodist
Church appears
at the end of the
section of Peachtree
Street running from
the Luckie Street
intersection to today's
Margaret Mitchell
Square. Atlanta's first
church building was
a one-room frame
structure erected in
1847 near this site.
Prior to that, Dr.
William N. White
noted that "not a
church has yet been
built . . . preaching is
held in the railroad
depot."

Carriages wait for passengers outside the station along Wall Street. The street was created in 1870 with the removal of the original city park during construction of the new depot. The Markham House stands at the end of the street along present Central Avenue. Built in 1875, the hotel was proud of its 105 sun-filled rooms, excusing two dark rooms as "adapted for railroad men and the night clerks who sleep in the daytime."

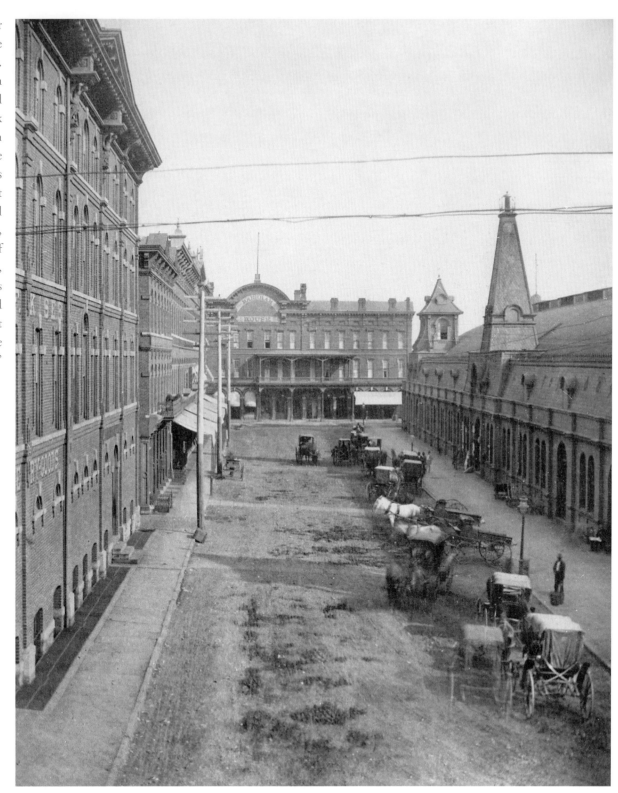

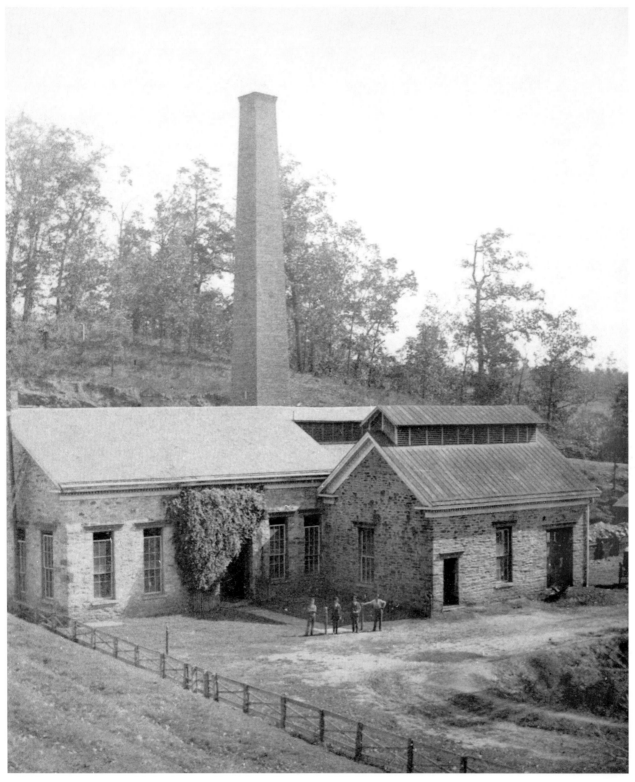

Atlanta's first waterworks were built by the Holley Waterworks Company in 1875 at Poole's Creek on property that became Lakewood Fairgrounds. The company constructed a 51-foot dam to contain the clear spring water. The system was tested on September 11, with trials at the Kimball House and on Peachtree and Marietta streets. The final was a fire service test using 1,000 feet of hose from the hydrant—the successful test maintained 100 feet of water for seven minutes.

Oglethorpe Park, the city's first recreational area, was approximately fifty acres located two miles north of the central city adjacent the Western & Atlantic Railroad. The property was acquired by Atlanta in 1869 and was first developed for use by the State Agricultural Association. In 1881, the park was the site of the International Cotton Exposition, the city's first agricultural and industrial fair intended to promote city businesses.

In 1875, the city dug an artesian well and constructed a water tank at the intersection of Peachtree, Marietta, and Decatur streets—now known as Five Points. Though this was an effort to ensure the city's water supply, it was never a reliable—or safe—source of city water. At this time, Edgewood Avenue had not yet been constructed from the Five Points area.

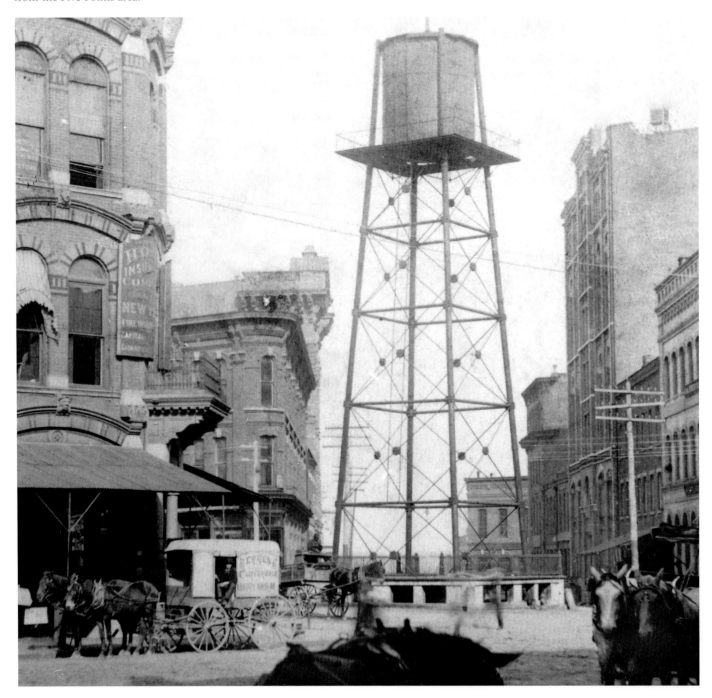

A shopper, carrying her store-wrapped package, crosses the hustle and bustle of busy Whitehall Street. In the distance beyond, a crowd fills the hectic intersection of the street, the rail line, and Peachtree Street farther on. The Kimball House rises in the background. The street here sloped downhill to the original surface grade of the railroad tracks before rising again along Peachtree Street.

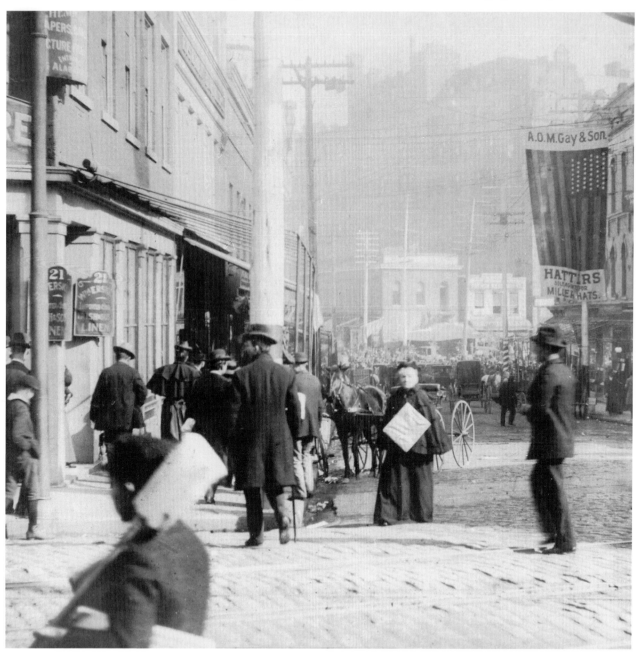

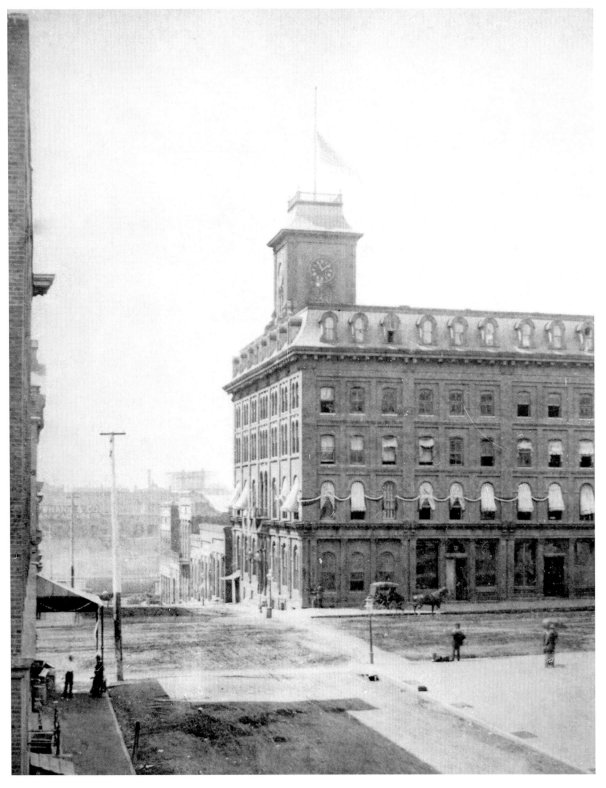

Atlanta's first state capitol sits on Marietta Street at the edge of the slope where Forsyth Street dips down to the railroad line below. When the city became the temporary state capital in 1868, Atlanta City Hall housed the legislature. In 1870, the state purchased the recently completed Atlanta Opera House for $250,000 as its new state capitol. After Atlanta became the permanent capital in 1877, the legislature continued to meet here until 1889.

This rare view of Atlanta from the countryside shows the Kimball House at right and the state capitol at left dominating the skyline. Kimball House builder, Hannibal I. Kimball, had also been a principal agent in the sale of the opera house to the state. In 1868, when the original opera building association ran out of money, Edwin Kimball purchased the building for $32,000. He later sold it to his brother Hannibal, who in turn sold it to the state.

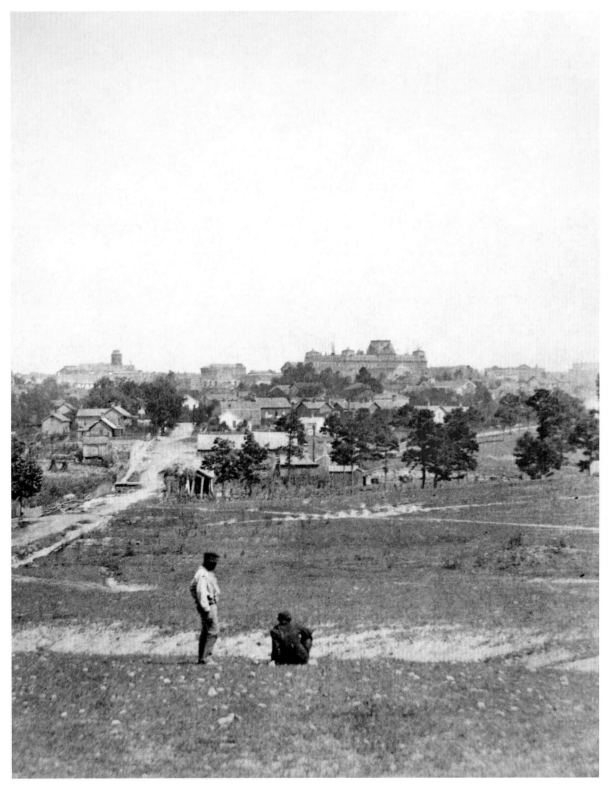

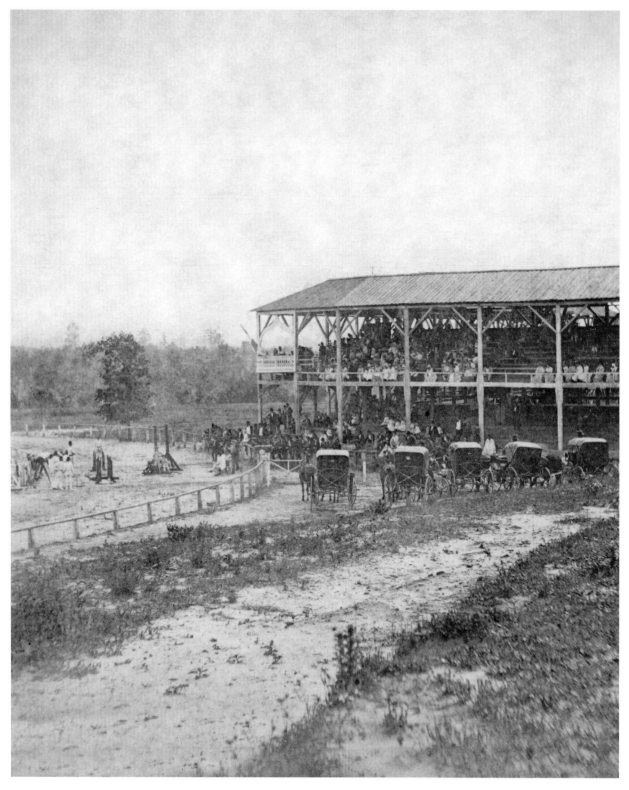

When the city formed Oglethorpe Park in 1869, it created a lake and built a racetrack and grandstand. Small annual fairs were held there until 1881, when it hosted the International Cotton Exposition. The trade fair included exhibitions of textile manufacturing and southern agricultural products as well as a working cotton mill. After the close of the exposition, the park property was sold and became the Exposition Cotton Mills textile plant.

In the years following the Civil War, Vinings Station became a popular destination for daylong pleasure trips to the countryside. Most people arrived by train and enjoyed not only the rustic charm of the crossroads town, but dancing and entertainment in the five pavilions built to attract the city's sightseers. An additional attraction was the distillery built here in the late 1860s by Rufus M. Rose, founder of the "Four Roses" whiskey blend.

Robert C. Foute stands at the lectern of the Old St. Philips Episcopal Church, built in 1847 on Washington Street between the Georgia rail line and present Martin Luther King Jr. Drive. Although the small church survived the war, the rectory, parish office, and other church buildings were stripped for building materials for Union army barracks. The church itself was used during the occupation as a bowling alley, commissary, dance hall, and stable.

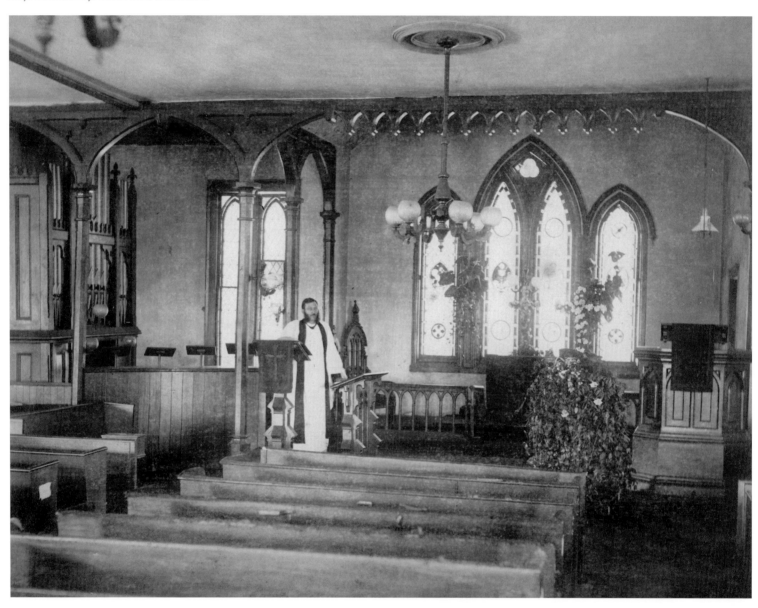

By 1875, the Old St. Philip's church had grown to be the largest Episcopal congregation in the state, including the attendance of Federal officers and their families stationed in Atlanta during Reconstruction. The building was repaired from the heavy damage suffered in the war with their assistance, including appeals to northern friends and military band concerts. The church's new cathedral rises in the background.

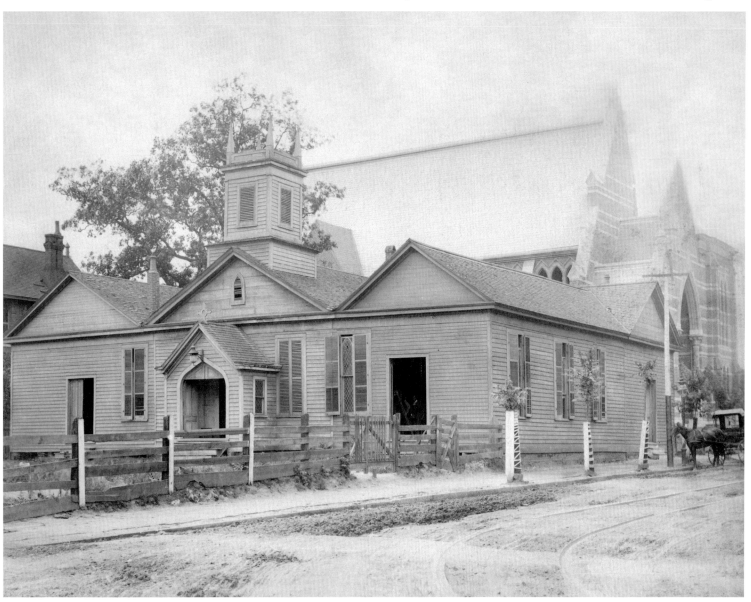

A display of ladies' hats fills the windows and doorway of Julius Regenstein's millinery and dry goods store founded in 1872. Originally called the Surprise Store, Regenstein's offered everything a woman could desire and was supposedly the first store in the South to have a woman sales clerk.

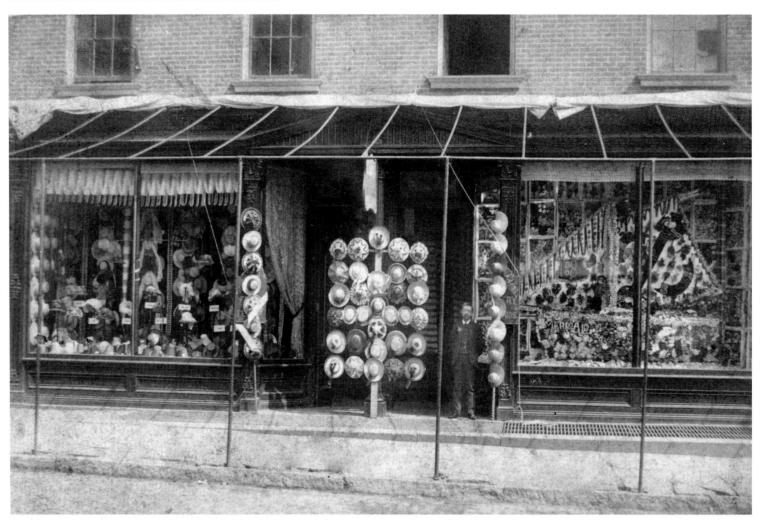

Passenger carriages and produce wagons cross the Broad Street Bridge providing safe access from one side of town to the other above the rail lines. A wooden bridge erected here in 1853 was the first of the bridges and viaducts created by the city to circumvent the danger posed by the railroads below. After burning in 1865, the bridge was reconstructed with suspension rods and widened to seventy feet.

Atlanta pioneer settlers Thomas W. Connally and his wife, Temperance Peacock, pose in front of their East Point home in 1883. The couple had sixteen children. Standing with them is their granddaughter Electa, and their domestic servant, Aunt Martha. In the 1850s, the city of East Point, like Atlanta, developed around the terminus of a rail line, the Atlanta & West Point Railroad.

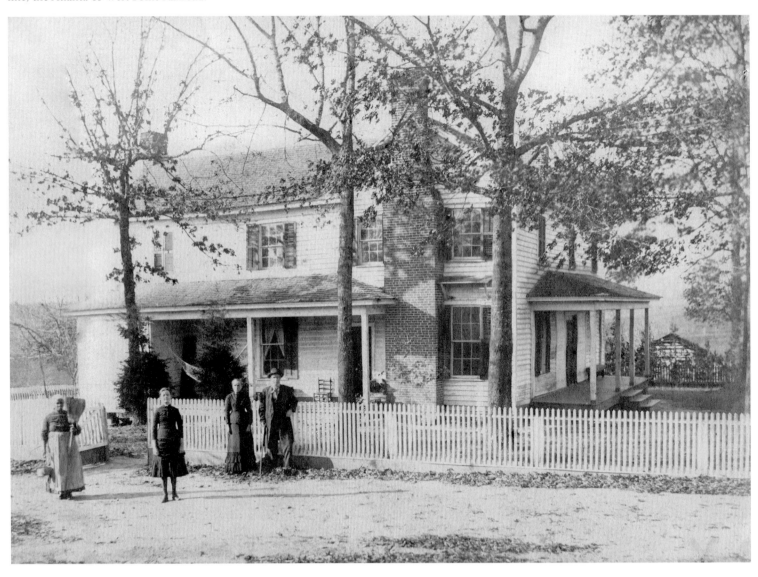

Throughout the nineteenth century, Atlanta's African American working-class population lived between freedom and Jim Crow. Thousands of former slaves and sharecroppers came to the city looking for work, most employed in white-owned businesses or in homes. The women were frequently employed as household workers—cooks, washerwomen, chamber maids, nurses. In addition to factory and railroad jobs, many men worked as carriage drivers, yardmen, butlers, and stable hands.

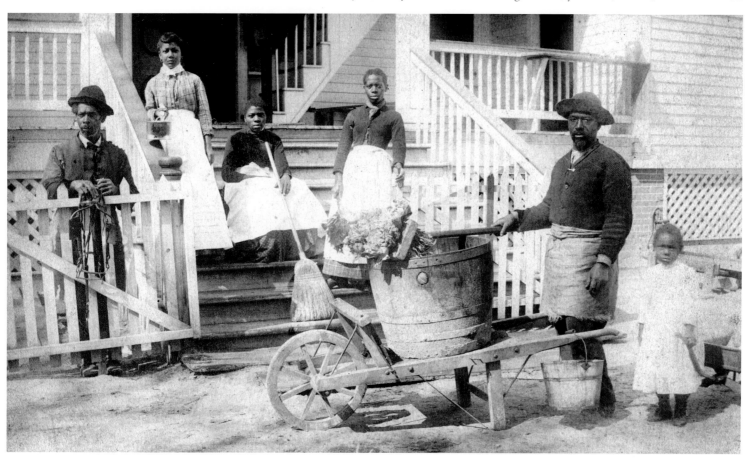

After the Kimball House burned in 1883, the hotel was rebuilt on its original site with the assistance of Hannibal I. Kimball, who then lived in Chicago. It reopened New Year's Day 1885, with 357 guest rooms, a 7-story atrium, 31 stores, and more than 20 public-event rooms. It was advertised as fireproof. In 1893, the owner, Hugh T. Inman, presented the Kimball House as a wedding gift to his daughter, Annie, and her husband, John W. Grant.

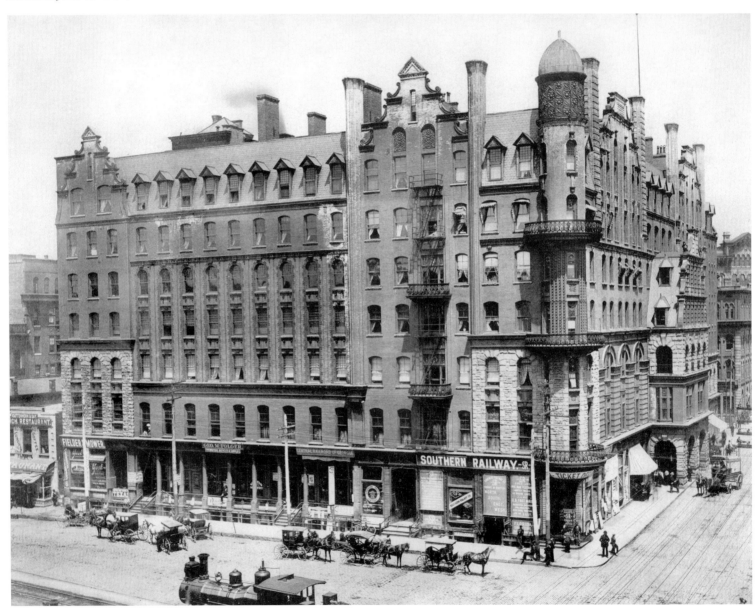

The Kimball House covered almost an entire city block, but its primary importance lay in its location along the rail line in central Atlanta. Despite the convenience for passengers staying at the hotel, the smoke and noise from the adjoining depot would have been striking to the modern traveler. In the mid 1880s, steam engines such as No. 12 of the Atlanta & Charlotte Air Line Railroad still burned wood, as seen in the wood-filled tender.

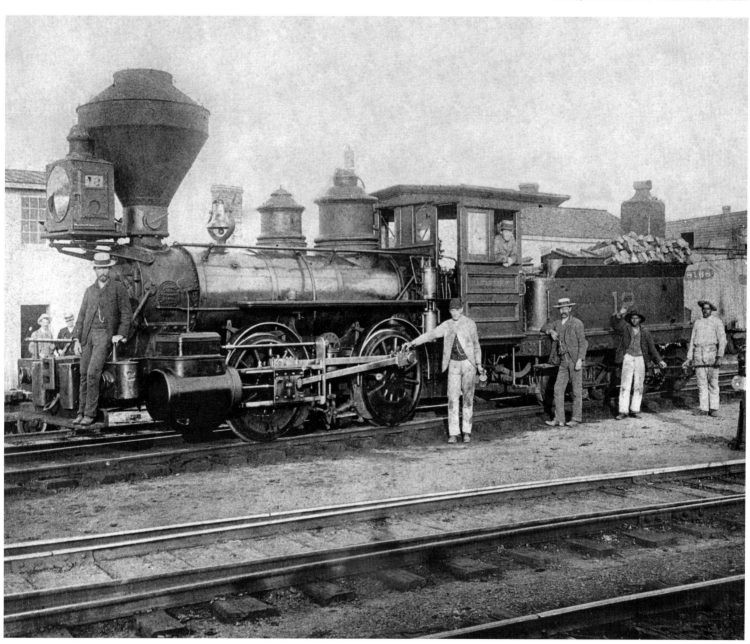

The city's first street railway line was a two-mile stretch called the West End
Line laid for horse-drawn trolleys in 1871. In 1874, the Atlanta Street Railroad
Company built a stable and a car shed near present Hurt Park. The brick stable
included an office, harness shop, blacksmith shop, and stalls in the rear of the
building for the mules. The car shed, seen here, held the paymaster's office,
bookkeeping, and nighttime storage for the cars.

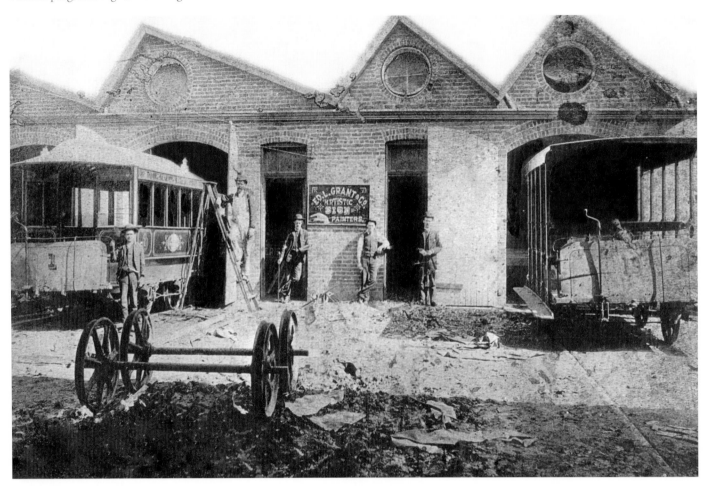

The Atlanta City Brewing Company was founded in 1867 at the corner of Harris and present Courtland streets as "City Brewery." When the wooden offices burned in 1880, a brick building was constructed directly over the existing storage cellars. During the 1880s, the firm brewed draught beer, delivered in barrels and kegs. At the same time, the company acquired an ice factory to supply its customers with free ice.

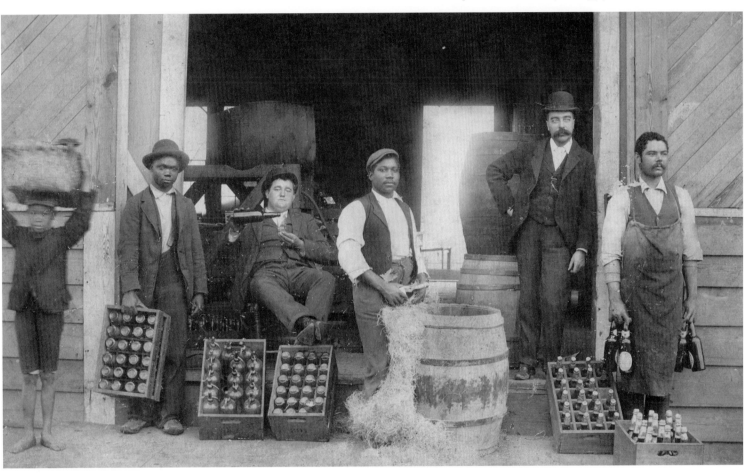

The fanlight of the Union Station train depot rises above a crowd waiting on President Grover Cleveland to emerge from his train car. Cleveland came to Atlanta in October 1887 to visit the Piedmont Exposition, the second of Atlanta's large fairs dedicated to southern manufacturing. The fair was organized by the Piedmont Exposition Company and was held on private grounds that now form the city's Piedmont Park.

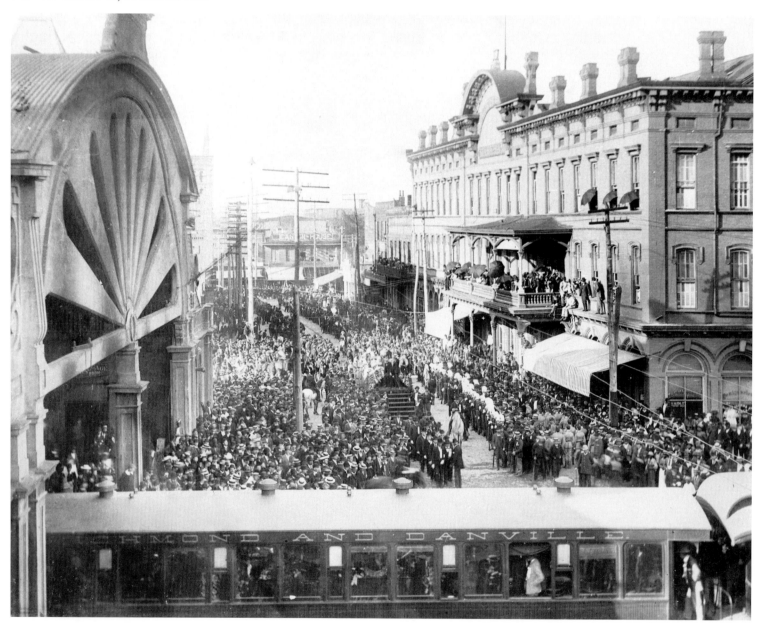

The rustic, tented scenery in this albumen print is actually an ornate studio setting with a painted backdrop. Although the men's group is unidentified, the man seated second from right is Charles Hardy Ivy, a grandson of Atlanta pioneer Hardy Ivy. About 1833, the older Ivy built a log cabin on high ground near the corner of Courtland and Ellis streets. In doing so, he became the first white settler to build a home in what became downtown Atlanta.

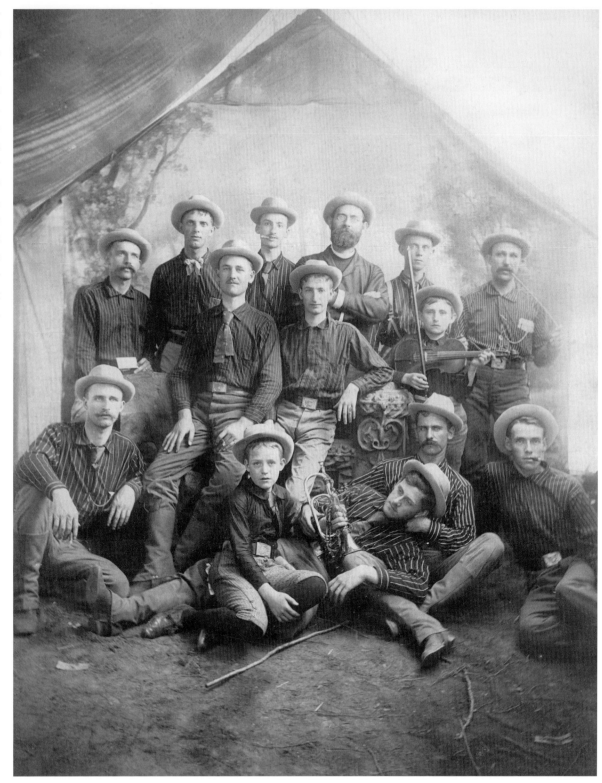

A nursemaid and her wards stand before Christian Kontz's house along Marietta Street. As technology allowed photographers freedom to move out of the studio to document the American landscape, the homes of wealthy city residents became a favorite subject. Hired by the homeowners, photographers recorded residences as a confirmation of late-nineteenth-century American prosperity—complete with family members and domestics posed proudly, if sometimes awkwardly, in front.

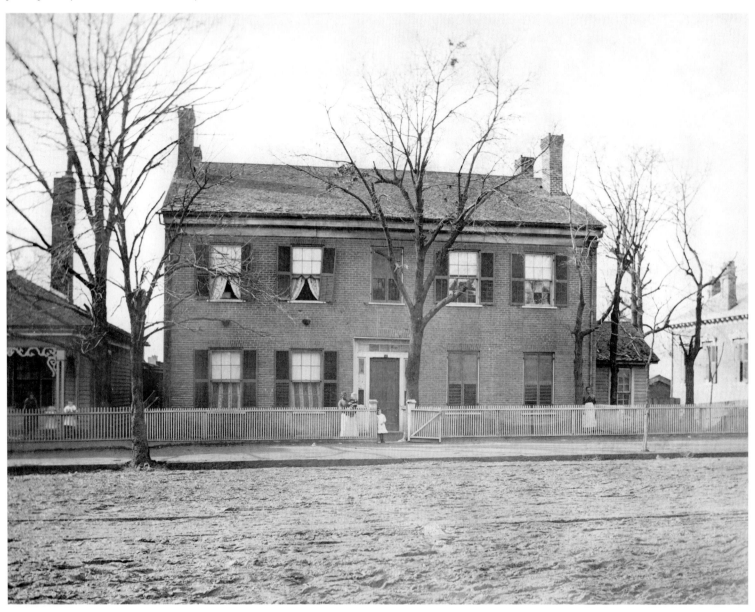

In 1880, the city constructed its first African American public school building, the Gate City Colored Public School, commonly known as the Houston Street School. When it opened, the building provided classrooms for 450 students, the male principal, and several female teachers. Though this was adequate at the time, within years the school was turning away hundreds of applicants and forcing students to share desks and teachers and to attend split-session classes.

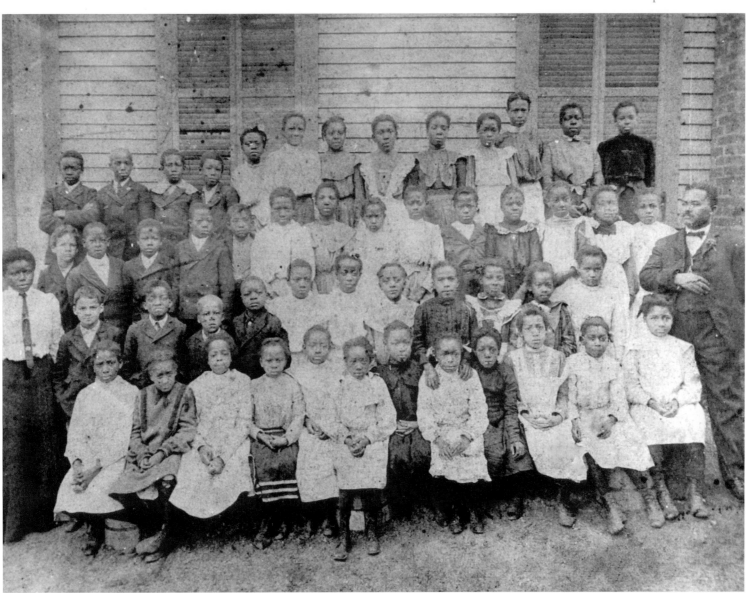

In 1867, local officials proposed the city as Georgia's fifth state capital when a constitutional convention gathered in Atlanta. It was approved, but the question rose again in 1877, leading to a statewide referendum that selected Atlanta over Milledgeville as the permanent capital. In 1889, construction of the new $1 million capitol was completed on the site of Atlanta's antebellum city hall.

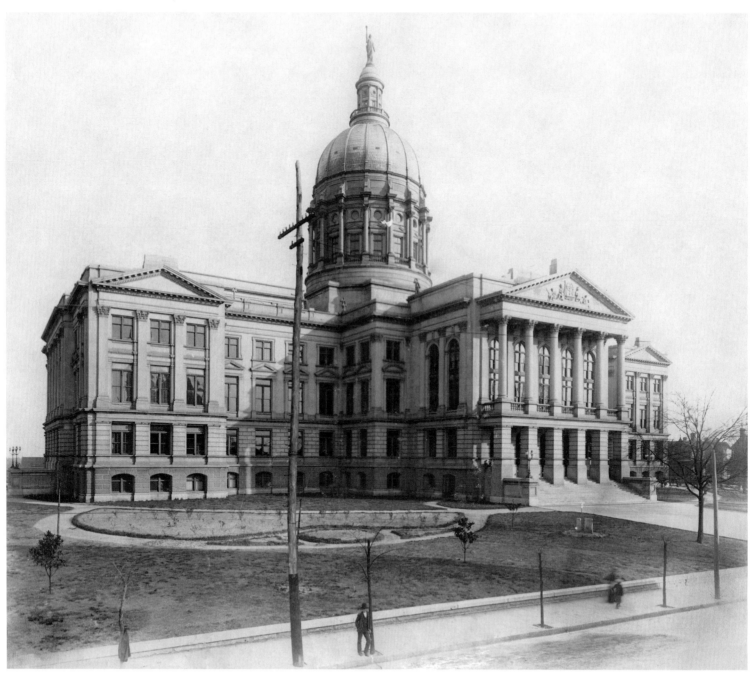

This panorama was taken from the dome of the new state capitol, facing northwest toward the heart of Atlanta in 1889. Just right of center is the barrel-vaulted roof of Union Station with the second Kimball House rising above it at the depot's north end. At lower-right are the cupola-topped Georgia Railroad Freight Depot and its long row of freight storage rooms running to the right edge.

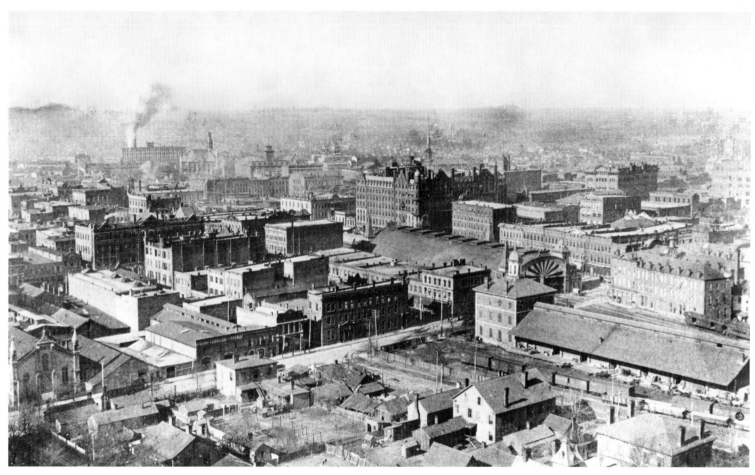

Peachtree Street during the 1890s was full of grand homes shaded by tall, old trees. This view faces north along the street from the Ellis Street intersection. The house visible at left belonged to banker Robert H. Richards; the columned house next door is the Herring-Leyden House, occupied by Union general George H. Thomas during the Civil War. The Georgia Governor's Mansion stood just one block north at Cain and Peachtree streets.

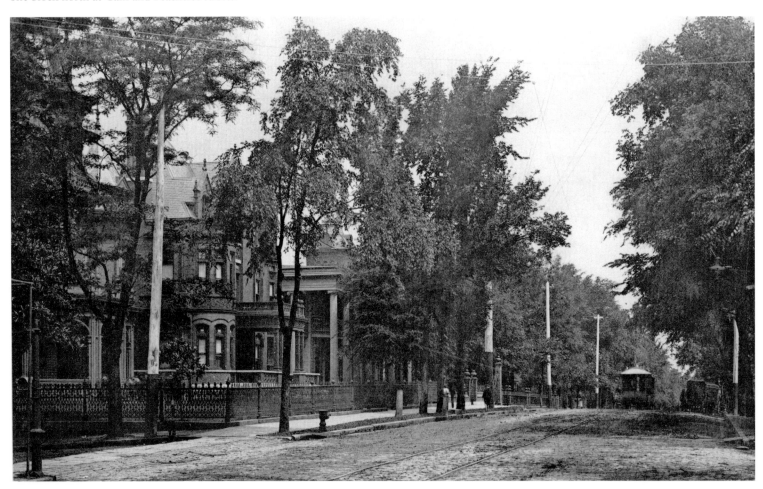

Though West Peachtree Street in 1890 was a quiet residential neighborhood of middle-class homes, it had a busy existence during the 1880s. Until the mid 1870s, this had actually been the original course of Peachtree Street. It was not until the early 1880s that the street was fully extended to the present Pershing Point where it rejoins Peachtree Street. During the same period, the name was changed to Georgia Avenue, reverting to West Peachtree Street in 1885.

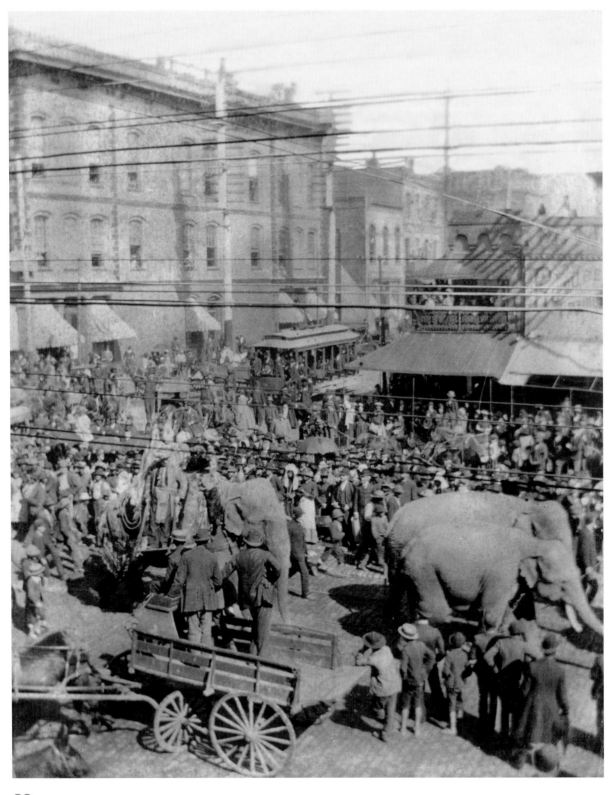

The Adam Forepaugh Circus, complete with elephants with trainers in Arabian costume, parades along Marietta Street in October 1892. Those who attended the circus were treated to two roundtops—one for the menagerie of wild and exotic animals and one for the circus performers. Under the tents, audiences saw spectacles like the Light of Asia (a white elephant), Battles of the War for Freedom, and "Jack," the boxing kangaroo.

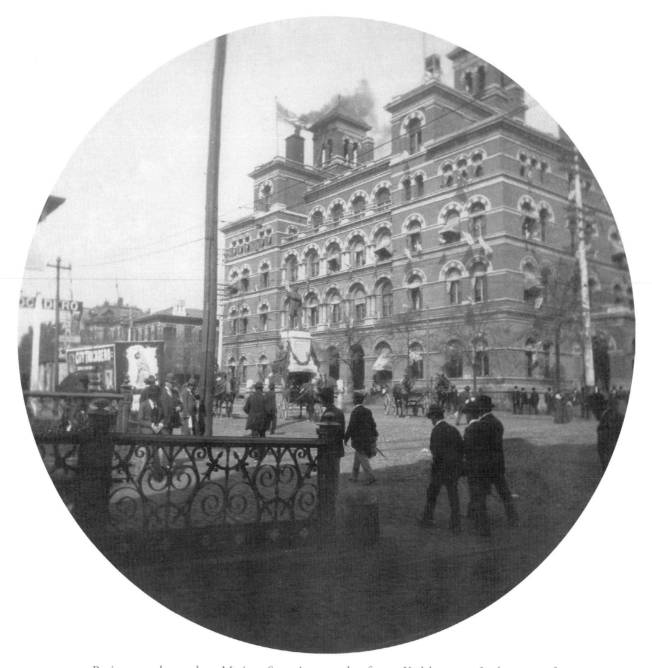

Businessmen hurry along Marietta Street in a snapshot from a Kodak camera. In the center of the street is the monument dedicated in 1891 to Henry W. Grady, who died two years earlier of pneumonia. Grady was an Atlanta journalist, orator, and spokesman who championed the New South. Across the street is the U.S. Post Office and Customs House, completed in 1879, which served as Atlanta's city hall from 1911 to 1930.

Before his death in 1889, New South promoter Henry W. Grady had encouraged the creation of a public hospital for Atlanta. In 1890, the year after his death, a hospital honoring him was approved by the city. In May 1892, Grady Memorial Hospital opened in its Butler Street building, providing one hundred beds in ten wards for patients. Today, Grady is the state's largest hospital, with nearly one million patient visits a year.

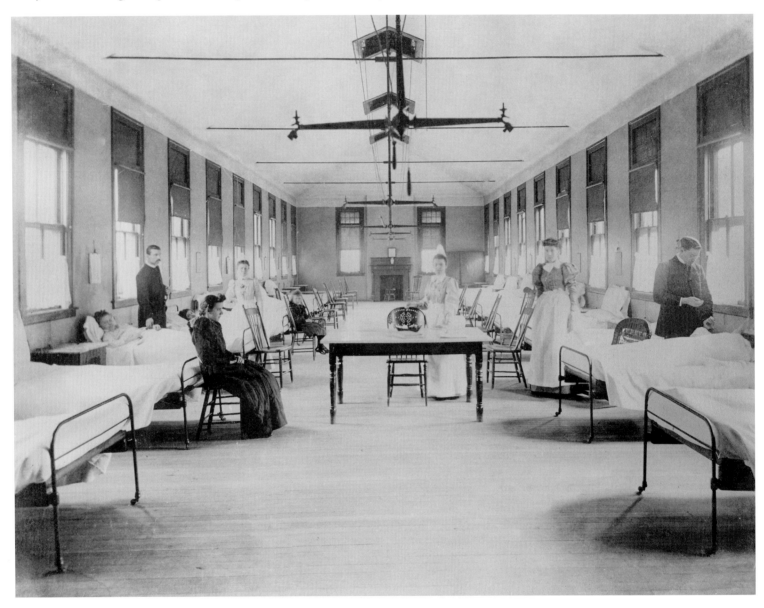

This portrait depicts Selena Sloan Butler with her husband, Henry Rutherford Butler, and son, Henry, Jr. Selena Sloan graduated from Spelman Seminary at age sixteen, becoming an English and elocution teacher before marrying Butler. Known for her philanthropic work, she organized the first African American Parent-Teacher Association in the nation. She was recognized as a cofounder of the National Parent Teacher Association following the merger of the separate organizations for blacks and whites in 1964.

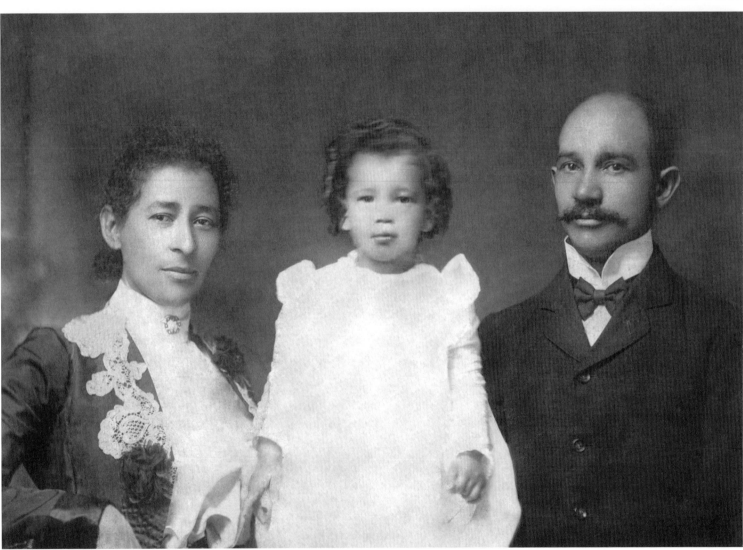

A group of bicyclists pose outside the home of William Bensel on Ellis Street. By the 1890s, "safety" bikes with a body frame and chain drive similar to modern bicycles provided both transportation and leisure. So many inexpensive, mass-produced bicycles were being devised and manufactured that the U.S. government maintained a separate patent office just for bicycles. Around the time of this photograph, Harry Dacre introduced his song "Daisy Bell (Give Me Your Answer True)"—also known as "A Bicycle Built for Two."

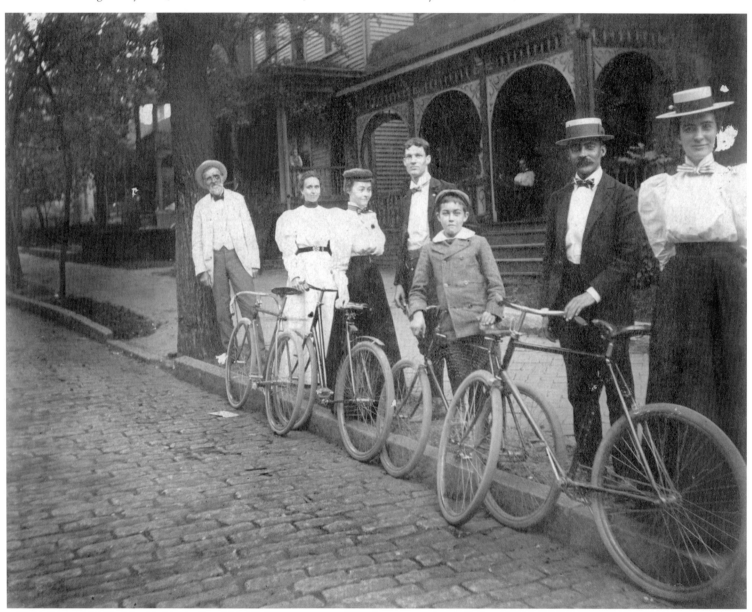

A new brougham sits on Ponce de Leon Avenue with horses Daisy and Dandy in harness. The coach has a front window, allowing occupants to see forward—here, the children of Clarence Knowles, Constance and Clarence, Jr. Knowles was president of the Piedmont Driving Club, founded to allow owners to display their horses and carriages on the club grounds, which became Piedmont Park. The names of the African American driver and nursemaid on the curb are not known.

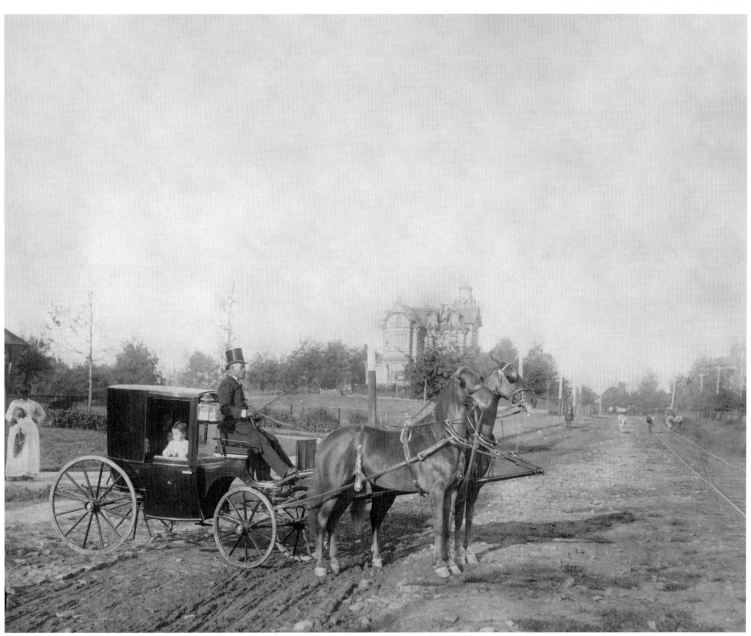

The University of Georgia and Auburn University compete in the "Deep South's Oldest Rivalry" at present Piedmont Park in 1895. The Tigers won, 16-6. The schools' first football game was held in the park two years earlier, Auburn winning, 10-0. Georgia's coach was Glenn "Pop" Warner, who led the team to its first losing season at 3-4. The following year, the Bulldogs were co-champions of the Southern Intercollegiate Athletic Association with an undefeated, 4-0 record.

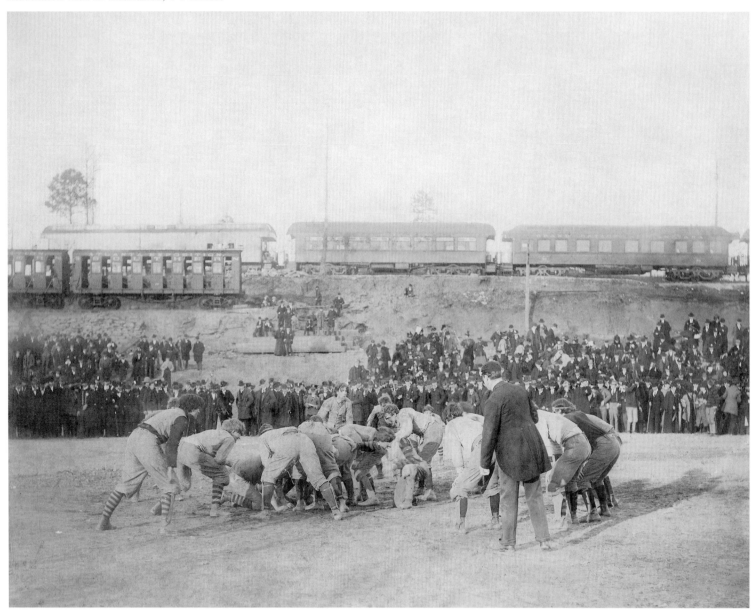

Atlanta's first electric streetcars plied the recently constructed Edgewood Avenue in 1889, providing access to the city's first suburb, Inman Park. This railway car, complete with striped curtains, served West End and the new U.S. Army post at Fort McPherson. The McPherson barracks were made a permanent post of the Fourth Artillery in 1889 and became a training depot for recruits during the Spanish-American War in 1898.

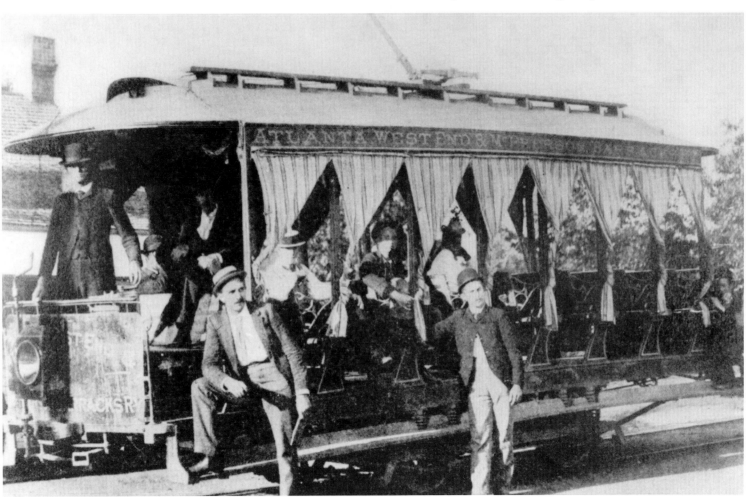

William Kuhns, at left, with his mother, Sophia, son Dwight, and African American laborers pick grapes in the family's vineyard in Edgewood. Shortly after the Civil War, the Kuhns family opened a photography studio on Whitehall Street, where most of the city's photographers were located. They maintained a studio in Atlanta for more than seventy years, including a studio wagon that traveled the local countryside. Their laborers are identified as Grace and Johnson.

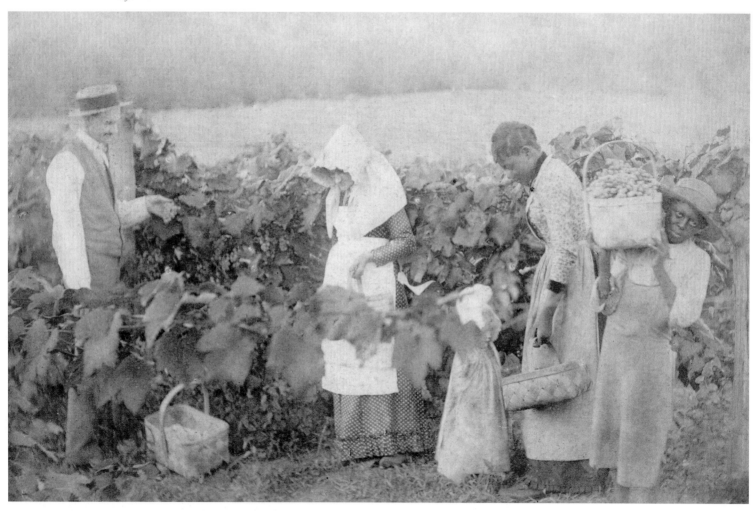

A group of boys pose in a studio setting—complete with logs—for a baseball portrait in the 1890s. The equipment includes bat, padded catcher's mitt, first baseman's glove, and the hard, leather-wrapped ball. Atlanta's first professional team was founded by Henry W. Grady in 1885 as part of the Southern League, of which Grady was the first president. The team went through a series of name changes until becoming the Atlanta Crackers in 1901.

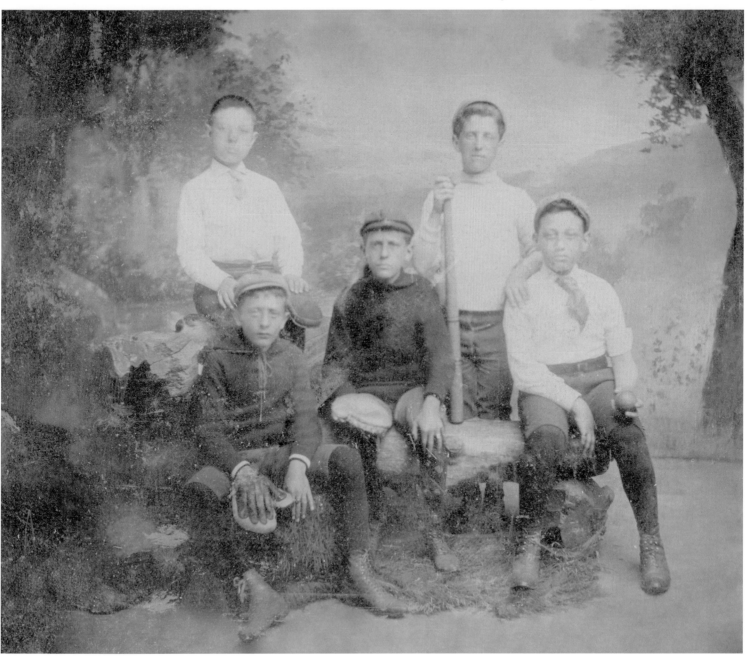

John Fritz stands on the back porch of his house along Piedmont Avenue north of present Tenth Street; his children, left to right, are Walter, Clara, Bertie, and Dolly, and family friend Albert McClure. Fritz opened a meat market in downtown Atlanta and maintained a cattle farm along the southern edge of present Piedmont Park. The cattle for his market grazed on leased property on what is now the park's Oak Hill area.

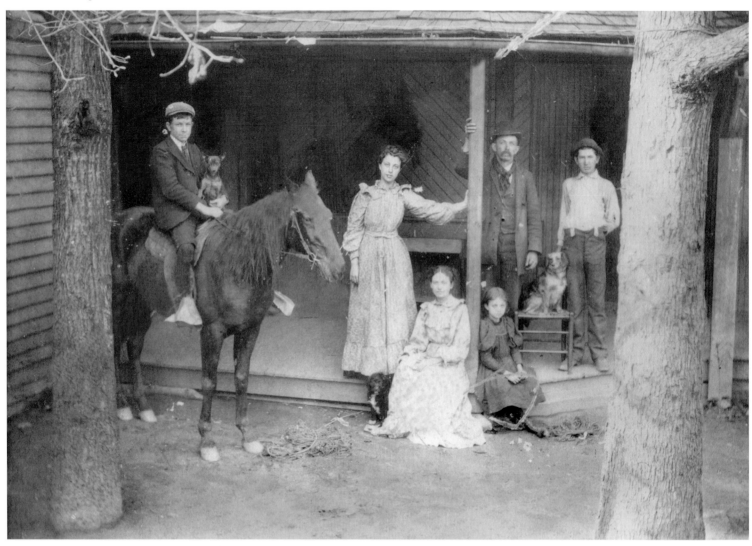

The Cotton States & International Exposition opened in 1895 as the third and largest of the city's fairs intended to promote the region's economy throughout the nation and the world. Creating facilities for the exposition included enlarging an existing lake into the present park's Clara Meer, whose name is laid out on the lake's bank. Family tradition maintains the lake was named in honor of Clara, John Fritz's young daughter who grew up on this land.

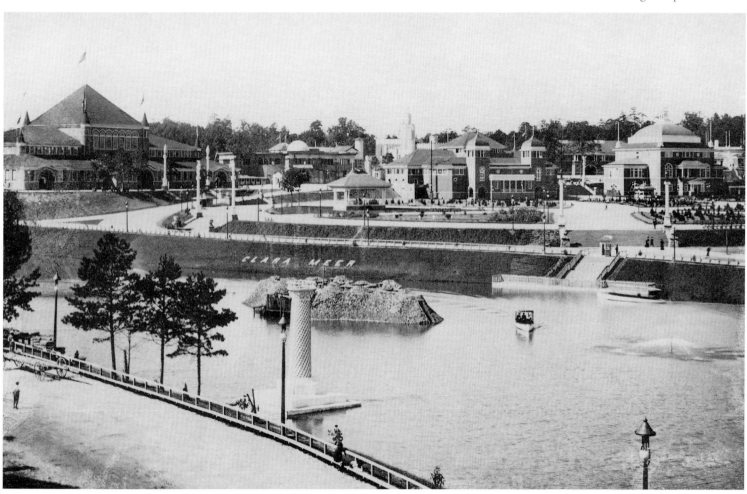

During the course of the three-month exposition, more than 800,000 attendees visited the grounds and buildings of the park. Public entertainment included motion pictures, at a public screening of the Phantascope, advertised as "Living Pictures." Admission was 25¢. In addition, guests were treated to a southern tradition, open-pit barbecue prepared on site. After the exposition, the buildings were removed and the grounds were purchased by the city, becoming Piedmont Park.

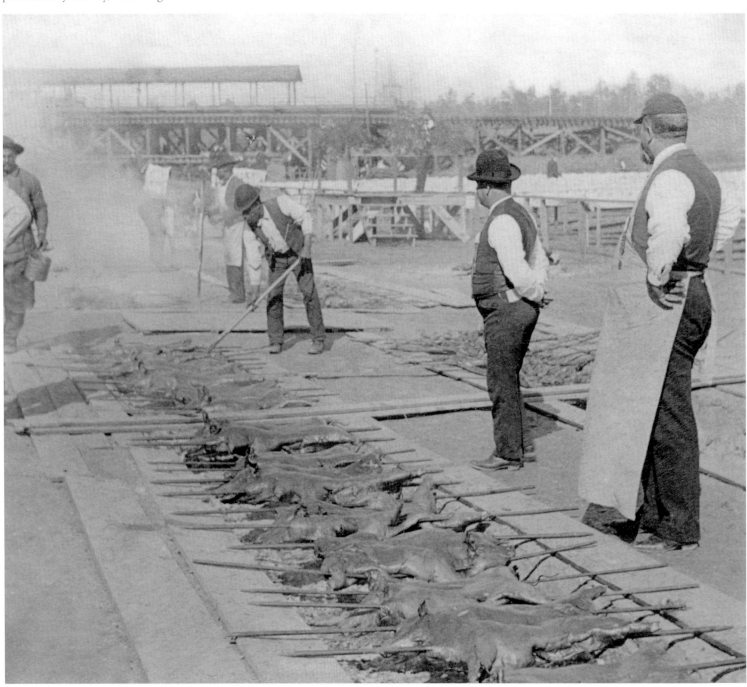

To publicize the southern economy, the exposition included displays of agriculture, industry, and manufacturing, as well as buildings dedicated to the achievement of both women and African Americans. Visitors to the exposition included former President Grover Cleveland, Booker T. Washington, who delivered his "Atlanta Compromise" speech, and John Philip Sousa, who composed his "King Cotton" march for the fair. Recreation included a midway with Ferris wheel, a Wild West show, and the "Shoot the Chutes."

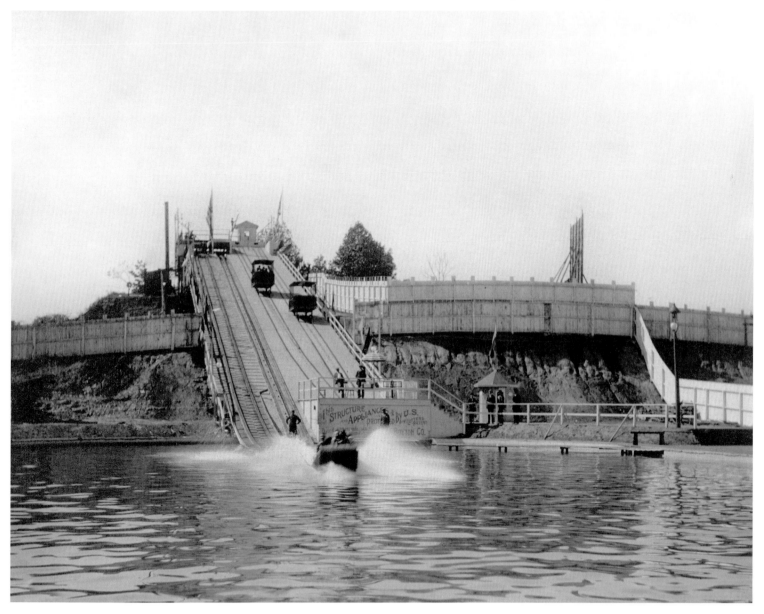

Women workers, including children, take a break for a company photograph at the Marsh and Smith pants factory. The production of ready-to-wear men's clothing increased throughout the nineteenth century, along with the growth of the southern textile industry and availability of women employees. Edward Marsh and John Smith ran their dry goods store offering boots and shoes along with their pants manufactory in the mid 1890s at the corner of Pryor Street and Edgewood Avenue.

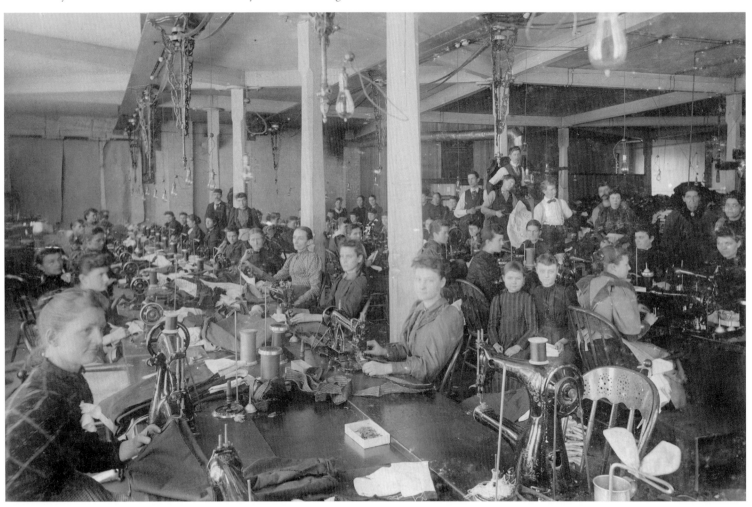

Gentlemen lodgers pose in front of their rooming house, which they designated the "Skull and Crossbones Boarding House." Family homes such as this were normally run by a landlady, who provided inexpensive room and board for single men and women. In the case of the Skull and Crossbones, two men shared each of the four available rooms. In certain ways, the boarding house concept lives on in the modern Bed and Breakfast.

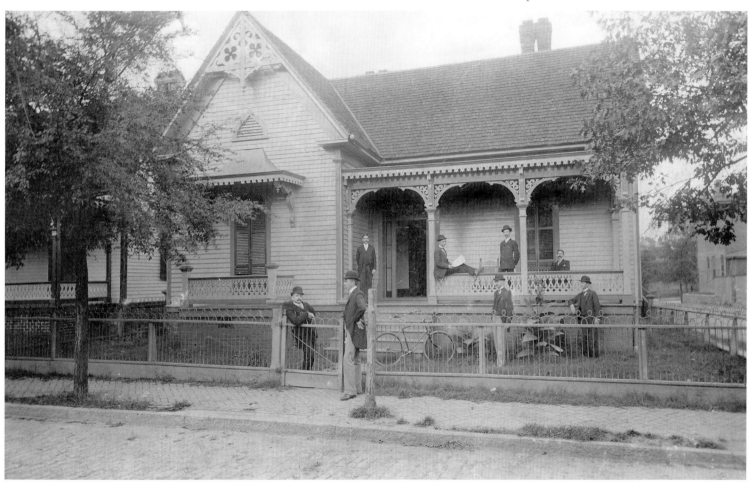

Customers meet and talk while inspecting curbside stalls constructed at the edge of the rail line next to the second Kimball House. By the end of the nineteenth century, an emergent African American middle class was involved in Atlanta's black educational institutions as well as in diversifying positions in business, trades, and services. In 1900, the city directory began publishing a separate listing for black residents, who composed 40 percent of the city's population.

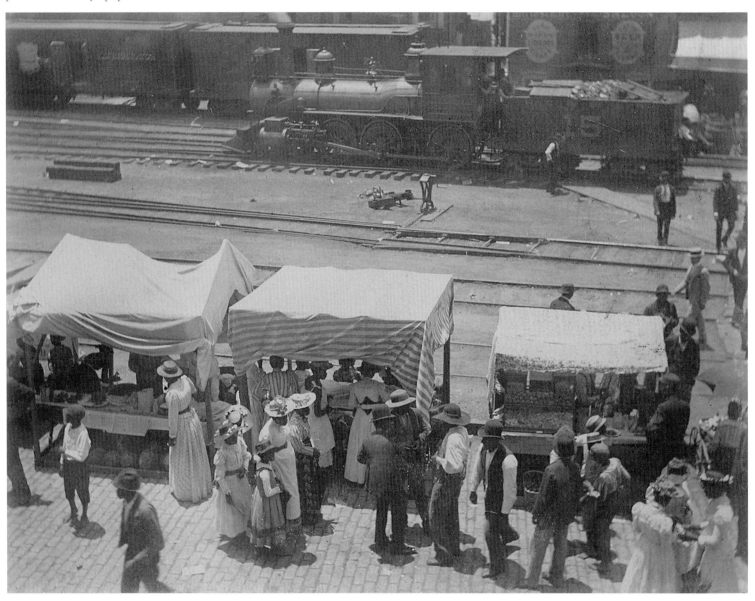

A laborer unloads coal along Edgewood Avenue a few years after the street was created. When developer Joel Hurt organized the Atlanta and Edgewood Street Railroad Company, he intended it to provide direct service from downtown Atlanta to the Inman Park suburb. When the company was chartered in 1886, however, the street did not exist. Only a short alley and some of these buildings existed there. Within a few years, Hurt bought the necessary right-of-way and opened the city's first electric trolley line.

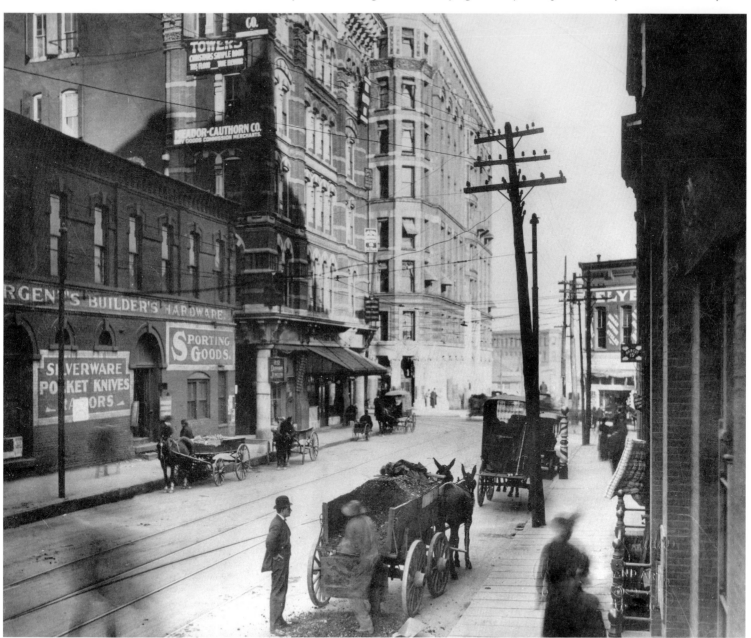

Men pose on a Courtland & Washington street railway car as they would have ridden: whites seated in the front and blacks in the back. Between 1900 and 1906, African Americans in many southern cities, including Atlanta and Augusta, Georgia, and Montgomery, Alabama, organized boycotts of segregated streetcars. The boycotts took place during a period of growing racial tension, culminating in Atlanta in the 1906 Race Riot.

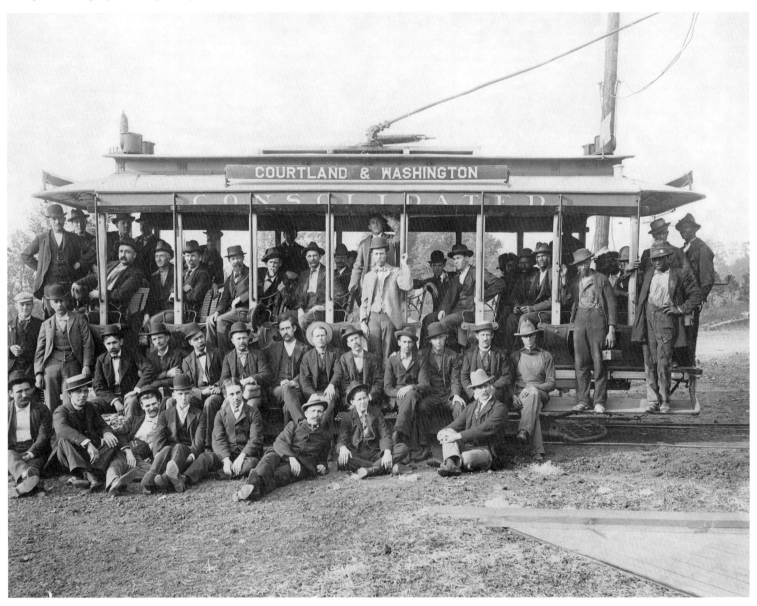

The first store to sell Coca-Cola was Jacobs' Pharmacy, located at Peachtree and Marietta streets. The drink was invented by Dr. John Stith Pemberton, who had already created a tonic, Pemberton's French Wine Coca, an alcoholic mixture popular in the city's drugstores. Originally, the syrup, one of the ingredients of which was cocaine, was mixed with soda water and sold as a fountain drink for 5¢. During the 1890s the company was incorporated, the formula patented, and in 1899 the first bottling plant approved.

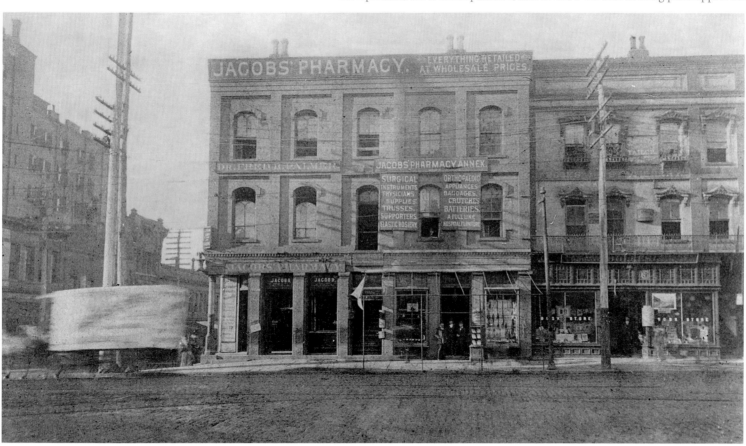

Symbols of the city's old and new, Atlanta's future electric railway system is under construction below the skeleton of the city's abandoned artesian well at today's Five Points intersection. As the nineteenth century drew to a close, the bustling business town had recovered from the destruction of the Civil War and grown into the self-proclaimed capital of Henry Grady's New South, promoting itself as the commercial and financial center of a changing southern economy.

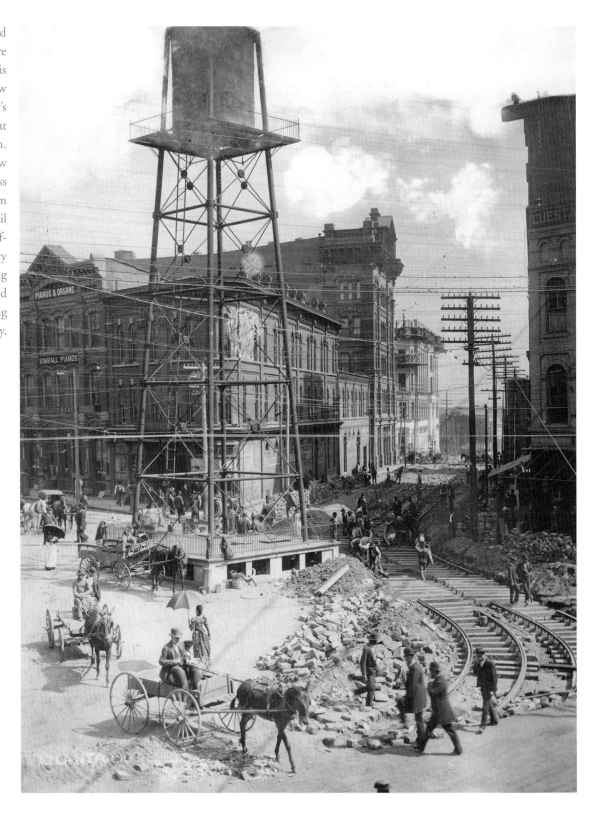

Forward Atlanta: From Boomtown to Southern Symbol

(1900–1939)

During the first four decades of the twentieth century, Atlanta's population tripled as its transportation and commercial base continued to expand. In 1925, the chamber of commerce launched the "Forward Atlanta" campaign, advertising the city itself. The program created twenty thousand jobs and added $34 million to the city's economy while introducing nearly eight hundred new businesses, including offices and plants for national companies, thus establishing Atlanta as a regional business and distribution center.

At the same time, the African American community created a focal district along downtown's Auburn Avenue as "Sweet Auburn" became the business, political, religious, and social center of African American life. The street is home to Big Bethel AME Church, the Royal Peacock Club, the Atlanta Life Insurance Company, the Butler Street YMCA, and the *Atlanta Daily World,* the city's first black-owned daily newspaper.

Despite this success, race remained a volatile issue. While Atlanta sought to be the model New South city, sustaining that mission was difficult. The majority of residents lived in segregated neighborhoods, which became more concentrated after the turn of the century. Growing racial tensions culminated in the Atlanta Race Riot of 1906, which left at least twenty-five blacks and two whites dead.

As downtown skyscrapers pushed upward, the city also stretched outward into suburbs, following trolley lines and automobiles into the surrounding countryside. Another change came as the rail lines that had been the center of Atlanta life began to lose significance. Despite construction of two new stations, the arrival of the city's airport dramatically affected the future of the city as American transportation moved from rail to air.

Perhaps no other event established Atlanta in the public mind as much as the publication of Margaret Mitchell's novel, *Gone With the Wind.* As the world became acquainted with Scarlett and Peachtree Street, Atlanta became identified with the characters in the book. The premiere of the motion picture was held in Atlanta in December 1939 and the success of the film reinforced images conveyed in the novel. Atlanta, linked in the public imagination to Tara and Sherman's burning of Atlanta, became an international symbol of Old South Romanticism.

Shoppers on foot and in buggy pass along Whitehall Street beneath the recently completed Century Building at the Alabama Street intersection. At the turn of the century, Atlanta's population was 90,000, making it the largest city in the state and the third largest in the Southeast. Residents included a large number of African Americans, drawn to the city by opportunities for employment and for its educational institutions, including Atlanta University and Spelman College.

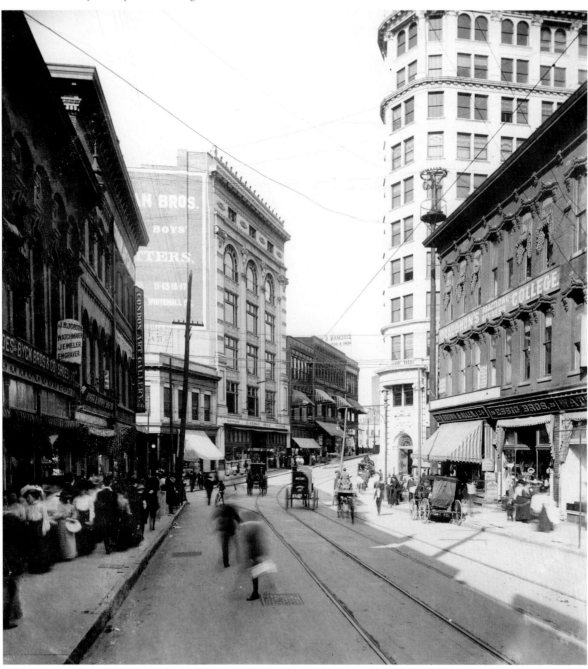

The Georgia State Capitol rises above central Atlanta, towering over area churches, hotels, and buildings associated with the downtown railroads. In late 1900, however, efforts began to replace the city's old Union Station, now almost thirty years old. Within a few years, Atlanta would no longer converge around the Zero-Mile post that marked the city's founding. New stations, the automobile, and the airplane would transform the terminal city into a new sort of transportation center.

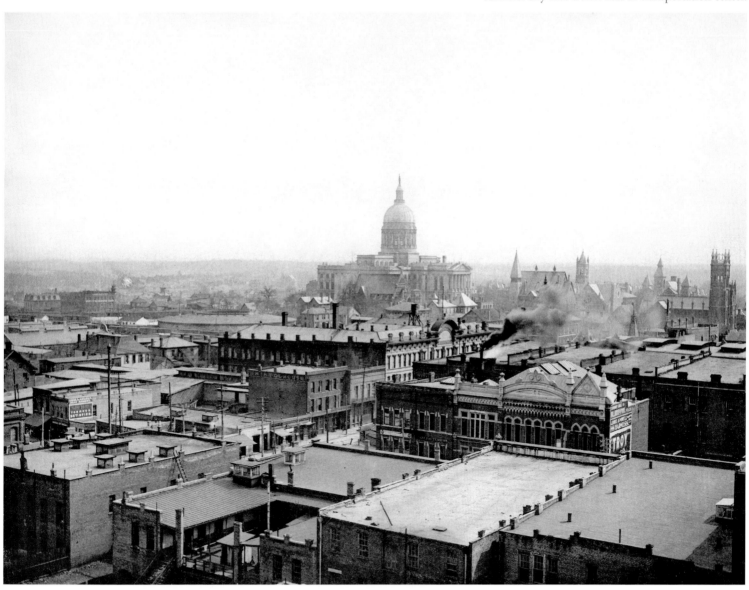

By 1901, there were only two remaining street railway systems in the city: Atlanta Rapid Transit Company and the Atlanta Consolidated Street Railway Company. The resulting competition between the two—dubbed the Second Battle of Atlanta—was severe, resulting in fare wars, court injunctions, and meetings to plan battle strategies. Ultimately, the mayor and city council approved an ordinance permitting the two companies to consolidate, thus creating the Georgia Railway & Electric Company.

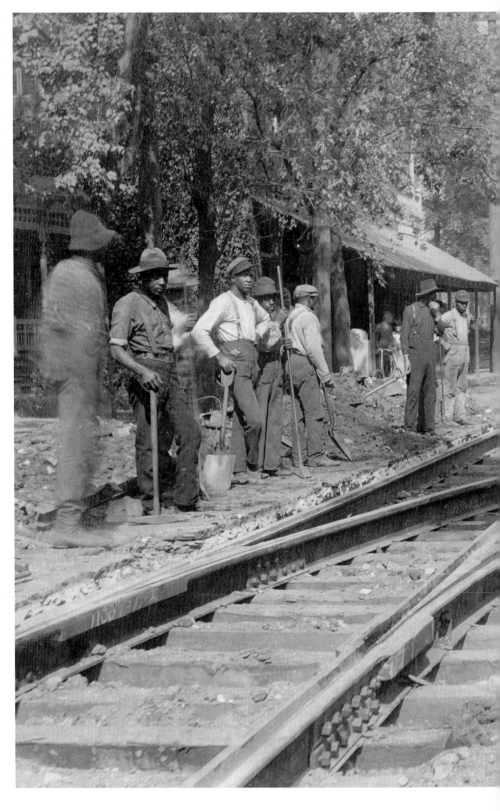

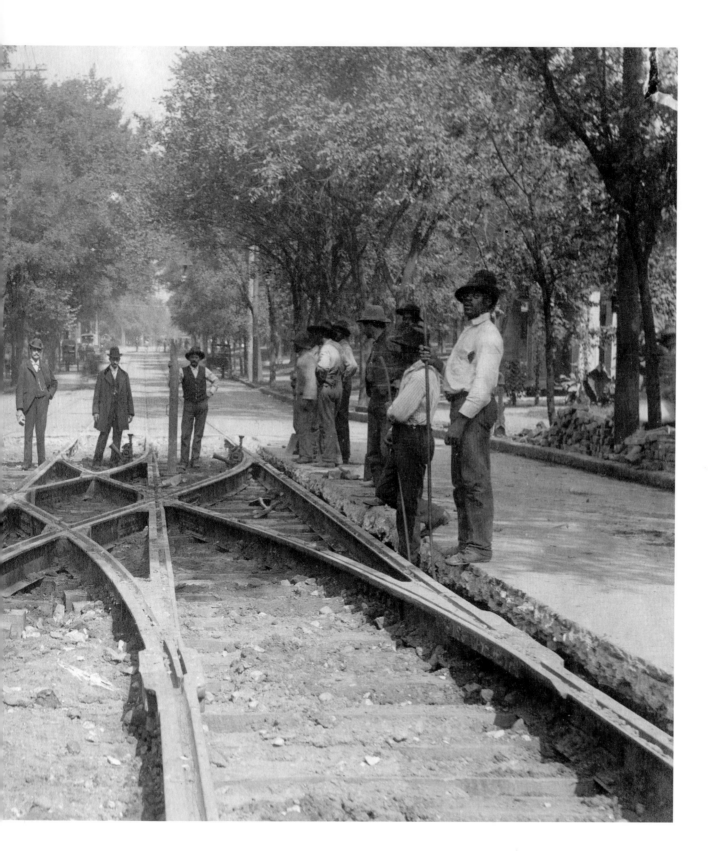

Maxwell Berry's garden gives an indication of the appearance of upper-class homes shortly after the turn of the century, including a well, smokehouse, and stable for one horse. Berry was a contractor who built both Kimball houses, the Church of the Immaculate Conception, Trinity Methodist Church, First Presbyterian Church, and the U.S. Post Office and Customs House. During the Civil War, his ten-year-old daughter, Carrie, kept a diary of the siege of Atlanta.

Maxwell Rufus Berry sits in the living room of his 1859 home at the corner of Walton and Fairlie streets, which survived the siege of Atlanta. The room was lighted by the single hanging gas lamp, which was lit by the folded newspaper tapers kept on the mantelpiece. Berry had the floor matting replaced with carpeting every fall and warmed a soapstone brick on the hearth to heat his bed during winter.

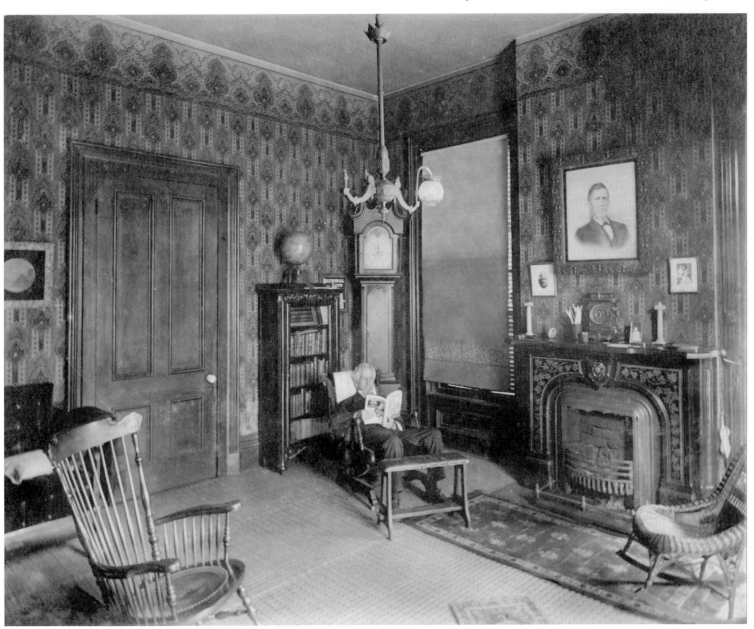

Franklyn Howland poses at left with his brother, Leroy. Between 1904 and 1906, Franklyn's wife, Anne, kept a trip log for another car, his red Cadillac Runabout. In her first entry, July 31, she writes: "We started from the Kimball House at 9 a.m. Road fair. Every blooming horse & team we met was 'skeered' into fits & but for the courtesy of our chauffeur the road would have been full of broken teams & mashed women & babies."

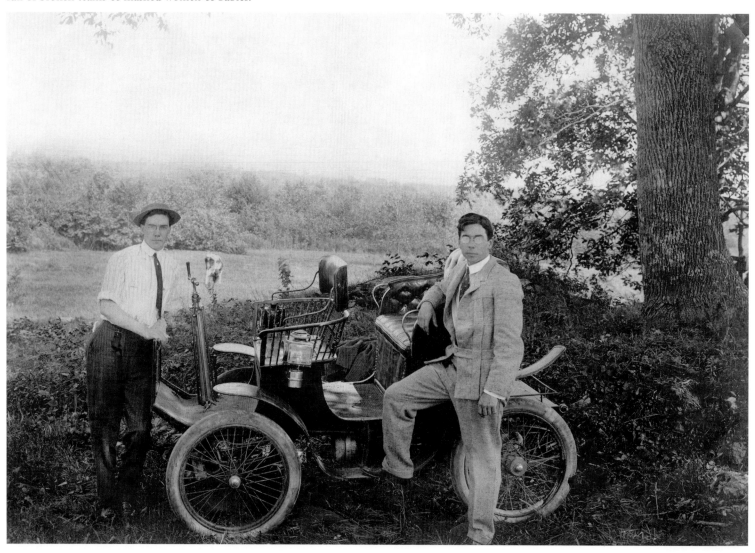

A familiar question in the history of photography is, Why didn't people ever smile in old pictures? With the advent of amateur snapshots like this one, the formality of the professional photographer's studio no longer inhibited the person whose picture was being taken. This group, photographed out-of-doors by a friend, feels at ease to pose in jest in an area lumberyard.

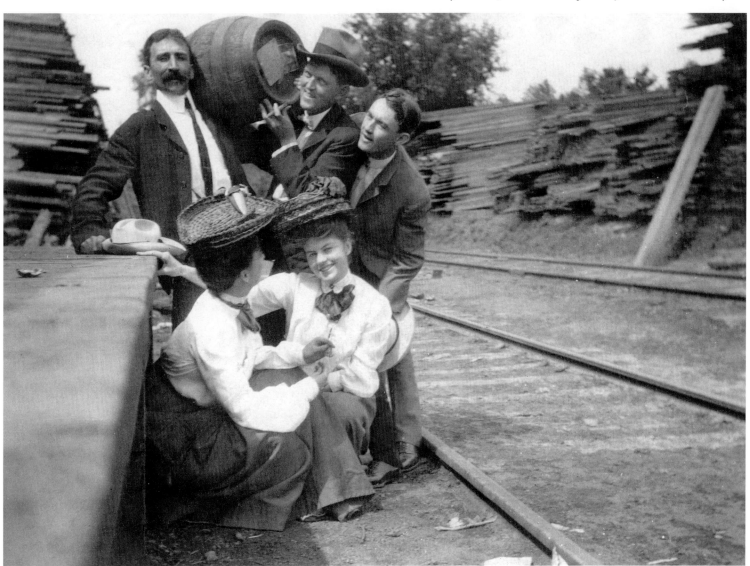

Crowds line downtown Atlanta streets as President Theodore Roosevelt, standing in his carriage, passes up Peachtree Street in October 1905. The parade took an hour to work its way to Piedmont Park, where Roosevelt spoke to a crowd of thousands. Roosevelt then toured parts of the city before giving a speech to students at Georgia Tech. While he was in Atlanta, Roosevelt also visited his mother's family home, Bulloch Hall, in Roswell.

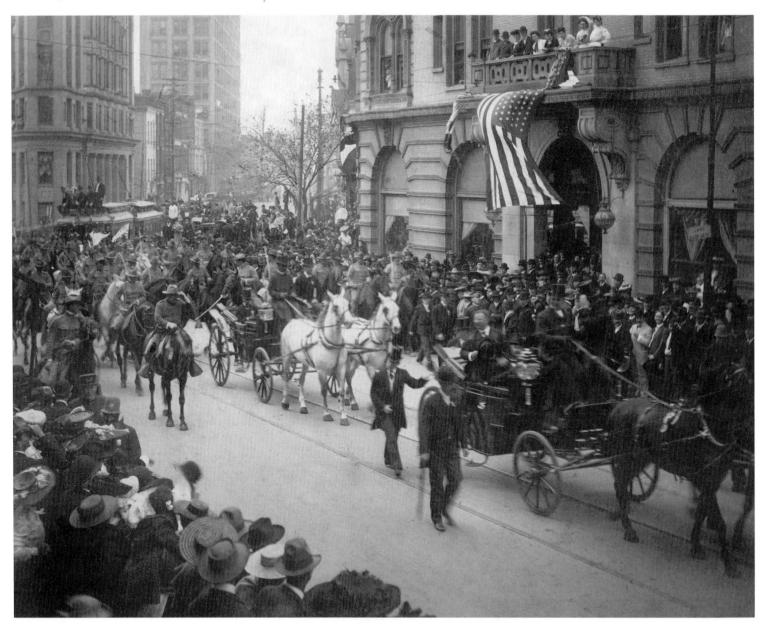

A family's cook, identified as Aunt Lula Boynton, poses next to a carriage house in the rear garden of a house. For many southerners, the image of black women as devoted caregivers to the white family endured for generations. In many ways, the image reassured them of their place in society and their connection to a past most memorably romanticized as Mammy in *Gone With the Wind*.

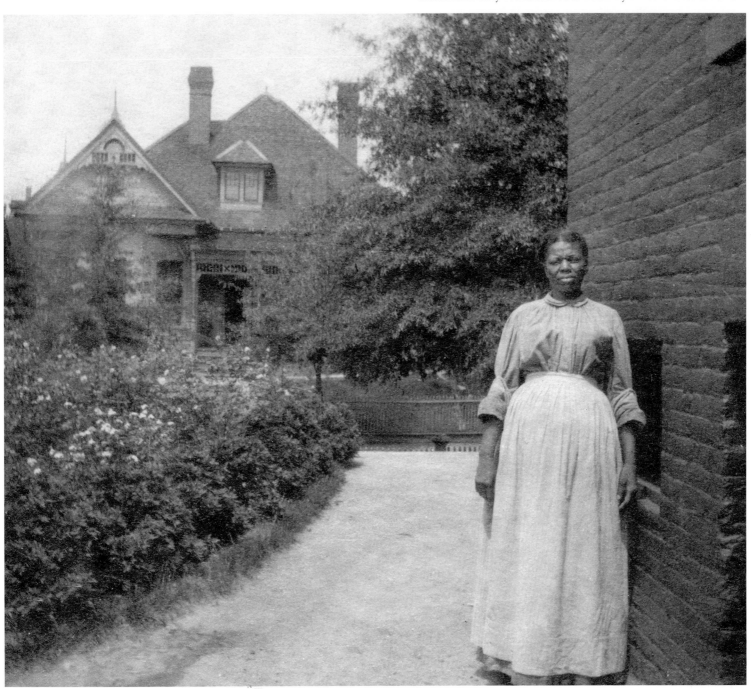

Unfortunately, the photographer of this exceptional portrait of five women in succeeding generations of the same family is unknown. Yet it is a simple and elegant image in which the individual personality of each is clearly conveyed. Left to right are Julia Ann Hollingsworth (Stewart), Bobbie Jones (McClain), Allie Frances Walters, Frances McClain (Walters), and Sarah Elizabeth Stewart (Jones).

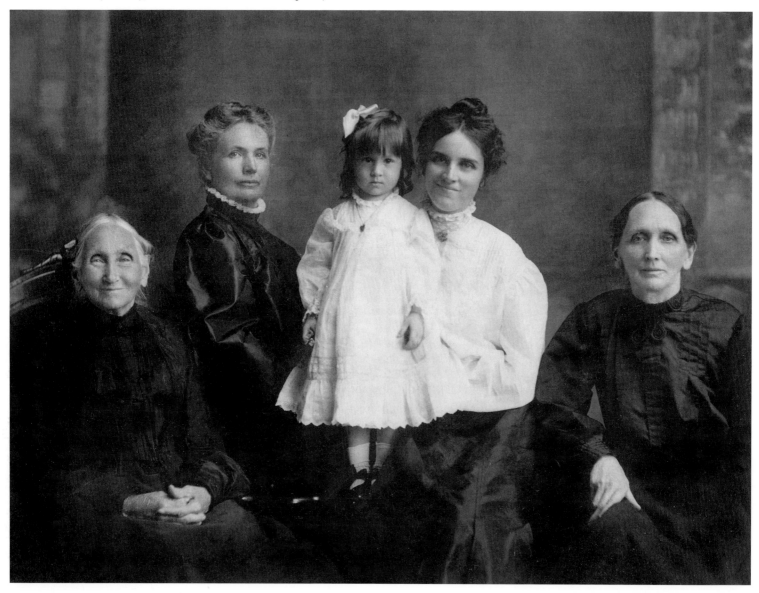

In 1883, the city accepted one hundred acres offered by businessman Lemuel P. Grant for a park southeast of downtown. Named Grant Park in his honor, it remains the city's oldest public park. The park included Lake Abana, popular for scenic boat rides. It was expanded in 1906 but drained in the 1960s. The park is home to the present Zoo Atlanta and the Cyclorama, a circular painting depicting the Battle of Atlanta.

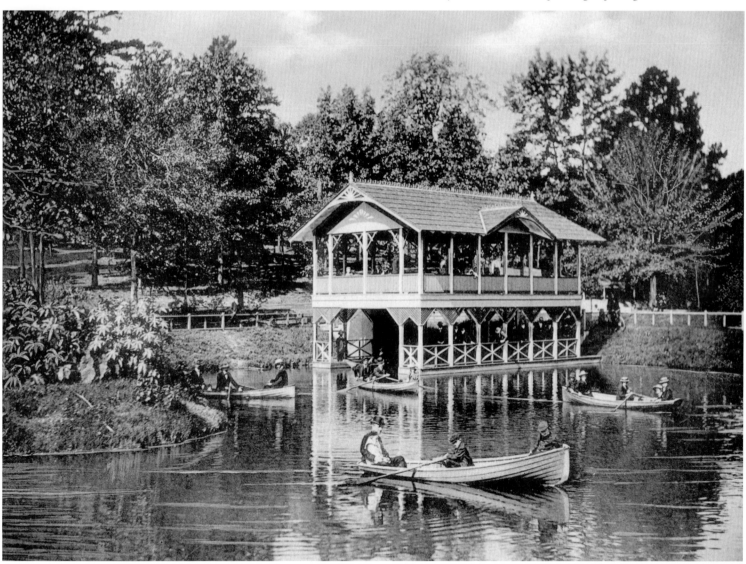

Charles Golden stands at the entrance to his meat market and home, located on Marietta Street at Ponders Avenue. Meat sanitation was a concern in early Atlanta and in 1853 slaughterhouses were removed to beyond the city limits, which at that time was near Golden's future butcher shop. By 1905, city residents had a wide variety of grocers from whom to choose, as well as specialty vendors for meats, fruits, milk, fish and oysters, and coffee roasts.

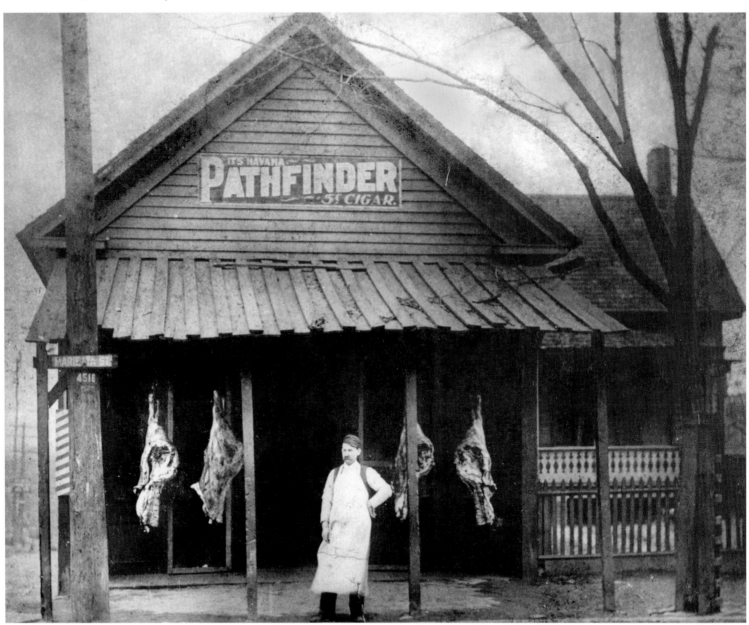

Dorsey's Grocery stood at the corner of Peachtree and East Paces Ferry roads in the heart of today's Buckhead neighborhood. Robert Dorsey provided delivery services throughout the area in the buggy at right, but closed his store around 1907 because of unpaid bills. In 1841, the first post office had come to the area, named Irbyville for Henry Irby, owner of a tavern that once had a buck's head mounted on a post.

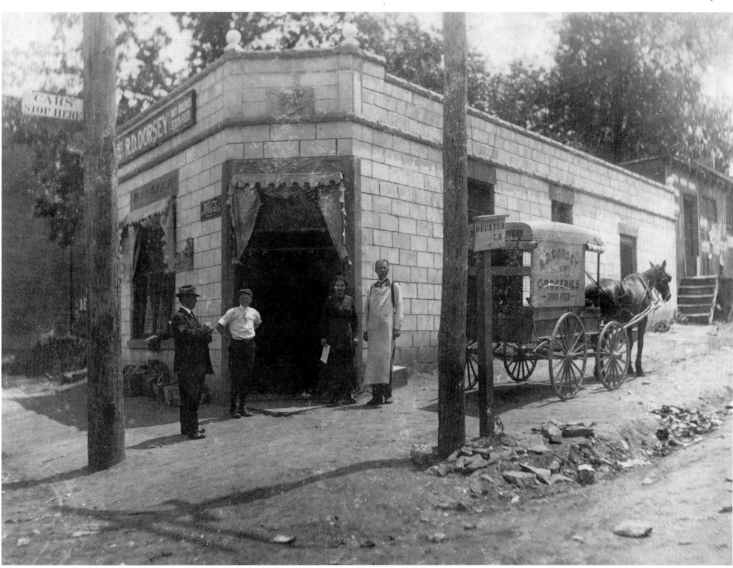

Opening in 1905, Terminal Station offered service via Southern Railway, Seaboard Air Line, Central of Georgia, and the Atlanta and West Point railroads. The building, located at Mitchell and present Spring streets, was planned by architect P. Thornton Marye, who also designed the Fox Theatre. The station served Atlanta for more than sixty years until it was demolished in 1972. By that time, air travel had replaced the city's rail lines as the primary mode of transportation in the Southeast.

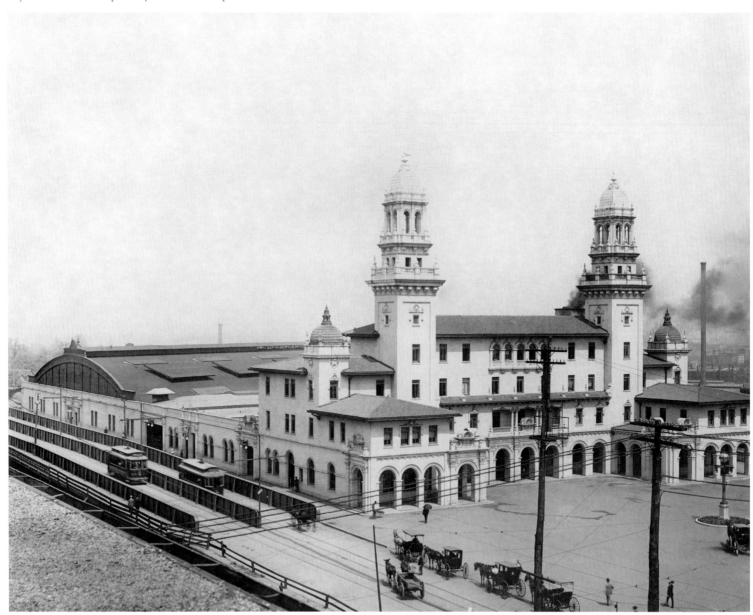

Troops of the Georgia state militia line Peachtree Street north of Five Points during the Atlanta Race Riot of 1906. After a summer of growing racial tension, attacks by white mobs against black men and women erupted on September 22. The violence was ignited by sensational reports in local newspapers of alleged assaults by black males against white women. Following two days of bloodshed, twenty-five blacks and two whites were dead, and dozens more wounded.

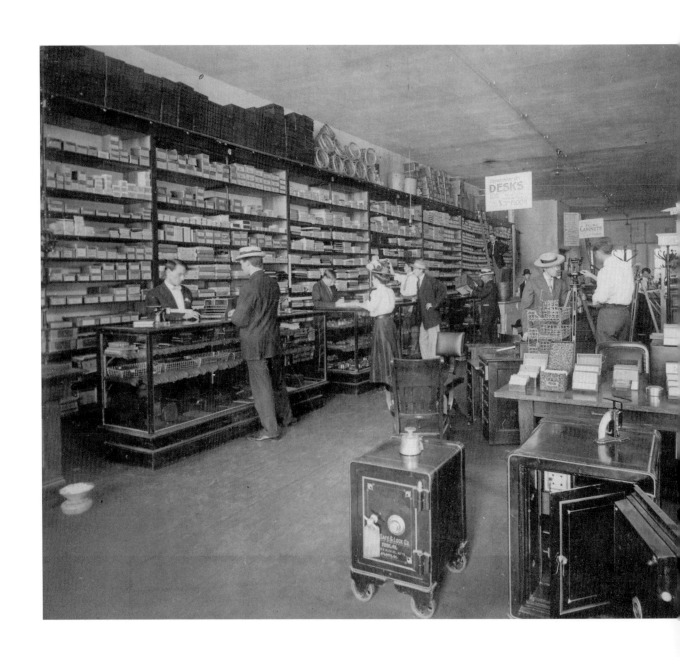

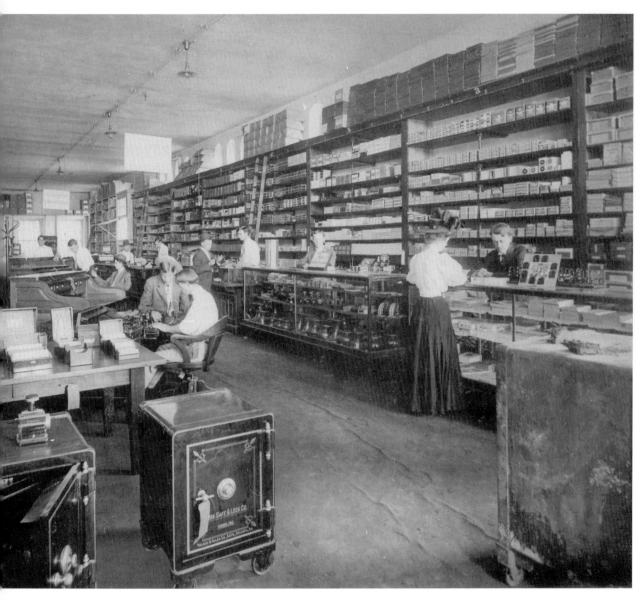

An interior panorama shows employees and customers of the Fielder & Allen office supply company on Marietta Street in 1908. Over the next few decades, founder Ivan E. Allen became a leading civic booster, writing frequently in the newspapers, organizing public fund-raisers, and serving as president of the Atlanta Chamber of Commerce. In 1919, the company changed names to the Ivan Allen–Marshall Company and became the Ivan Allen Company in 1953.

An automobile full of sightseers from the city pulls along a dirt street in rural Dunwoody in 1911. This area of DeKalb County had been partitioned for white settlement following the first Treaty of Indian Springs, signed with the Creeks in 1821. Between 1805 and 1832, the state redistributed Native American property through a lottery; this area was awarded to settlers through a lottery held the same year the treaty was signed.

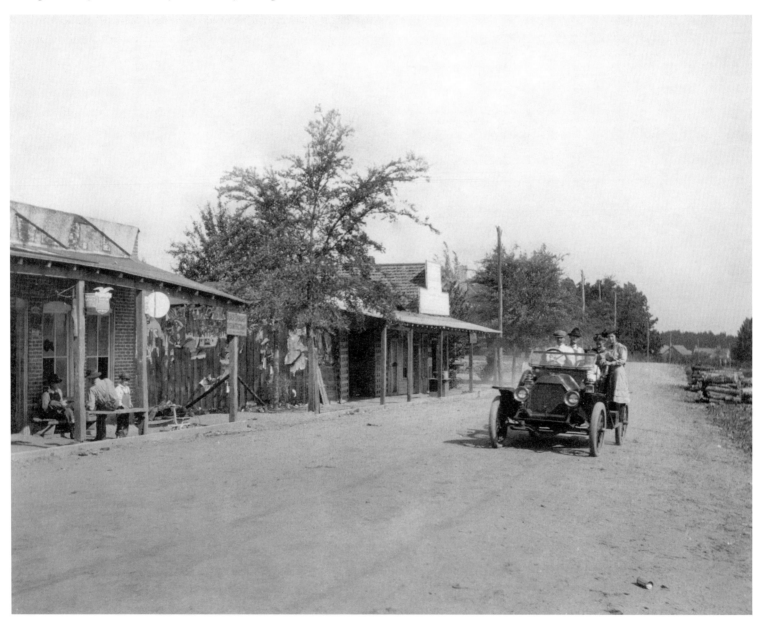

Dunwoody is named for Charles Archibald Dunwoody, a major in the Civil War, who promoted the area in the late nineteenth century. The first rail line passed through here in 1881, but it was not until suburban development following World War II that the area became one of Atlanta's bedroom communities.

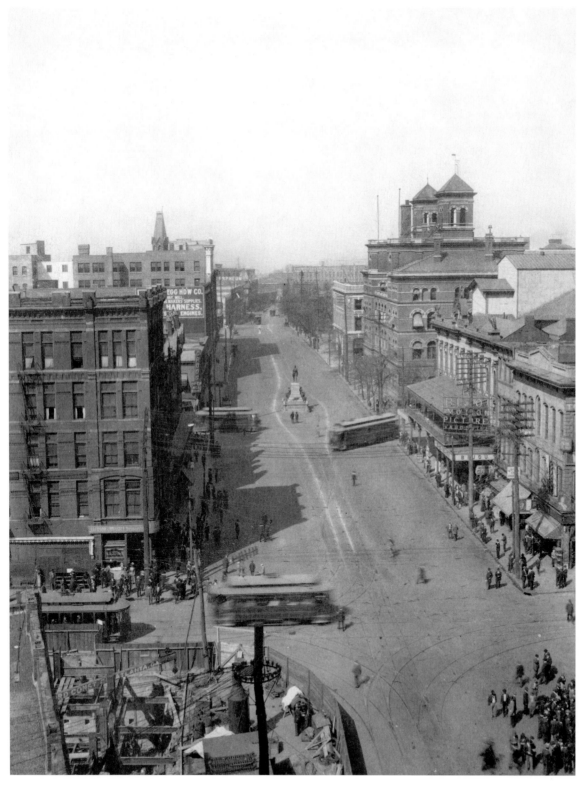

Before the arrival of white settlers to the area, this was the intersection of two important trading routes of the Creek confederacy. The Peachtree Trail, which began in northeast Georgia, ended here; Peachtree Road was built along a section of this trail during the War of 1812. The Sandtown Trail ran between Stone Mountain and the Creek settlement of Sandtown on the Chattahoochee River. Today's Cascade Road in southwest Atlanta follows the route of the Indian trail.

Completed in 1897, the Flatiron Building is Atlanta's oldest surviving steel-framed skyscraper, rising eleven stories above Broad and Peachtree streets. It was designed by Bradford Gilbert and is officially named the English-American Building for the English-American Loan and Trust Company for which it was built. It was labeled "flatiron" after New York City's famous Flatiron skyscraper, which was actually constructed five years after Atlanta's building.

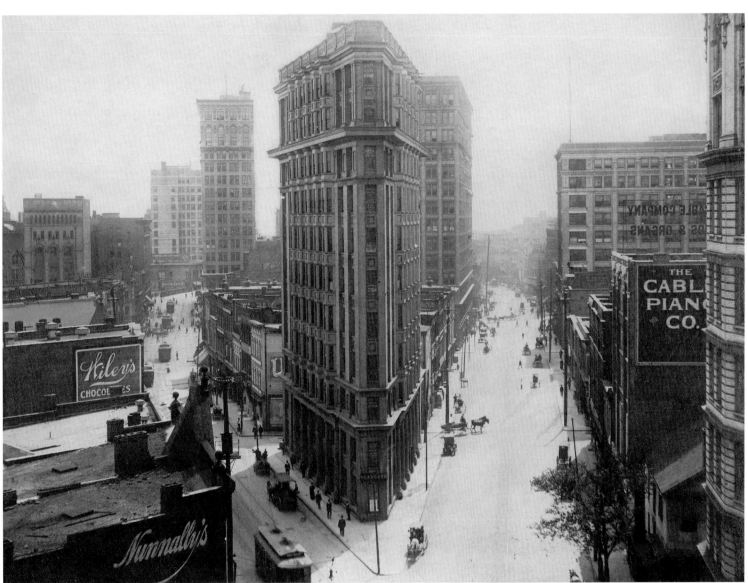

A group of Gideons poses with Bibles in front of the second Kimball House before delivering them to city hotels. Founded in 1899, Gideons International began distributing free Bibles in 1908 and had placed more than one million Bibles in hotel rooms within twenty years.

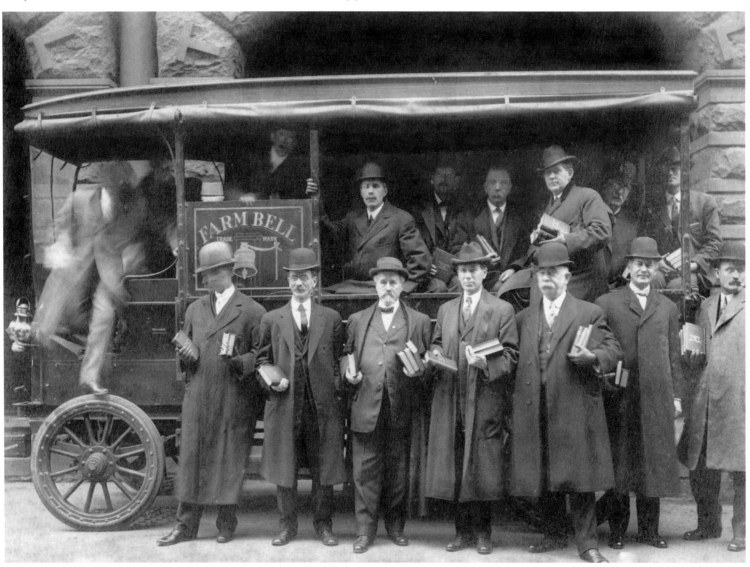

This lighthearted group, with guns pointed at each other and the viewer, are out for a drive and picture-taking near Chamblee on Christmas Day 1910. The city of Chamblee had been incorporated only two years earlier, and the surrounding countryside, though home to pastures for the local dairy farms, was still heavily wooded.

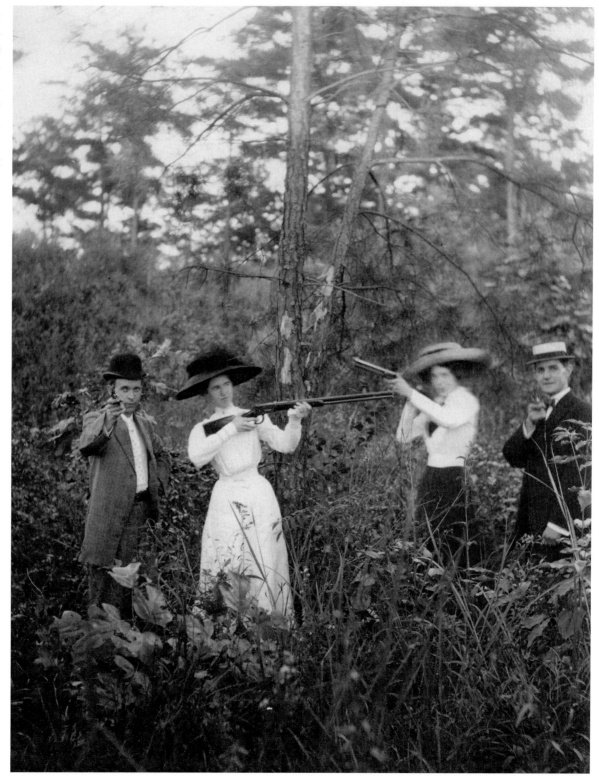

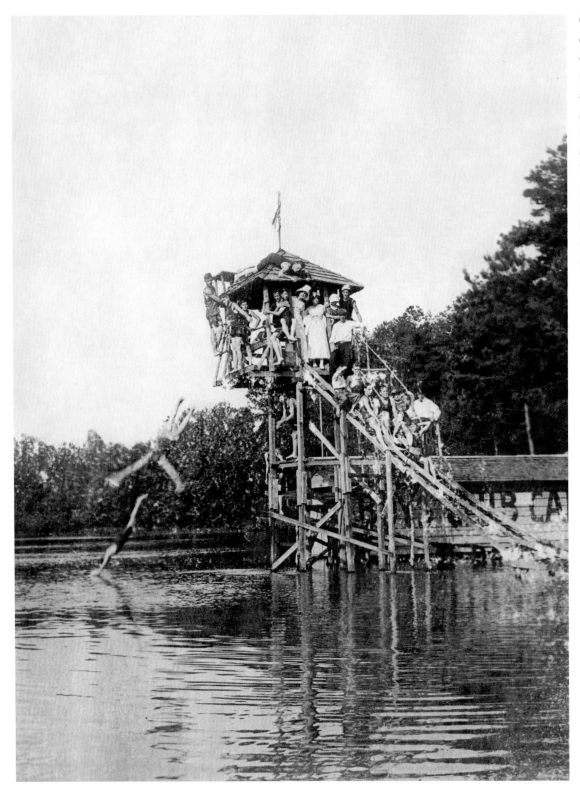

City residents, out in the country at an unidentified camp, cram in and on the diving platform of a nearby lake in 1912. Atlantans were swimming in designated "bathing" sections of the lakes in both Grant and Piedmont parks before this time. The city constructed a public bathhouse alongside the bathing area of Clara Meer in Piedmont Park in 1911.

Although snow is rare in Atlanta's climate, it creates a white wonderland after the first fall, as here in 1914. Unfortunately, it also brings the city to a standstill when it arrives, especially when it includes ice. Atlanta was paralyzed for several days in February 1905 by the heaviest snow and ice storm on record up to that time. The city again stopped when an unpredicted storm, dubbed "Snow Jam," hit Atlanta in January 1982, stranding thousands of commuters.

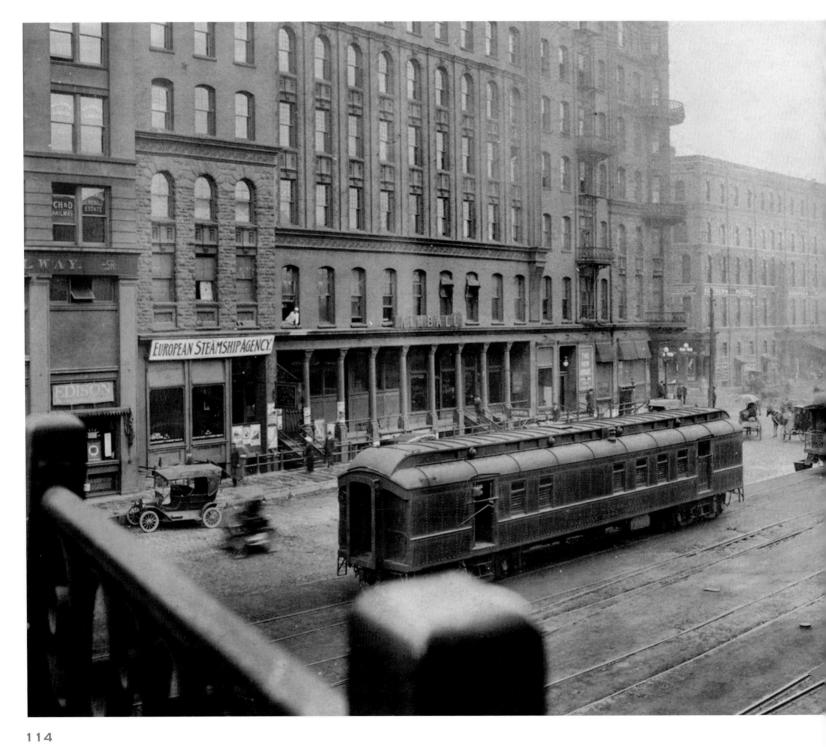

Union Station continued to serve the city even after the opening of Terminal Station a few years earlier. This image, recorded from the vantage of the Peachtree Street viaduct in 1914, gives a strong impression of the area dubbed the "train gulch." Enclosed by the surrounding buildings, including the Kimball House at left, the old rail depot was a center of smoke and noise.

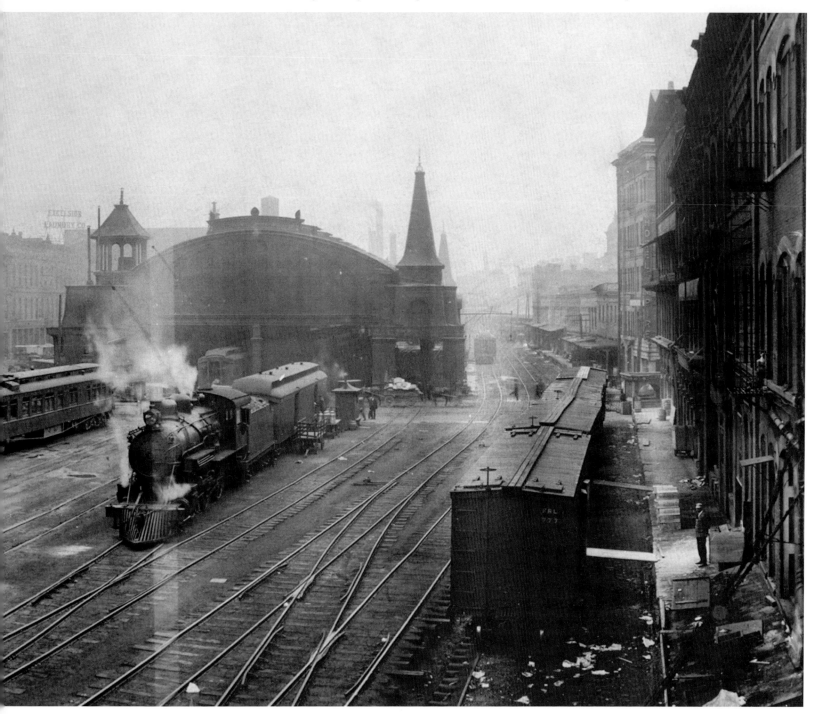

A group of ladies leaves the Butler Street Christian Methodist Episcopal Church in 1915. The church was organized in 1882 by S. E. Poe and a small frame church was built on property donated by Lemuel P. Grant. The church stands in the historic Sweet Auburn neighborhood, also home to the Butler Street YMCA, known as the "black city hall" of Atlanta and the center of a biracial coalition promoting progressive city politics.

City day-trippers pose along the climb to the top of Stone Mountain, referred to on early maps of the region as Rock Mountain. The dome of the mountain, formed 300 million years ago, is the largest exposed granite outcrop in the world. Once owned by the Venable family, the mountain is now part of a state park that offers a cable car to the top and the same trail used by these sightseers.

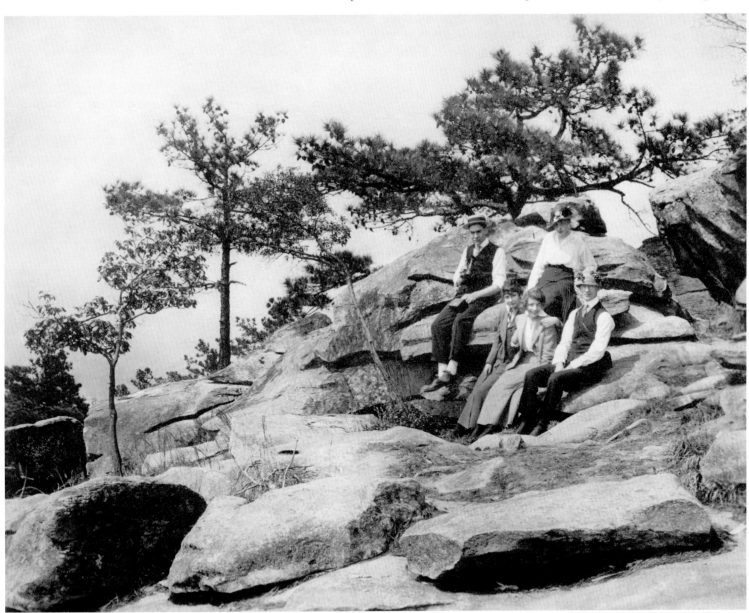

Firemen pose with their horse-drawn and horse-less equipment in front of Fire Station No. 11 on North Avenue in Midtown. The station opened in 1909 and was listed on the National Register of Historic Places in 1980. It still stands after reopening as a restaurant in 2003.

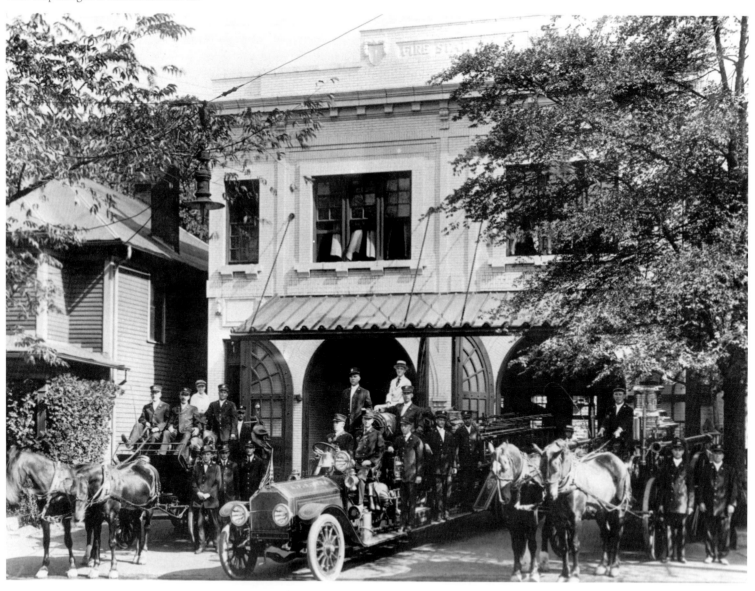

The month of December 1917 was one of the coldest in Atlanta's history and provided the rare opportunity to play and skate on the lakes at Piedmont Park and here at Grant Park. The city newspaper wrote that "the glimmering surface of a once liquid lake presented a sight which made onlookers doubt their sobriety." The original circular home of the Cyclorama painting, built in 1893, stands on the shore in the distance.

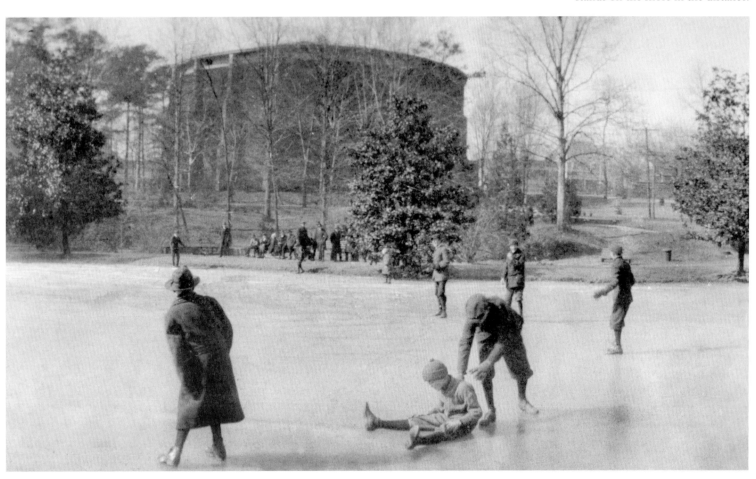

Inman Park was the city's first suburban community, developed by businessman Joel Hurt between 1885 and 1889 two miles east of the central business district. Planning for the ninety-acre neighborhood included ten acres set aside for Springvale Park, including Crystal Lake, located in the center of the community. It was at this time that Hurt also constructed Edgewood Avenue and the street's railway running in a direct line from downtown to the Inman Park Trolley Barn.

The Georgia Tech football team competes against an unidentified team on Grant Field in their first national championship year, 1917. Tech completed the season undefeated, 9-0, under Coach John W. Heisman, who coached the Yellow Jackets from 1903 to 1919. The previous year, Tech scored on every possession in defeating Cumberland College, 220-0, in the most one-sided victory in college football history.

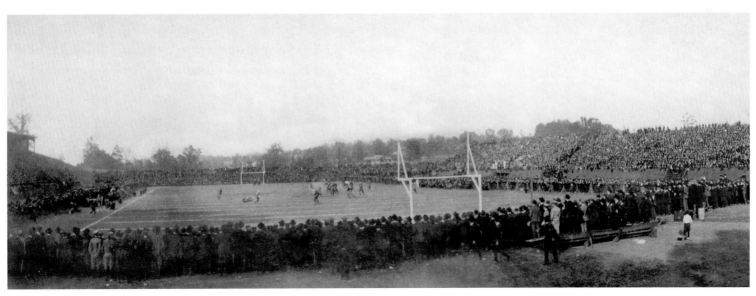

Following U.S. entry into World War I, a site near Chamblee along the Southern Railway was selected for a new training camp, named Camp Gordon. By the middle of the summer tents had appeared, and as the *Atlanta Journal* reported, "Cornfields have given way to barracks that will shelter Uncle Sam's fighting men, roads have been cut through hills, spurs of railroad track have been laid, trees have been felled to make way for barracks and mess halls . . ."

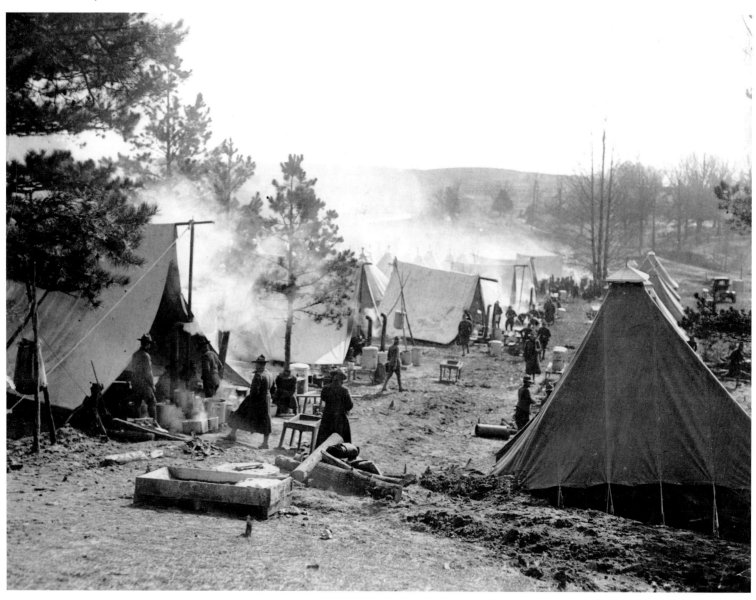

Lacking female partners, new army recruits at Camp Gordon practice their social skills by dancing to recorded music. Opening in September 1917, the camp became temporary home to more than 230,000 officers and enlisted men trained for the battlefields of Europe. With more than 1,500 buildings, the camp had barrack space for 46,000 men as well as corrals for more than 7,000 horses and mules. Following the armistice of 1918, the camp was abandoned by 1921.

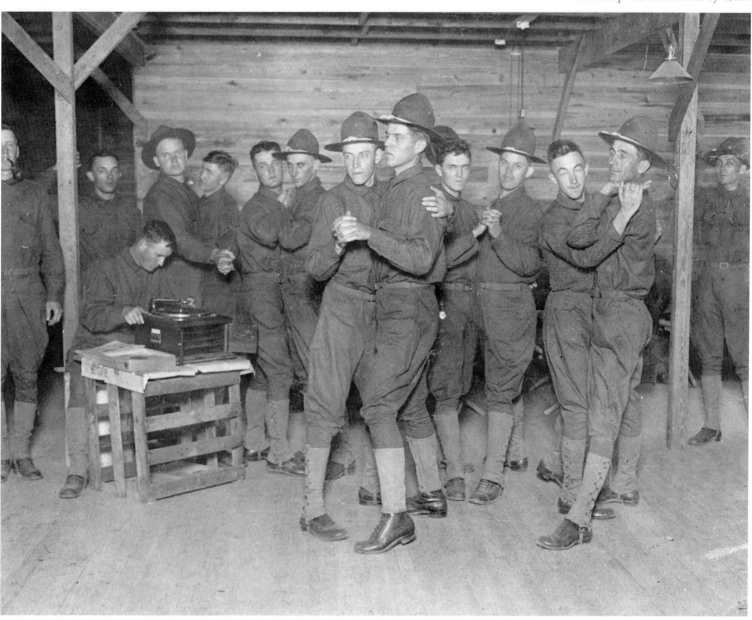

Born a slave, Alonzo F. Herndon (standing behind the word "Atlanta" in the banner) owned a series of barber shops in the city, becoming Atlanta's wealthiest African American at his death in 1927. In 1905, he founded the basis of the Atlanta Life Insurance Company, which when this photograph was taken had become one of the nation's largest African American insurance companies. Herndon was a leader in the civic life of the community, supporting education, orphanages, the YMCA, and local churches.

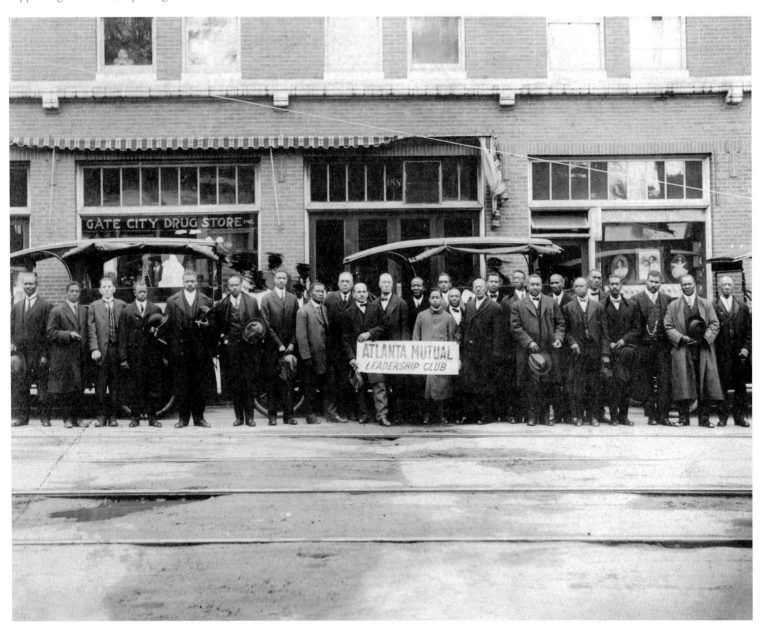

The Henry Grady Hotel appears at center above Peachtree Street in this image facing south toward today's Margaret Mitchell Square. Peachtree Plaza, which opened in 1976 as the world's tallest hotel, now rises on the site. To the left is the Davison-Paxon department store constructed in 1924, whose building housed the downtown Macy's at the end of the twentieth century. Beyond is the Winecoff Hotel, site of the nation's deadliest hotel fire in 1946.

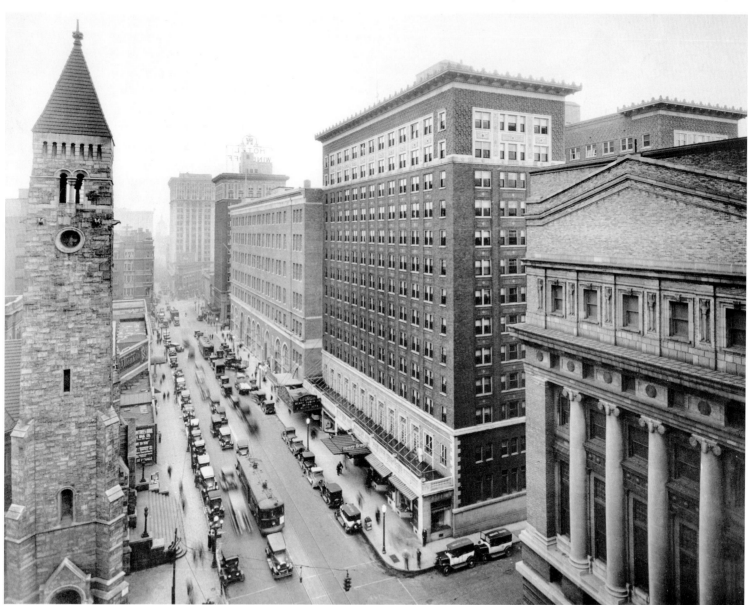

As businesses expanded north along Peachtree Street, the once-grand homes of the city's elite were adapted to commercial use. By the mid 1920s, this home had been converted to the Hotel Adair after serving as home to Miss Ballard's Seminary and other business firms. A one-story arcade of small shops has been erected along what would once have been the home's orderly front yard.

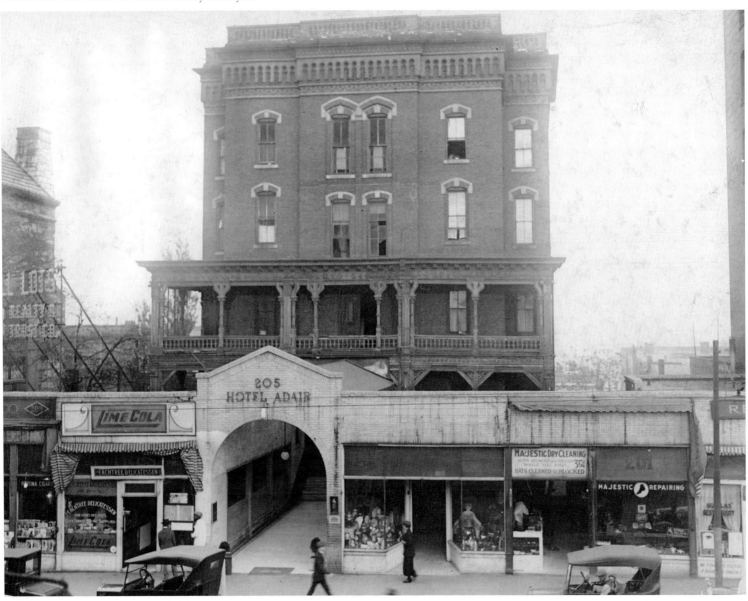

In 1921, the Southern Bell Telephone & Telegraph Company moved their central office to this new facility on Auburn Avenue. Before 1920, all telephone calls were handled by operators at switchboards; following an operators' strike that year, the Bell System recognized the need to convert to machine switching systems. At midnight on July 28, 1923, a panel switching machine began operation in the Auburn Avenue building, beginning the conversion of Atlanta to modern dial service.

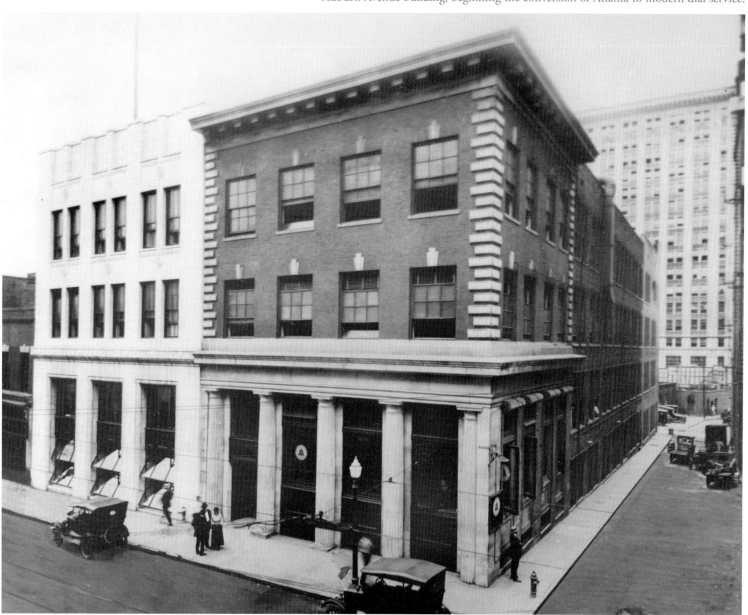

As early as 1912, the United Daughters of the Confederacy had supported the idea of a memorial carved into the side of Stone Mountain. Within a few years, a memorial association commissioned Gutzon Borglum to carve the proposed sculpture depicting Robert E. Lee, Jefferson Davis, and Thomas J. "Stonewall" Jackson. Work began in 1923 and General Lee's head was unveiled on Lee's birthday in 1924.

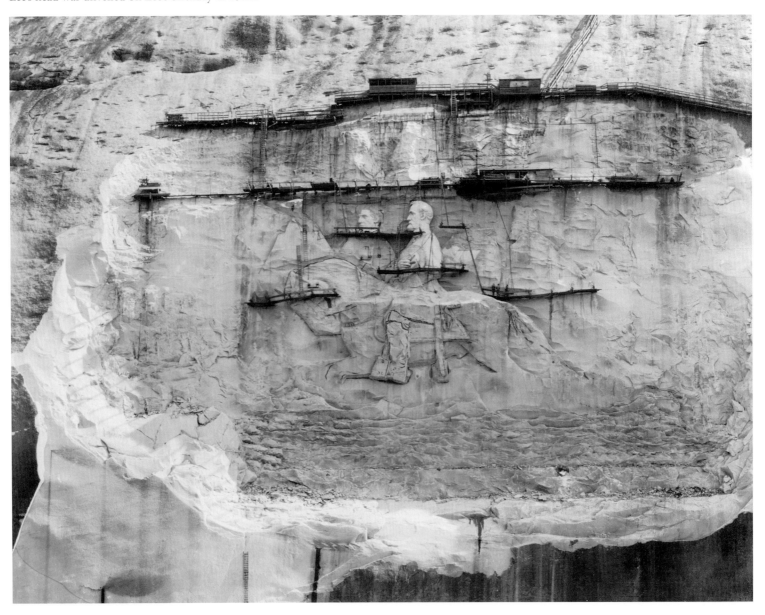

In 1925, Gutzon Borglum left the Confederate memorial project; he later executed the sculptures at Mt. Rushmore, from 1927 to 1941. A second sculptor, Augustus Lukeman, resumed work at Stone Mountain in 1925 by removing previous carving, only to abandon the project in 1928 when funding and a twelve-year deadline ran out. The carving remained unfinished until 1964, when work resumed under state sponsorship. Following a dedication ceremony in 1970, the last details were completed in 1972.

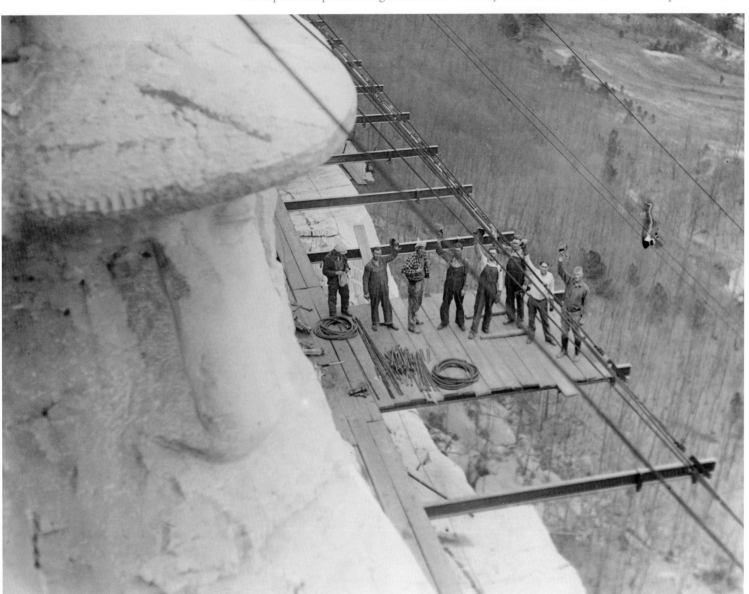

Cheerleaders and fans pose during an Atlanta University football game with Clark University in the mid 1920s. Atlanta University was founded in 1865 by the American Missionary Association. After its first classes were held in a railroad boxcar, the university acquired sixty acres on Atlanta's west side with funds from the Freedman's Bureau. In 1929, the university discontinued undergraduate work and united with Morehouse and Spelman colleges as the Atlanta University System.

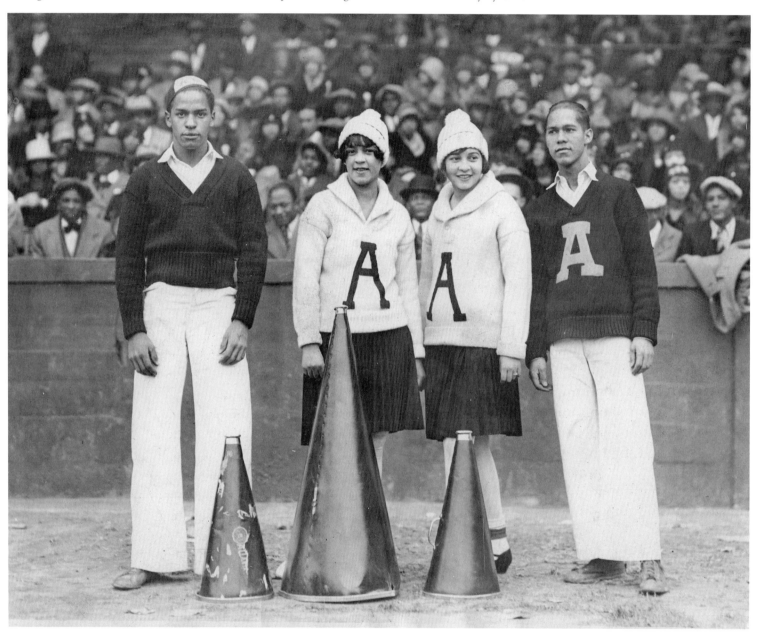

Clark University was founded in 1869 as the Summer Hill School by the Freedman's Aid Society of the Methodist Church. The school later moved to a campus at Whitehall and McDaniel streets and was chartered as Clark University in 1877. In 1941, the university was renamed Clark College and relocated to its present site adjoining Atlanta University. In 1988, the two football rivals merged into the present Clark Atlanta University.

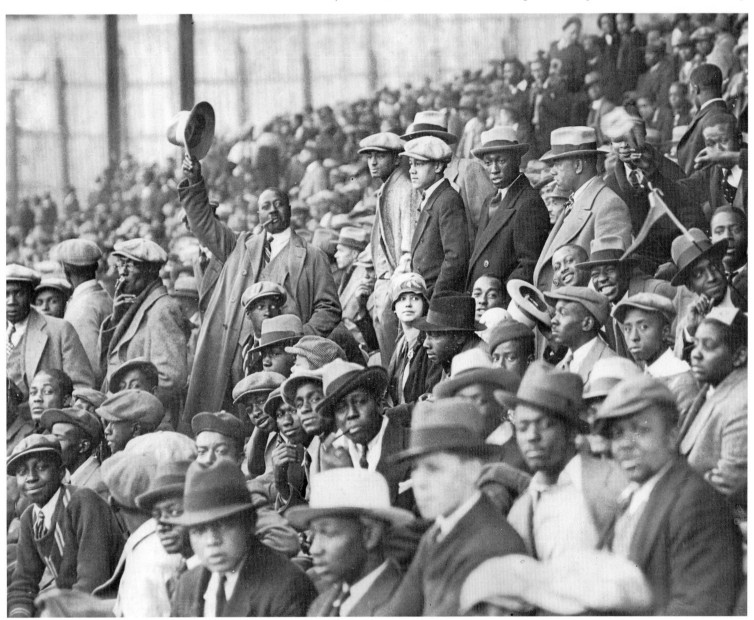

Among the many subjects photojournalist Tracy Mathewson documented were the cultural traditions of Atlanta and the South, from religious baptism to political barbecues. The location of this baptism is unknown, but it would have taken place in the countryside near the city.

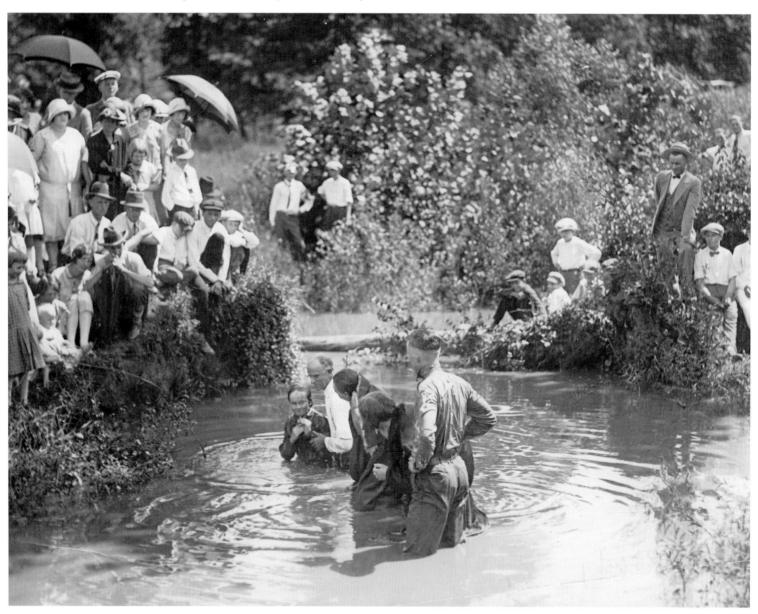

Tracy Mathewson was Atlanta's first professional news photojournalist, working for the *Atlanta Georgian* and other local newspapers beginning in the 1910s. As a photojournalist, his still photographs and newsreels covered a rich variety of topics, including the Atlanta fire of 1917 as well as sports figures, city and state politicians, and sporting events.

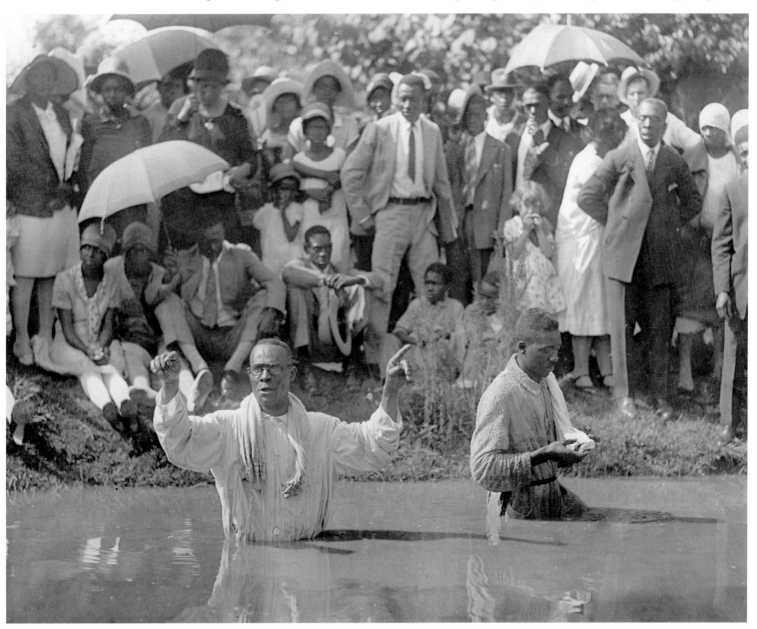

A runner rounds third base during an Atlanta Crackers baseball game at Ponce de Leon ballpark, around 1920. The Crackers first played here in 1907 and remained until 1965, the final season before the Atlanta Braves came to town. In 1923, the grandstand and bleachers seen here, constructed in a former lake bed, burned in a spectacular fire. During the 1920s, the Black Crackers of the Negro League shared the ballpark with their white counterparts of the Southern League.

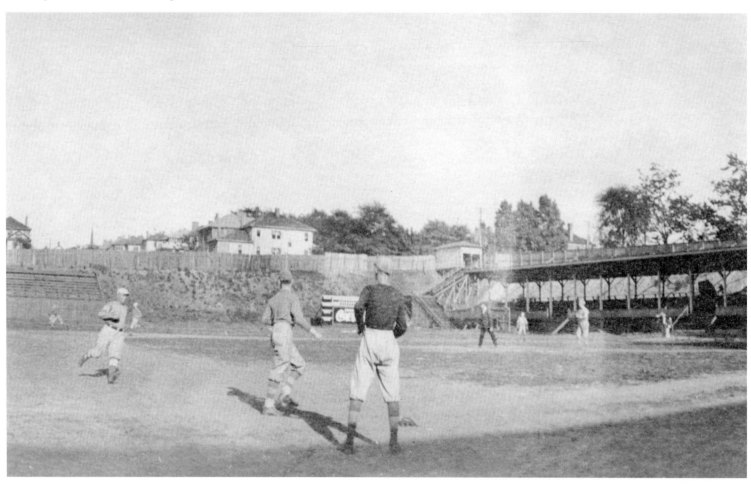

An aerial view of Atlanta's airport before the nation's first passenger terminal was constructed at Candler Field, in 1931. In 1918, the city had formed a committee to locate a landing field "to place Atlanta in a position where she will be among the very first of American cities to secure the benefits of airplane service." The name derived from the previous owner, Coca-Cola businessman Asa Candler, who had built a motor speedway on the property in 1909.

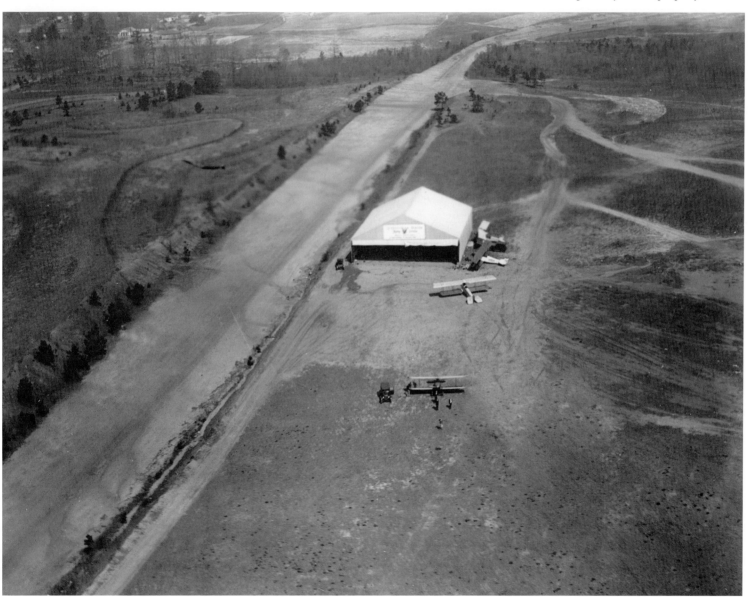

Forsyth Street appears dark and unfriendly as the Depression begins in 1929, but the decade had been good to Atlanta. The city's "Forward Atlanta" campaign had created 20,000 jobs valued at $34.5 million to the local economy. Although the economy slowed during the 1930s, some innovative components were developed, including the new airport, Candler Field. Although Candler eventually supplanted the rail lines that had formed the city, it secured Atlanta's future as a transportation center.

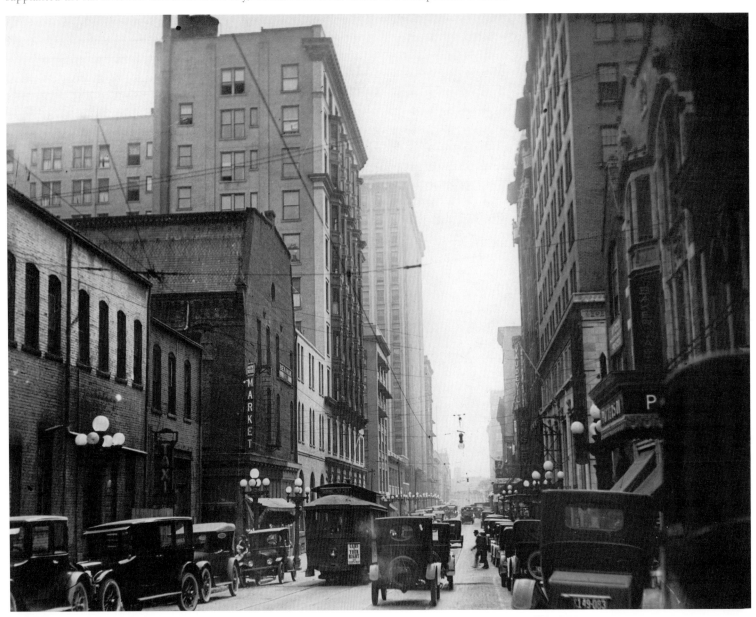

Atlanta in 1930 is dominated by the rail lines with Terminal Station at lower-right. Crossing horizontally across the rail lines is the city's largest civic project of the foregoing decade—the Spring Street Viaduct. At a cost of $1 million, the overpass was part of a long-range plan to construct bridges or "viaducts" spanning the rail lines to ease crosstown traffic. The process resulted in Underground Atlanta as streetscapes were raised one floor to match the viaduct's level.

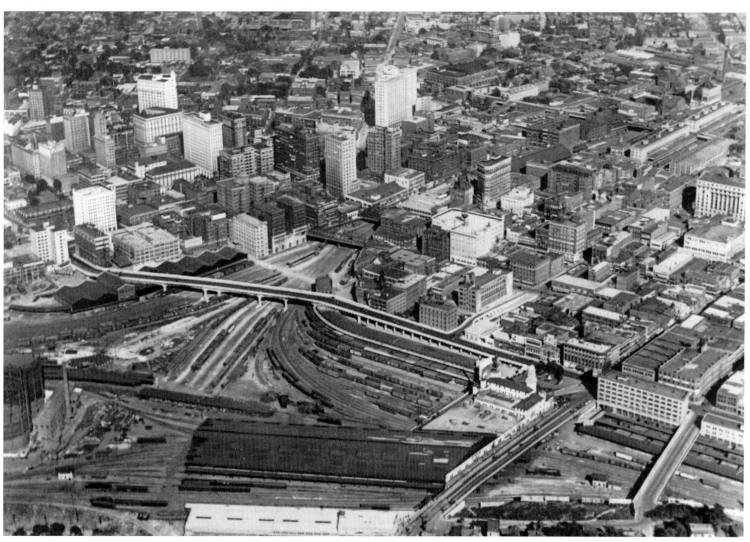

The Paramount Theater at today's Margaret Mitchell Square opened in 1920 as the Howard Theater, designed by Hentz, Reid, and Adler, one of the city's most prestigious architectural firms. When the theater closed and was demolished in 1960, the front elevation was saved and reused as the facade of a residence. The theater stood next to Loew's Grand (the former DeGive Opera House) where *Gone With the Wind* premiered in 1939.

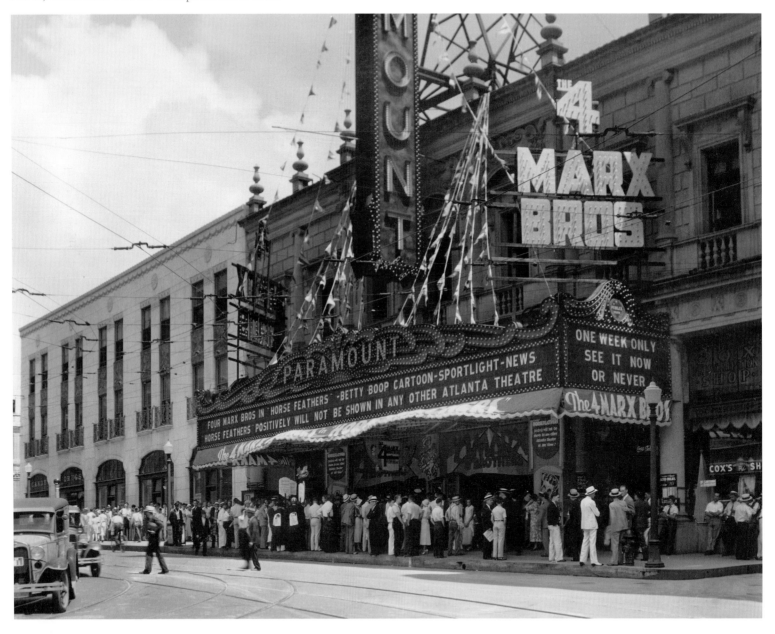

Like something out of a Marx Brothers comedy, students at the Ivy Street School dress as cavemen for a class event. Atlanta had established a public school system in 1872, yet by the turn of the century only about 50 percent of the youth attended classes. Reforms in the 1920s, including a compulsory attendance law, free textbooks, and enforced child-labor regulations, resulted in 90 percent attendance by the end of the 1930s.

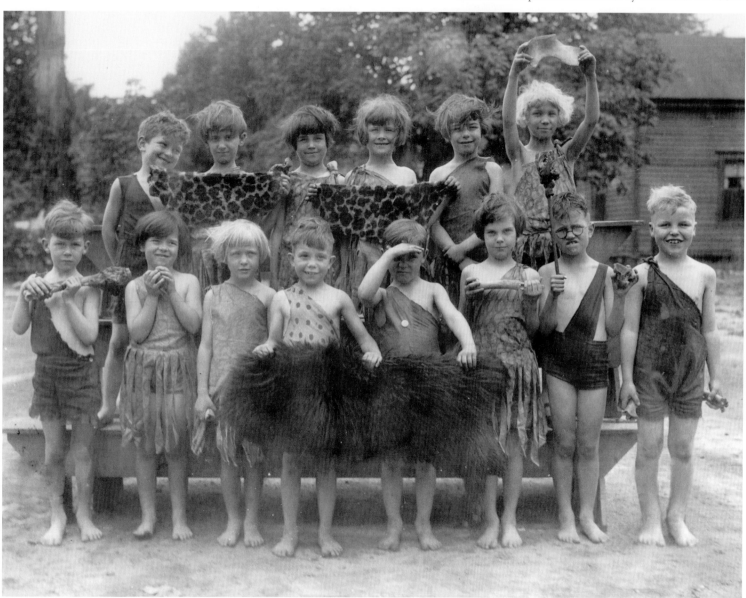

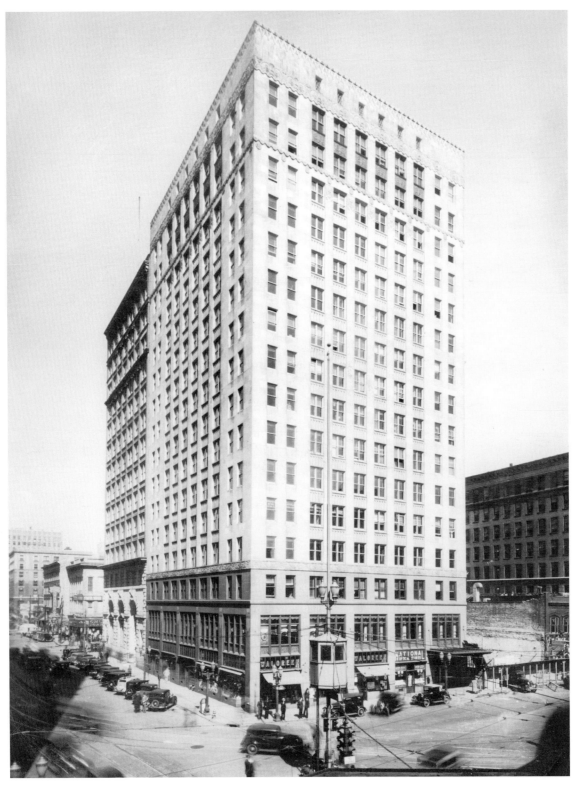

The William Oliver
Building—named for
sons William and Oliver
Healey of the original
owner—remains an example
of art deco architecture
as part of the Fairlie-
Poplar Historic District in
downtown Atlanta. Bounded
by Marietta, Peachtree,
Luckie, and Cone streets,
the district holds a variety
of architecture, including
Renaissance revival,
neoclassical, Georgian
revival, and Victorian styles.

On February 22, 1930, city records were moved to Atlanta's new neo-Gothic City Hall at Washington and Mitchell streets. The building was erected on the site of Girls' High School, property which included the Neal-Lyon House that had served as General Sherman's headquarters during the Civil War. The building is Atlanta's fourth city hall. The main city offices remained here until a new addition on Trinity Street opened in 1989.

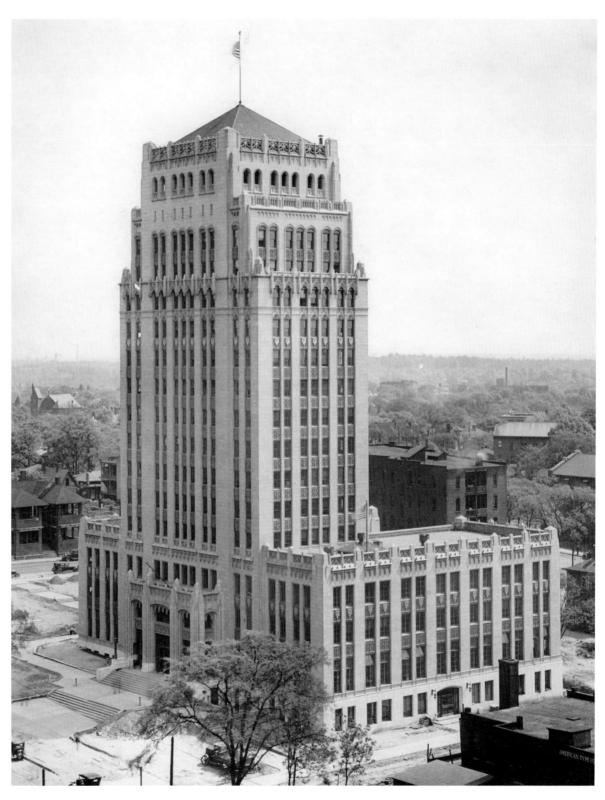

Atlanta's Fox Theatre opened Christmas Day 1929, just as the Roaring Twenties came to a close. Originally built as the Yaarab Temple Shrine Mosque, the theater declared bankruptcy less than one year after opening. Despite success in the 1940s, audiences decreased in the following decades until corporate interests sought to demolish the building in the 1970s. Saved through a preservation campaign, the Fox remains home to films, ballet, theatrical productions, and other cultural events.

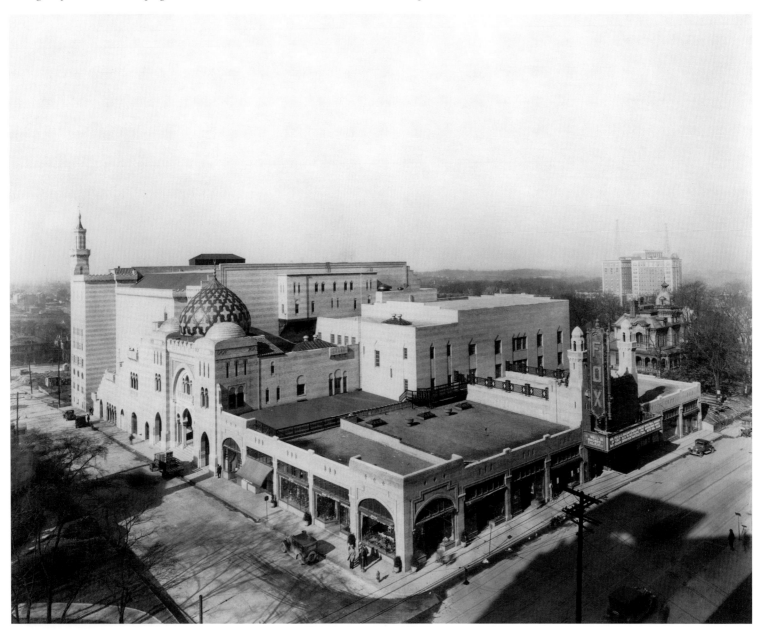

Crowds gather outside the city's third Union Station, opened in 1930, to hear President Franklin D. Roosevelt. The depot was built above the tracks along the Forsyth Street viaduct rather than at ground level. It marked another crossroads in transportation, ending nearly eight decades in which the old depot had been the city center. "Feet that for generations have worn a path to the old station," remarked the newspaper, "will beat another to the new."

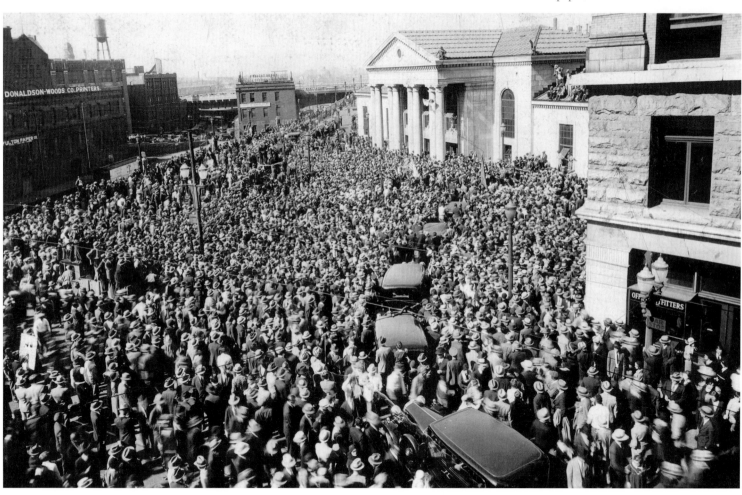

This model home on former Chestnut Street near Simpson Street was procured and remodeled by the construction firm of Walter H. "Chief" Aiken in 1936. Aiken, former football coach of Atlanta University, was a leading civic and business leader in Atlanta's African American community. During the Depression, Aiken remodeled this home to show what could be done to improve property through assistance from the Federal Housing Authority.

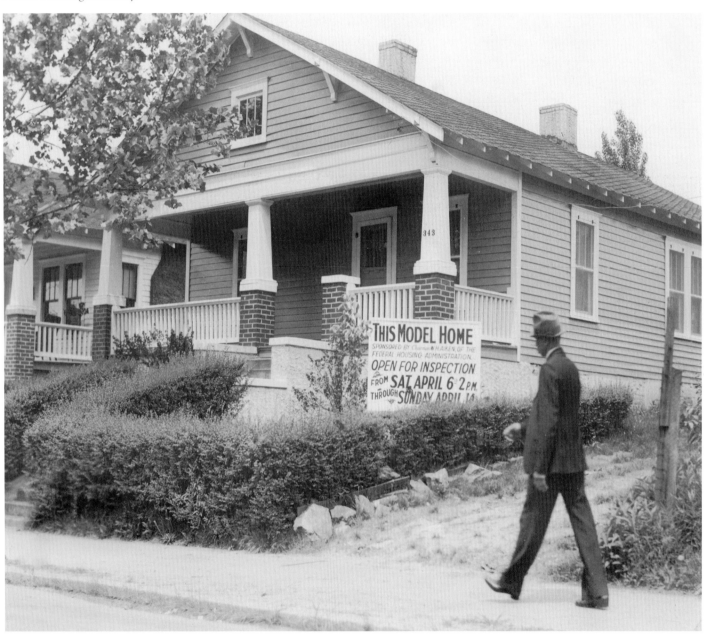

President Franklin D. Roosevelt speaks at Georgia Tech's Grant Field during the dedication ceremony for Techwood Homes, the nation's first public housing project. In 1935, the New Deal sponsored two urban renewal projects in the city, Techwood Homes for whites and University Homes for blacks. The latter project was a collaborative effort between Atlanta real estate developer Charles Palmer and John Hope, president of Atlanta University.

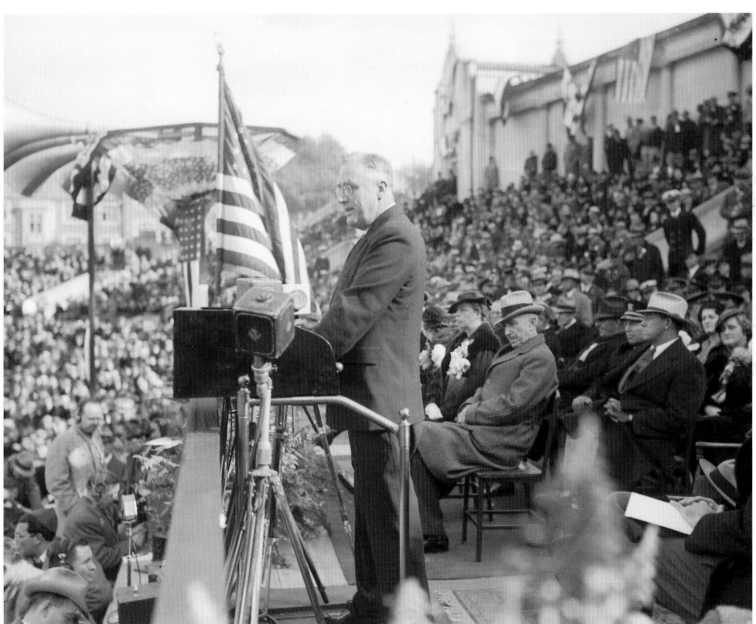

In September 1926, the first air mail flight left Atlanta for Macon, Jacksonville, Tampa, Fort Myers, and Miami. Passenger service from Atlanta to Dallas and Los Angeles was inaugurated in October 1930 with service by American Airlines. By the end of 1930, only New York and Chicago had more regularly scheduled flights than Atlanta's Candler Field. Sixteen planes a day were arriving and departing, carrying mail, express, and passengers.

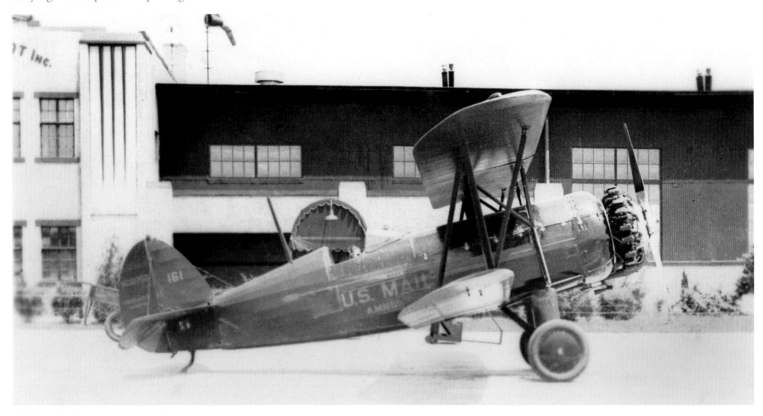

The nation's first air-traffic control tower opened at Candler Field in March 1939. During World War II, the airport doubled in size and set a record with 1,700 departures and arrivals in a single day, making it the nation's busiest airport for flight operations. In 1946 Candler Field was renamed Atlanta Municipal Airport, and two years later, more than one million passengers passed through its terminal.

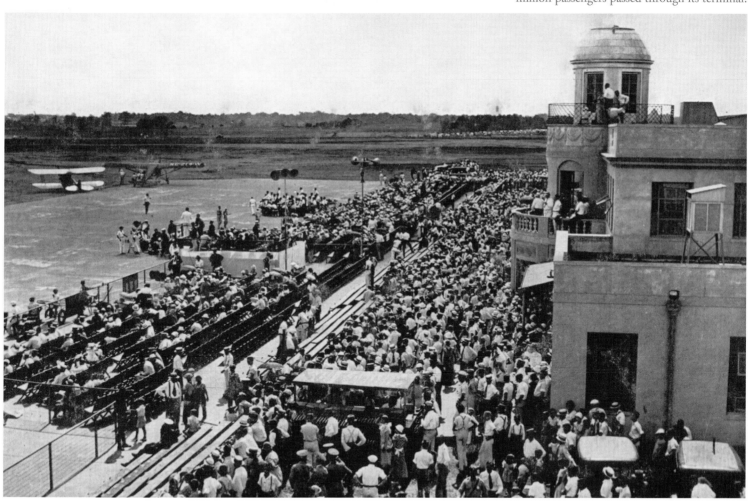

Atlanta Constitution photojournalist Kenneth G. Rogers took this view of snow-covered track in downtown Atlanta after an ice storm. The tracks in the foreground lead from the new Union Station depot at Forsyth Street. Working for the newspaper for more than fifty years, Rogers served as the head of photography for the paper's magazine, earning the title "dean of southern photographers."

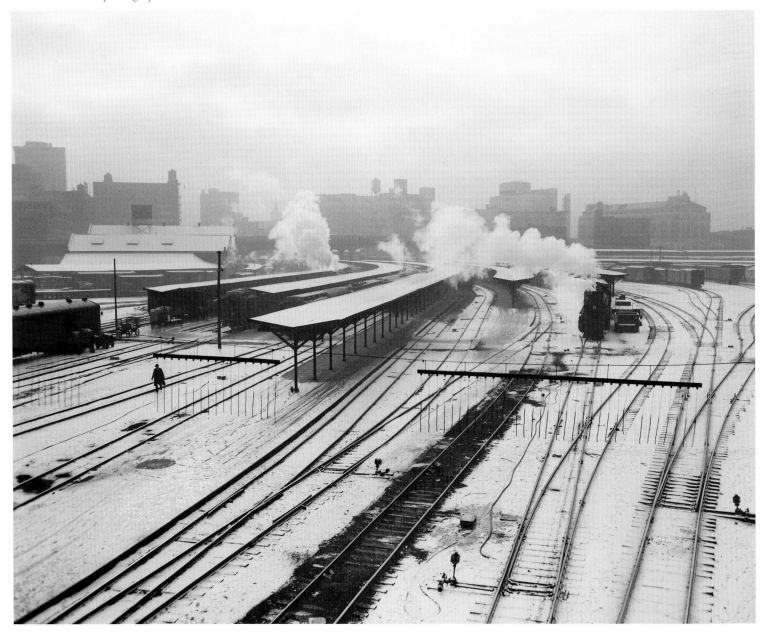

One of the city's most tragic fires occurred in November 1936, when a blaze gutted the Cable Piano Company building on Broad Street. The fire resulted in six deaths, and another six persons jumped from the building. A subsequent investigation determined the city fire department lacked adequate equipment, including aerial ladders and smoke masks. In addition to firefighting equipment, firefighters needed less crowded conditions, which had resulted in "mob hysteria" at the scene.

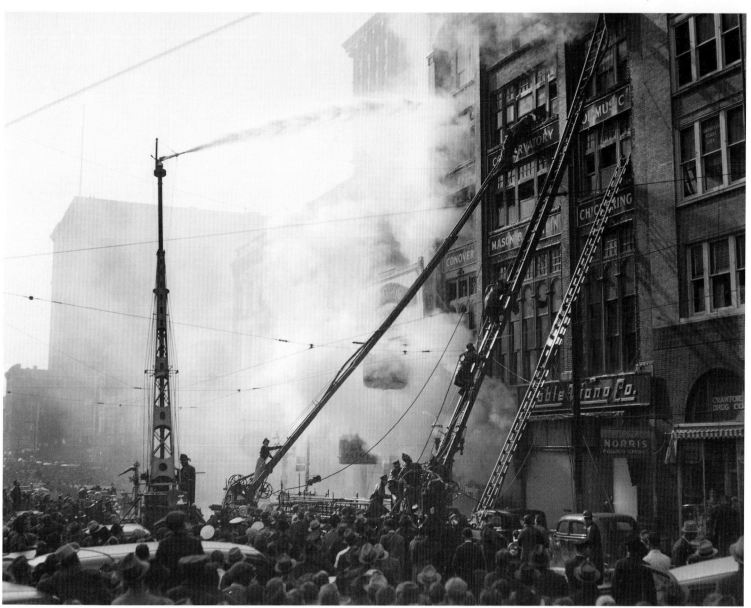

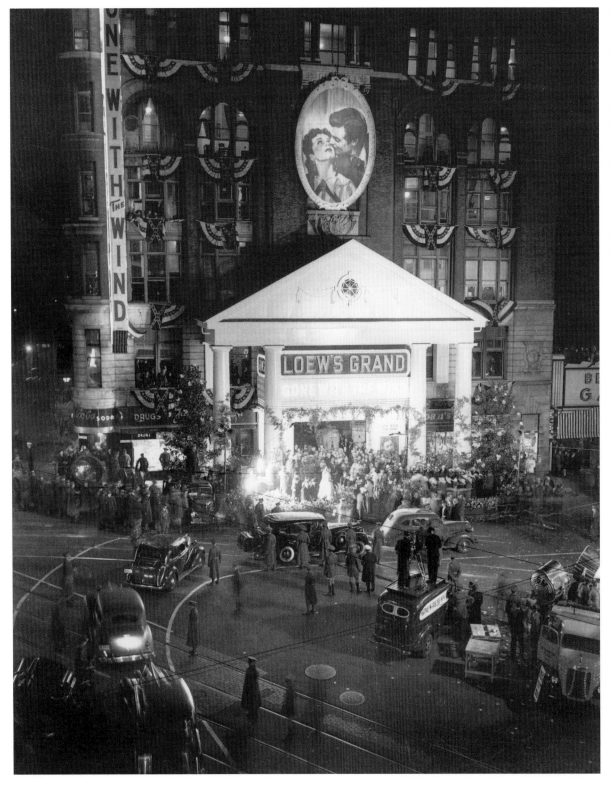

On December 15, 1939, the motion picture version of Margaret Mitchell's Pulitzer Prize–winning novel, *Gone With the Wind*, premiered at Loew's Grand Theater. The movie release only added to the legend surrounding the book, its characters, and the author. As the 1930s drew to a close, Atlanta, Peachtree Street, and Scarlett O'Hara had entered the public imagination as symbols of the American South.

Mrs. John R. Marsh prepares to enter the theater the night of the premiere. Known to her friends as "Peggy," she was from an old Atlanta family that first settled in the area in 1835. Writing under her maiden name, Margaret Mitchell, she published her first and only novel in June 1936. The film showing followed three days of festivities, including a parade along Peachtree Street, receptions, and a costume ball at the municipal auditorium.

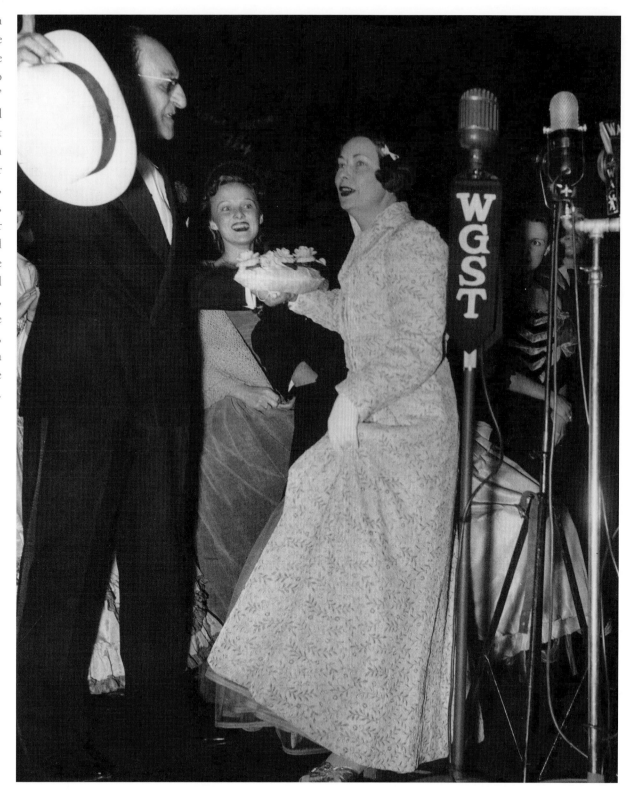

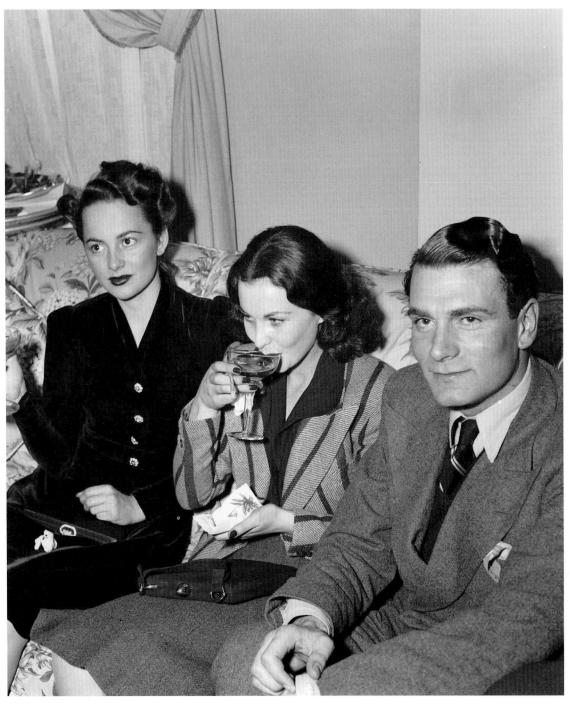

Flanked by Olivia de Havilland and Laurence Olivier, the film's star, Vivien Leigh, sips champagne at a press party held at the Georgian Terrace Hotel. Following the premiere of *Gone With the Wind,* the actors attended a breakfast complete with southern dishes, including ham, biscuits, and hominy. By 8:00 A.M., they had all departed by plane for Hollywood and by train to New York.

The movie version of *Gone With the Wind* was filmed almost entirely in California. Both Clark Gable and Vivien Leigh, therefore, participated in a number of events intended to introduce them to Atlanta and the South. The pair toured columned southern mansions and visited the Cyclorama painting depicting the Battle of Atlanta, where Gable was introduced to a miniature figure with his likeness that had been added to the diorama.

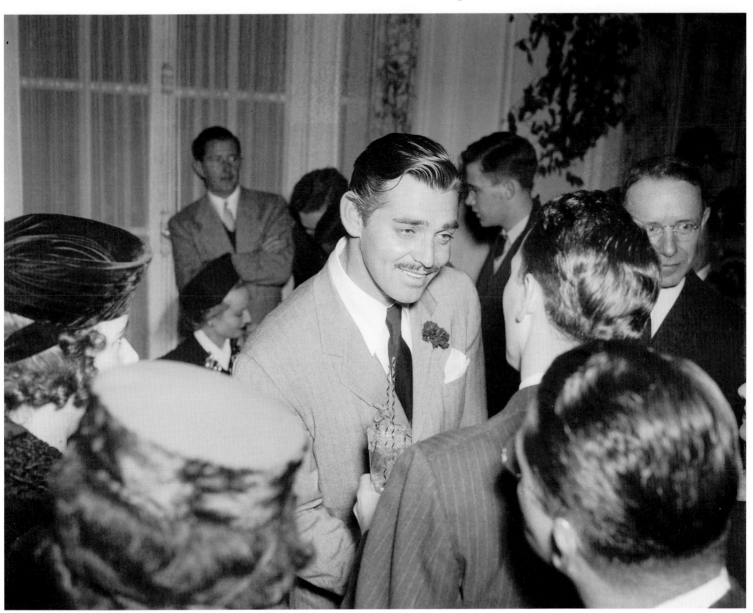

White boaters and white shoes were the fashion of the day in 1940s downtown Atlanta. During the decade, a once-familiar sound throughout the city would disappear—the grinding, screeching sound of the steel-wheeled railway car against metal rails.

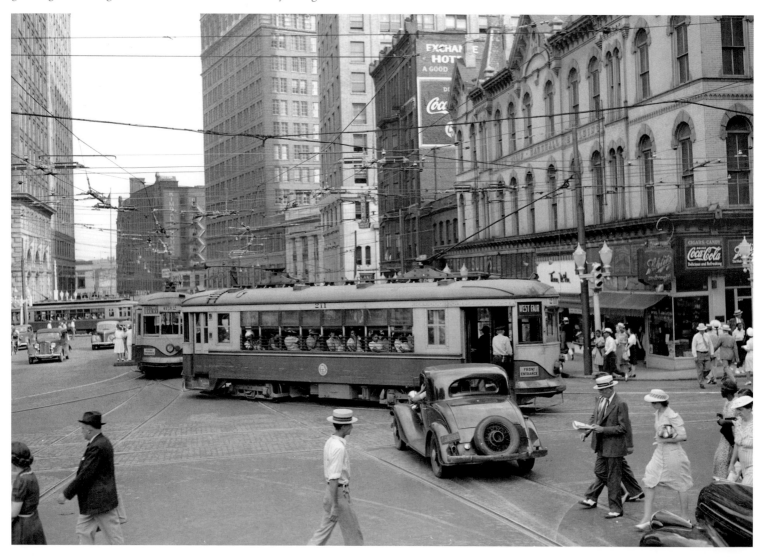

Centennial City: From Southern Metropolis to Olympic Village

(1940–1996)

World War II had a dramatic effect on every sector of life in Atlanta, including the economy, politics, race, and population. Men and women, regardless of race or class, enlisted in the armed forces or were employed in war-related industries. Although Atlanta remained racially segregated, women and African Americans were economically and politically empowered by their wartime service at home and abroad. Beginning in 1940, the federal government spent more than $10 billion on war expenses in the South, of which Atlanta became an important recipient. By the end of the war, Atlanta's economy and way of life had been significantly changed for the future.

In addition, the expansion of roads, automobiles, and air travel allowed individuals to cross cultural, geographic, and social lines. The city's airport facilities and services experienced dramatic growth, bringing greater numbers of business and vacation travelers in and out of Atlanta. City streets, expressways, and the interstate highway system connected downtown with the suburbs, rural and urban areas, and cultural, racial, and social spheres. As the rail depots were closed, Atlanta remained a transportation hub through the interstate highway system and the airport, which became the world's busiest.

Two events had an impact on the international image of Atlanta: the civil rights movement and the Centennial Olympic Games. The city and the nation underwent dramatic social change from the 1940s through the 1960s. As African Americans fought for political and economic justice, Atlanta played a pivotal role in the struggle for civil rights. As the birthplace of Dr. Martin Luther King, Jr., and home to other key leaders and organizations, the city became recognized throughout the world as the home of the civil rights movement.

The city effectively closed out a century of growth and change by hosting the world in the 1996 Summer Olympics, formally known as the Games of the XXVI Olympiad. In seventeen dramatic days, Atlanta made a significant advance in its development as a modern, international city. Besides world recognition, the city's Olympic legacy includes downtown revitalization in the form of Centennial Park, now the site of a growing list of cultural attractions and nearby urban housing.

In a century and a half, Atlanta was transformed from a stake in the wilderness to global city. Shortly after he drove the stake, railroad engineer Major Stephen H. Long was offered property in the new town. Declining, he expressed his belief that the area was "a good location for one tavern, a blacksmith shop, a grocery store, and nothing else." He should have accepted the offer.

Coming north from the original depot site, the intersection of Peachtree and Forsyth streets with the present Park Place is the point where Peachtree Street turned north to follow a ridge line that is a geological drainage-basin divide. Since Atlanta sits along the Eastern Continental Divide, rainwater falling on the east side of the divide runs into the Atlantic Ocean while rainwater on the west side runs into the Gulf of Mexico.

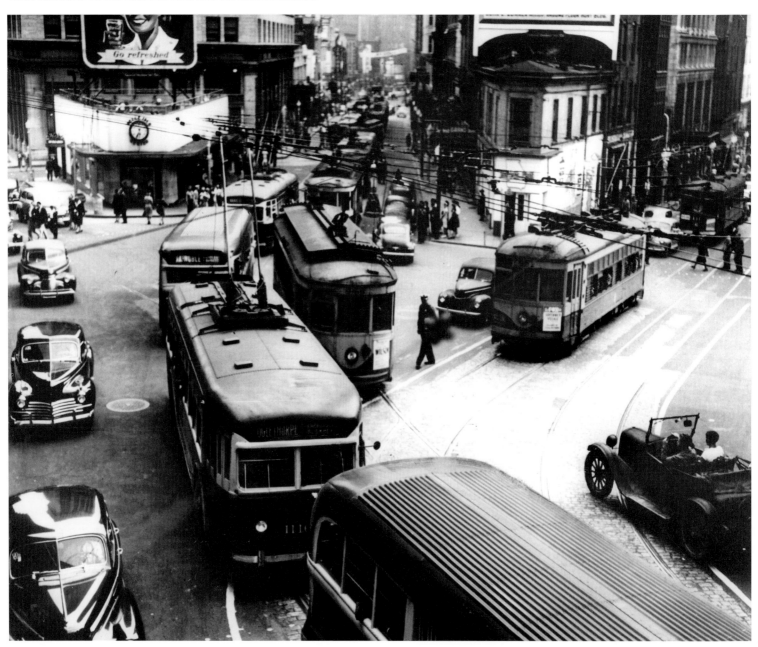

A streetcar turns the bend on Peachtree Street at West Peachtree and Baker streets. In 1886, Jefferson Davis dedicated a monument to Georgia senator Benjamin H. Hill that stood in a small park here. The statue was later moved to protect it from vandals and the "inevitable and ubiquitous initial carvers," in the words of city historian Franklin Garrett. In 1912, the grade of Peachtree Street was lowered, leveling the descent into West Peachtree Street and clearing the park for business development.

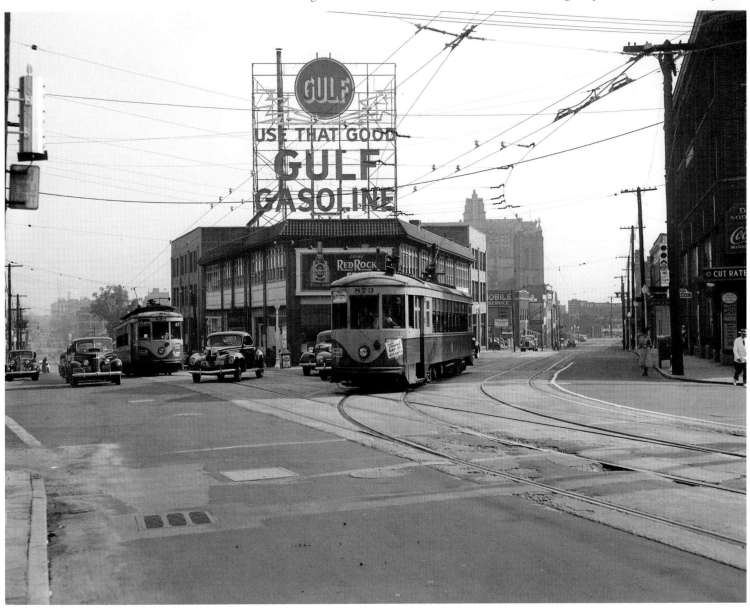

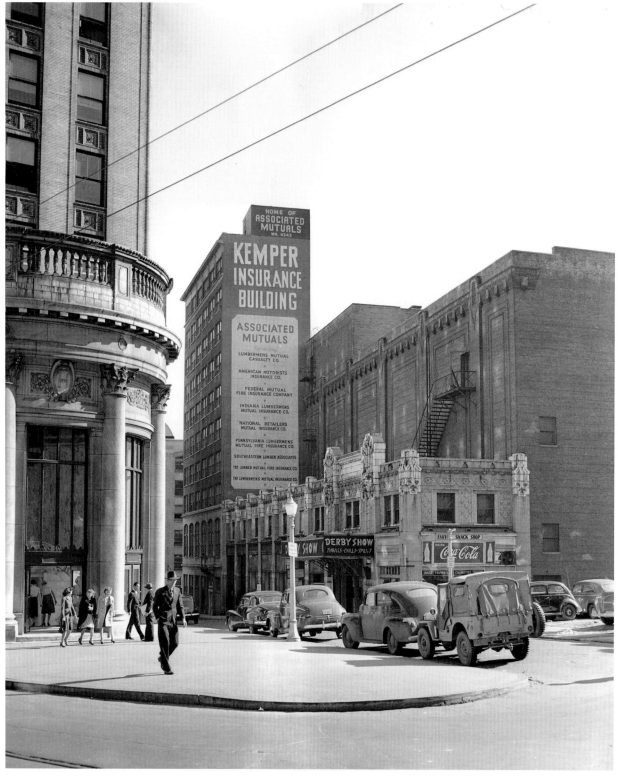

The columned entrance to the Hurt Building appears at left, located on the site of the car barn for the mule-drawn railway. The building was constructed from 1913 to 1926 in a triangular V-shape similar to other Atlanta skyscrapers, including the nearby Candler Building. Businessman Joel Hurt planned the building before hiring J. E. R. Carpenter, a New York architect experienced in high-rise designs, to complete the final plans.

Bell Bomber workers, 37 percent of them women, manufactured more than 600 airplanes during World War II at the Bell Aircraft plant in Marietta. Although the plant closed following the end of the war, it was reopened in 1952 by the Lockheed Corporation. The federal government's investment in war industries in Atlanta during World War II had a dramatic impact on the area's future economy.

Buses, automobiles, and streetcars let passengers out in front of Davison-Paxon's department store at Peachtree and Ellis streets. Atlanta has always been a shopping destination with important local retail stores including Rich's, Davison's, J.P. Allen, Regenstein's, and George Muse's clothing company. All of these establishments maintained a flagship store in downtown Atlanta. Today, Atlanta remains a regional retail center with shopping malls such as Lenox Square and Phipps Plaza.

The Winecoff Hotel was considered the finest in the city when it opened in 1913. Advertised as "fireproof," it nevertheless had no fire alarms, fire escapes, or sprinkler system. On December 7, 1946, the hotel was filled almost to capacity when a fire began around 3:00 A.M. With the loss of one hundred and nineteen people, it remains the deadliest hotel fire in U.S. history. The building still stands at the corner of Peachtree and Ellis streets.

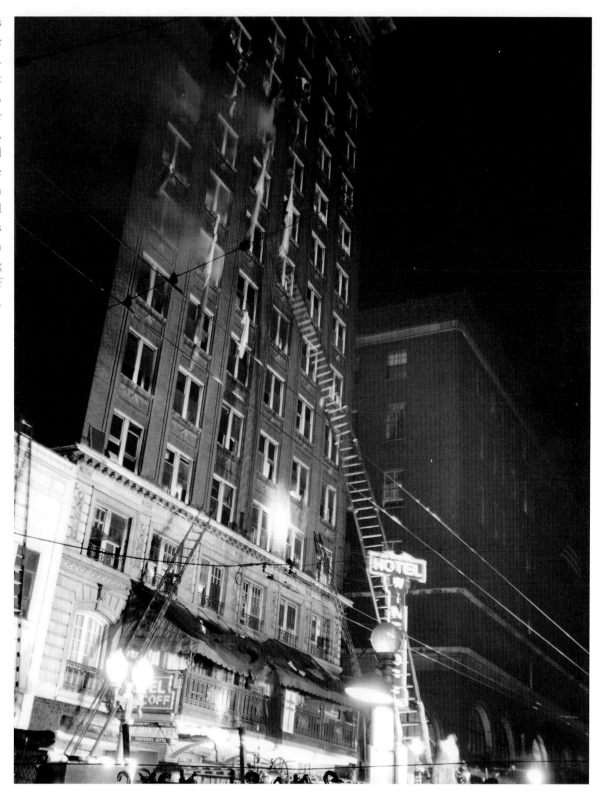

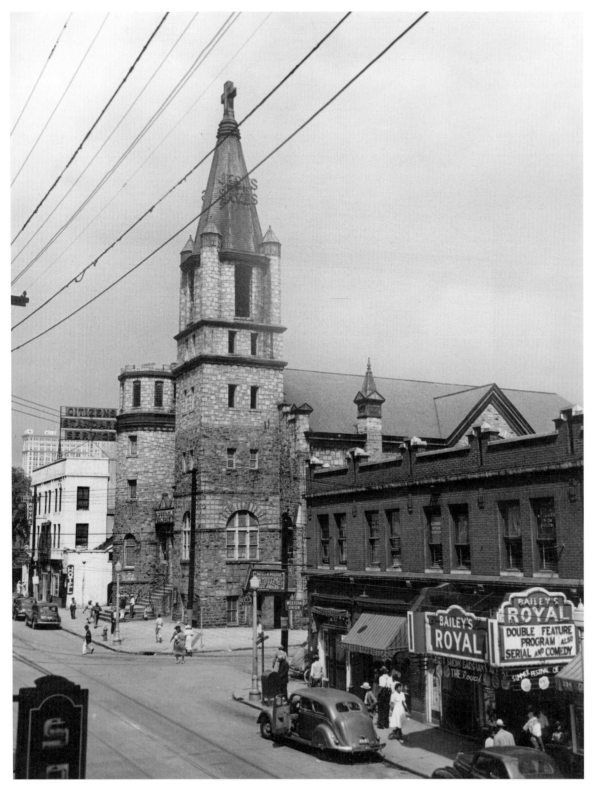

The message "Jesus Saves" rises over Auburn Avenue on the Big Bethel AME Church in the historic African American neighborhood called "Sweet Auburn." The street became the center of the city's black social, political, economic, and religious life in the 1930s. Other significant buildings include Ebenezer Baptist Church, where Martin Luther King, Jr., was pastor; the Royal Peacock club, headlining B. B. King and Gladys Knight; and the Atlanta Life Insurance Company, founded by Alonzo Herndon.

In 1945, Atlanta contained approximately 3,000 registered African American voters. The following year, the All-Citizens Registration Committee registered almost 18,000 new black voters in less than two months. The committee was a coalition of representatives of the National Association for the Advancement of Colored People (NAACP), the Urban League, the Atlanta Civic and Political League, and other black organizations. Though still a minority, the African American community enjoyed growing electoral strength because of such efforts.

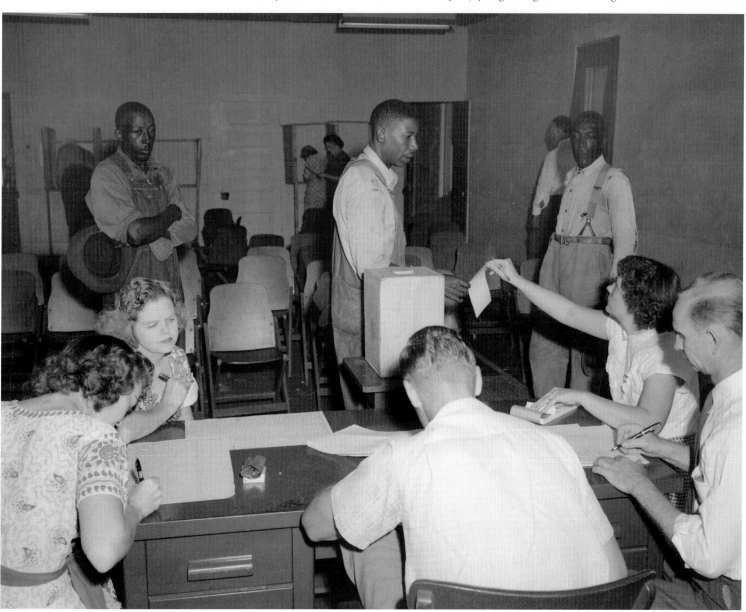

Newspaper reporters, photographers, and managers moved into the new offices of the *Atlanta Constitution* on December 26, 1947. The newspaper was founded in 1868 and at one time or another included Henry W. Grady, Joel Chandler Harris, and Margaret Mitchell as staff writers. Around 1890, the newspaper had the widest geographic distribution in the nation. The building was designed by Robert & Company with relief sculpture by Julian Harris, who executed sculpture for fifty-two public buildings in the Southeast.

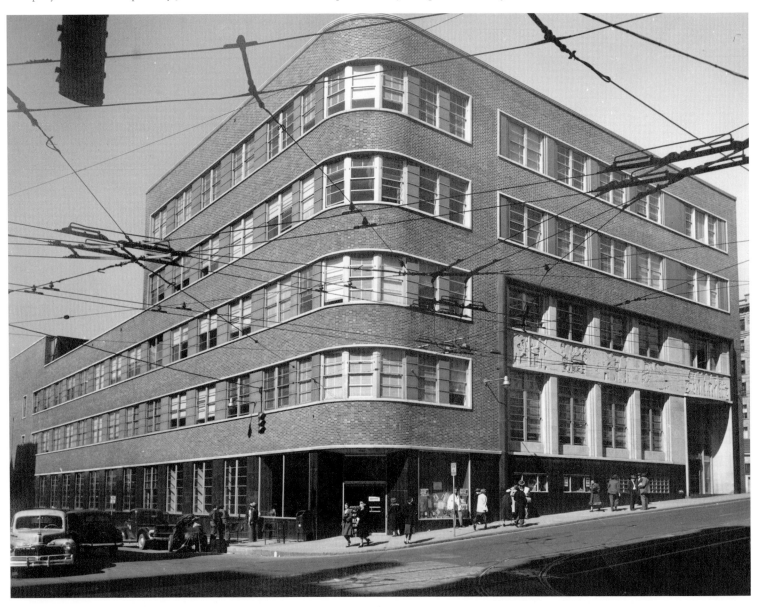

Plaza Park, dedicated in August 1949, was a modernist island amid the remnants of the past. To its right is the second Kimball House, built in 1885, and unlike its neighbor, the small urban park existed only briefly. The area has become the plaza entrance to Underground Atlanta, where a giant peach is dropped at midnight on New Year's Eve.

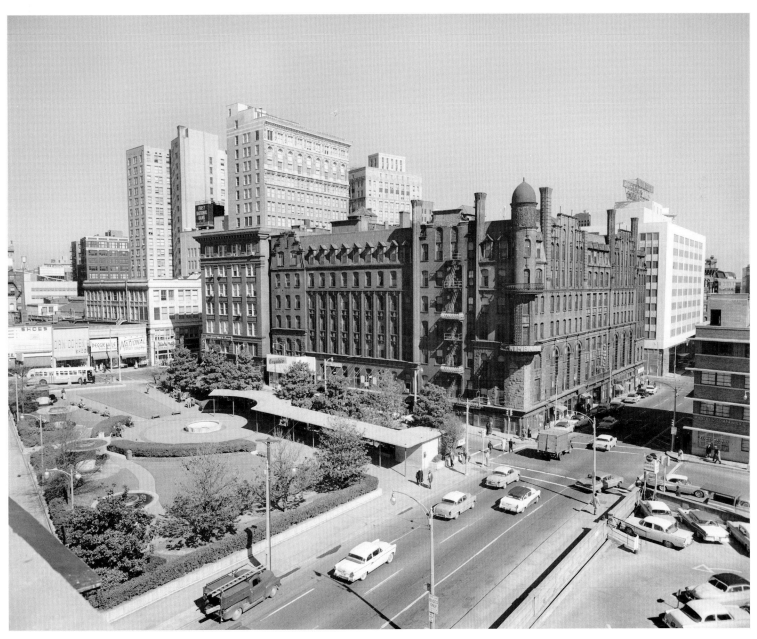

In 1948, construction on the downtown connector divided the Georgia Tech campus from the Varsity on the opposite side of the future interstate. Two years earlier, the city had approved a highway program for a limited-access highway through downtown Atlanta. This project laid the groundwork for combining with the national interstate system in which six highways now connect in Atlanta.

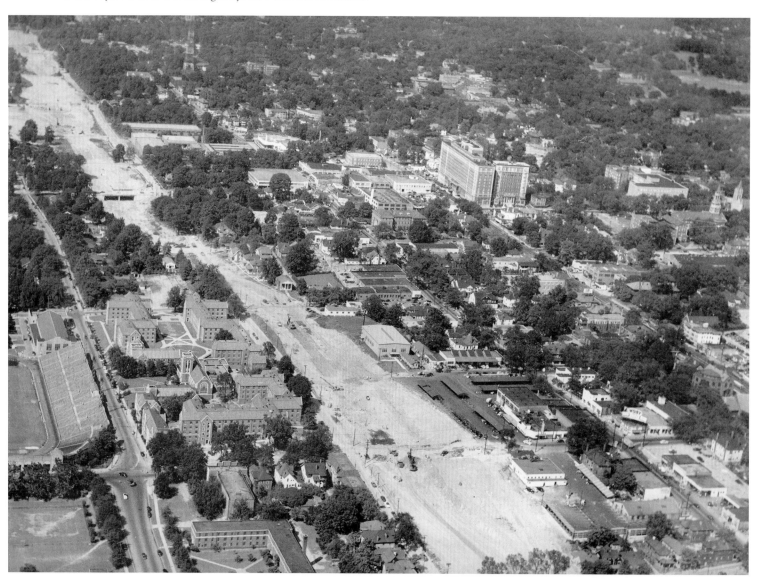

In June 1904, the city purchased the property of the Cotton States & International Exposition, creating Piedmont Park. A few years later, the city hired Olmsted Brothers to create a master design plan for developing the park; though that plan was never fully realized, it created a vision for the future. Today, the park serves as the venue for the Atlanta Pride Festival, the Montreux Jazz Festival, and the Atlanta Dogwood Festival.

Fireworks explode over Lakewood Park, site of the annual Southeastern Fair located on the grounds of the original city waterworks. From 1916 to 1978, the fair was often the state's largest attraction, with displays of livestock, agriculture, art, and farm machinery, horse and auto racing, a midway, and a fireworks show.

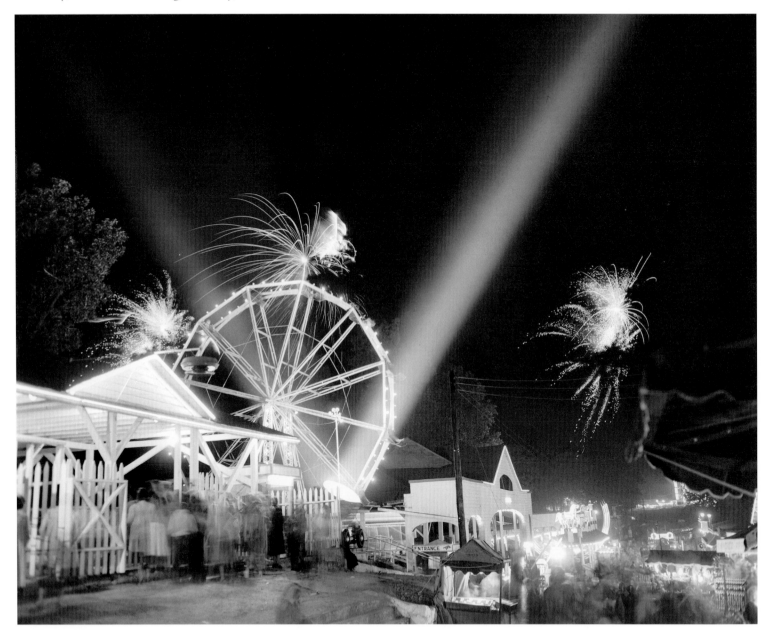

The Peachtree Center
Avenue side of the Hurt
Building overlooks tulip
time at Joel Hurt Park on
the edge of the Georgia
State University campus.
In the 1880s, businessman
Hurt developed Atlanta's
first suburb, Inman Park,
and in the 1890s, he hired
Frederick Law Olmsted to
design the Druid Hills park-
like neighborhood. The
land for the park in memory
of Hurt was donated to the
city in 1940.

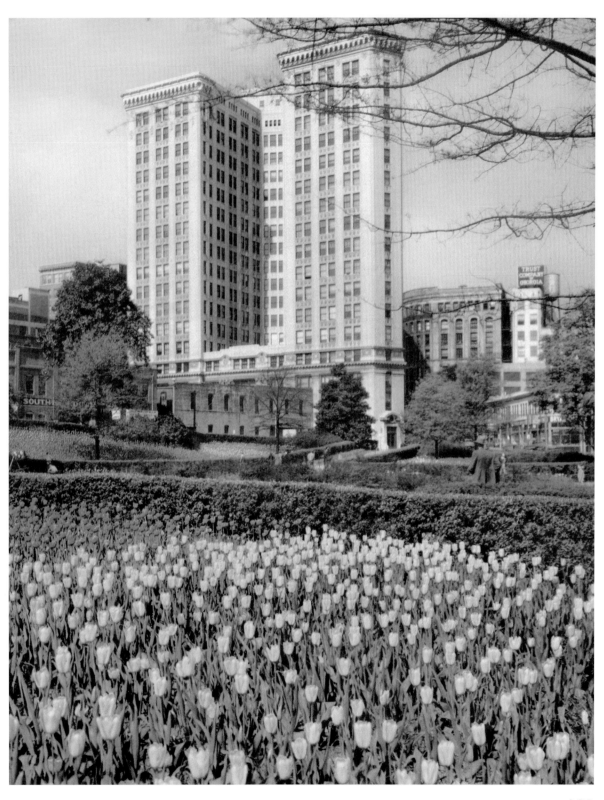

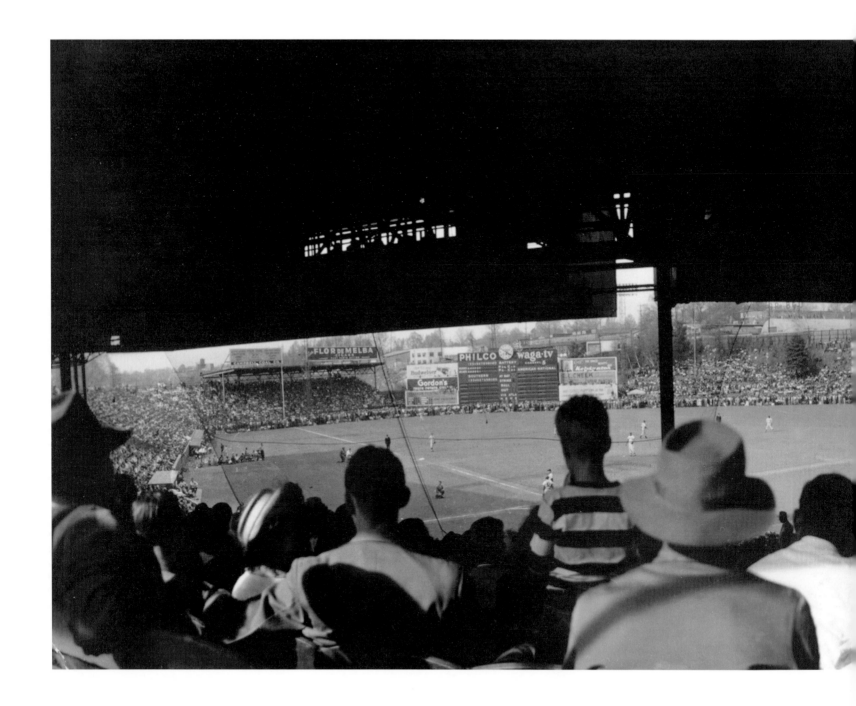

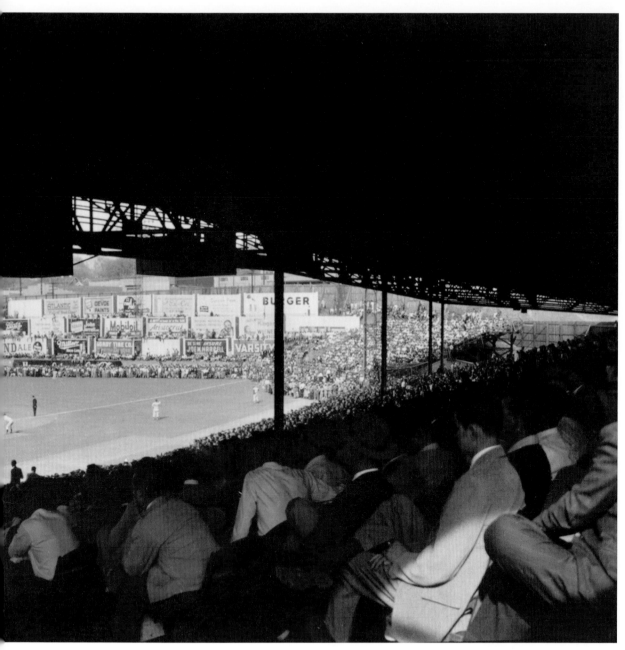

The view from the grandstand at Ponce de Leon ballpark in April 1949 included a magnolia tree just right of center field. The home of the Crackers, it was commonly called "Poncey" and was the only stadium allowing for a tree—462 feet from home plate—in the outfield. If a ball was hit into the giant magnolia, it was in play. After Atlanta-Fulton County Stadium was built, the ballpark was taken down in 1966. The magnolia tree still stands.

As Atlanta moved to the suburbs in the 1950s, downtown remained an entertainment district, including nightclubs, dinner theater, supper clubs, and fashionable motion picture theaters. Shorty's Steak House on rainy Decatur Street was a neighbor to the Five O'clock Supper Club at Margaret Mitchell Square, Club Peachtree for dancing and dining, Wits' End for comedy and dancing, and Mammy's Shanty restaurant on Peachtree Street, which offered dancing in the Plantation Lounge.

Spelman College, blanketed in snow, was founded as the Atlanta Baptist Female Seminary by Sophia B. Packard and Harriet E. Giles in 1881. With support from John D. Rockefeller, the school located to its current site in 1884 and was named Spelman Seminary in honor of Harvey and Lucy Spelman, the abolitionist parents of Rockefeller's wife, Laura. Spelman College is the nation's oldest historically black college for women and is a member of the Atlanta University Center.

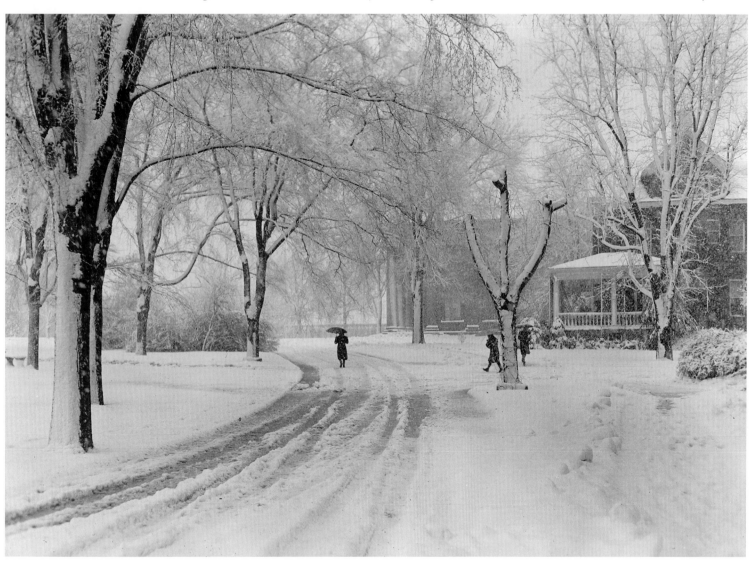

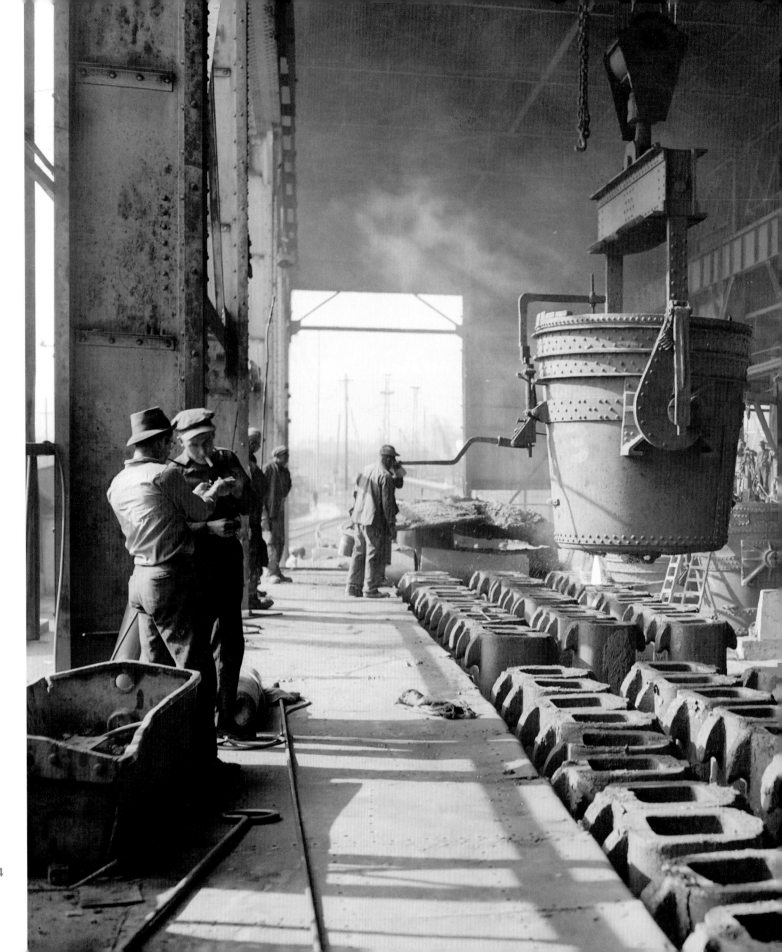

174

In 1901, the Atlanta Steel Hoop Company was founded to manufacture barrel hoops and cotton bale ties. The company changed its name to Atlantic Steel in 1915 and expanded its product line to include barbed wire, fence posts, rails, and nails. The company also expanded geographically to encompass a 140-acre industrial site just north of the Georgia Tech campus. The property has now been redeveloped as a mixed-use community, Atlantic Station.

With paper icicles hanging in the windows, Atlanta's first air-conditioned (trackless) trolley offers a cool ride on the East Point–to–Hapeville line. Following World War II, transit use fell as electric trolleys were replaced with buses. In an effort to attract riders, the system tried cool comfort and—descending the front steps—a bus stewardess. Around the same time, the seasonal highest demands on the power company's electricity generation switched from winter to summer as southerners embraced air conditioning.

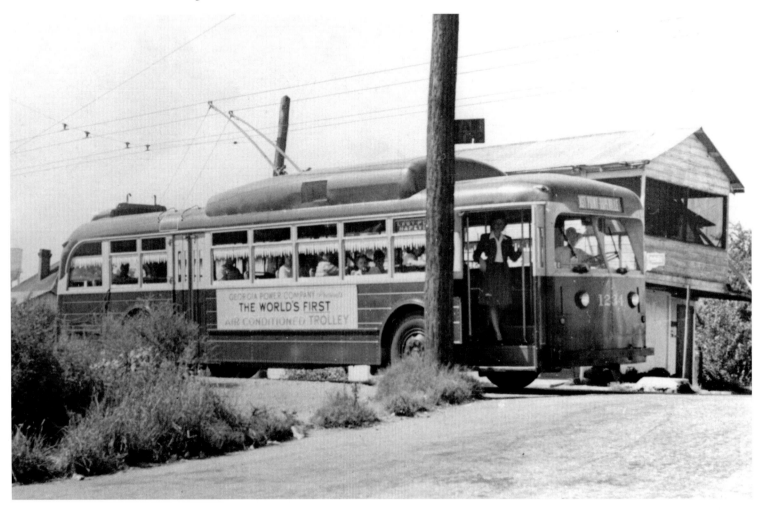

A night on the town could include cocktails, as here at Leb's Pigalley, comically named after the notorious Place Pigalle in Paris. The nightclub was located underneath Leb's Delicatessen at Luckie and Forsyth streets, advertising that they offered "something different for the discriminating epicure."

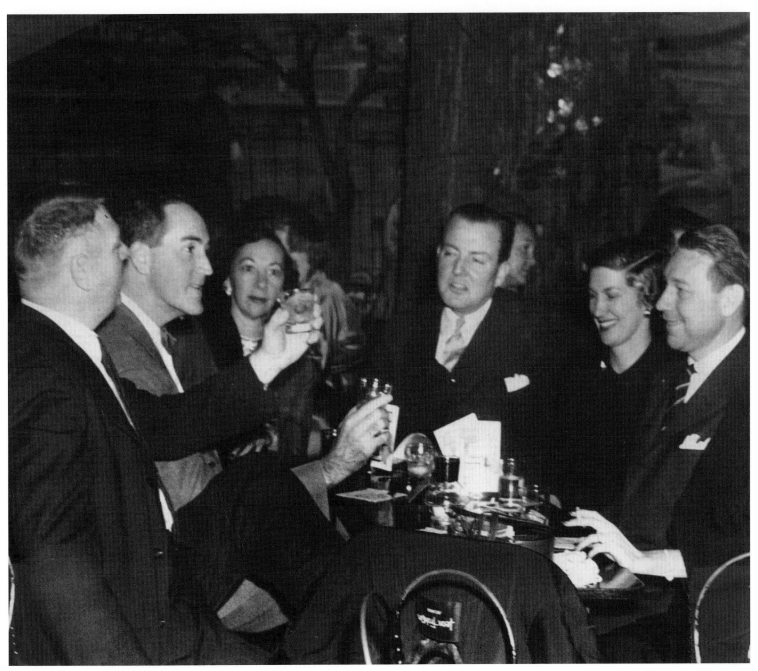

Though the lake behind this family at Grant Park no longer exists, the park today includes other attractions, including Zoo Atlanta and the Atlanta Cyclorama. The neighborhood surrounding the park is the city's largest historic neighborhood and includes Oakland Cemetery, established in 1850. The park also holds the remains of Fort Walker, a section of the Civil War fortifications designed and constructed by engineer Lemuel P. Grant, who donated the property for the park in the 1880s.

Delta customers at Atlanta Municipal Airport wait in line on the sunny tarmac to board a DC-3—a formal practice unusual compared with today's procedure leading from terminal to jet along an enclosed gangway. A few years later, the city opened a new airport, the largest single terminal in the nation, able to accommodate more than six million passengers annually. Today's airport in Atlanta, Hartsfield-Jackson Atlanta International Airport, is the world's busiest.

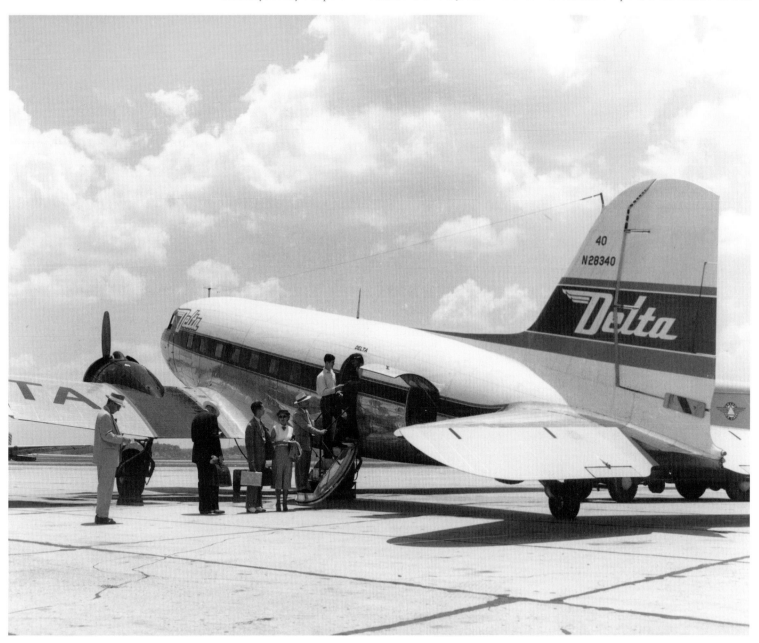

Atlantans today would be pleased at these light traffic conditions as commuters and travelers head out of Atlanta in an early view of the downtown connector. Six interstate highways converge in Atlanta, creating economic growth, along with urban sprawl, traffic congestion, and pollution. Nevertheless, the interstate highway system, coupled with the area's traditional rail and air transportation, shaped Atlanta as one of the boom cities of the second half of the twentieth century.

Children respond to a parade along downtown Peachtree Street, long the street of choice for parades, pageants, and marching bands. In addition to past special events, such as the circus or conventions, Atlanta has maintained a number of traditional annual civic parades, including those for St. Patrick's Day and the annual Children's Christmas Parade.

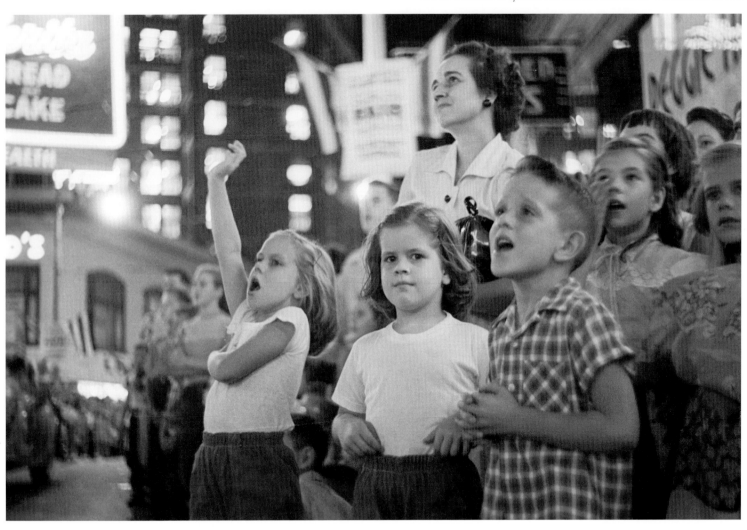

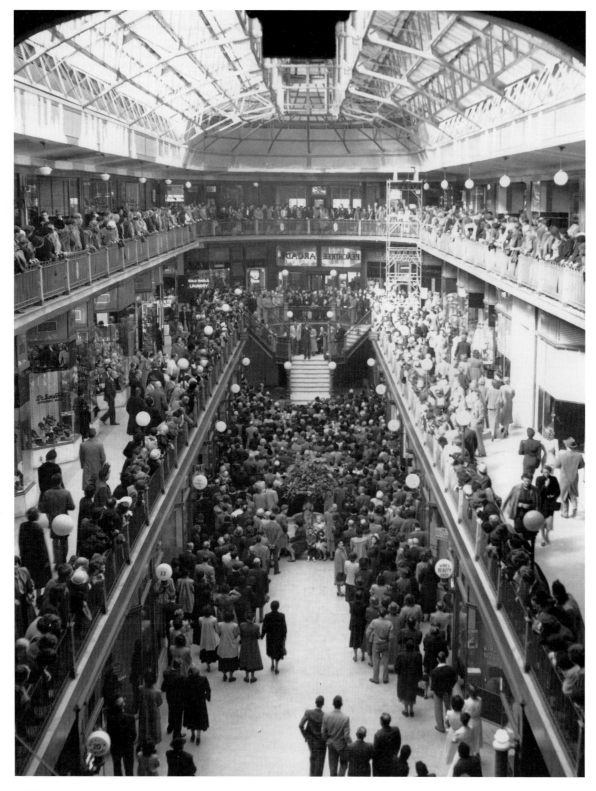

The Peachtree Arcade is packed with shoppers and visitors listening to evangelist Billy Graham, who is standing on the mezzanine stairs during a noon-time prayer. The arcade was built in 1917, providing an enclosed shopping mall, restaurants, and entertainment one block south of Five Points.

"The biggest, loudest parade in Atlanta history," according to the *Atlanta Constitution,* was the National Junior Chamber of Commerce parade through downtown in 1955. More than 200,000 people lined Peachtree Street for the festivities, which included dancing AC sparkplugs passing in front of the Arthur Murray studio.

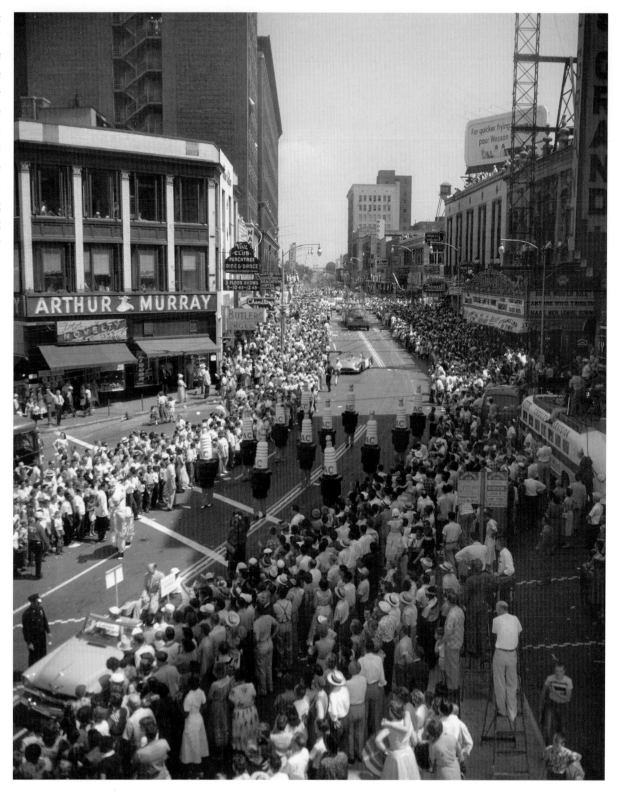

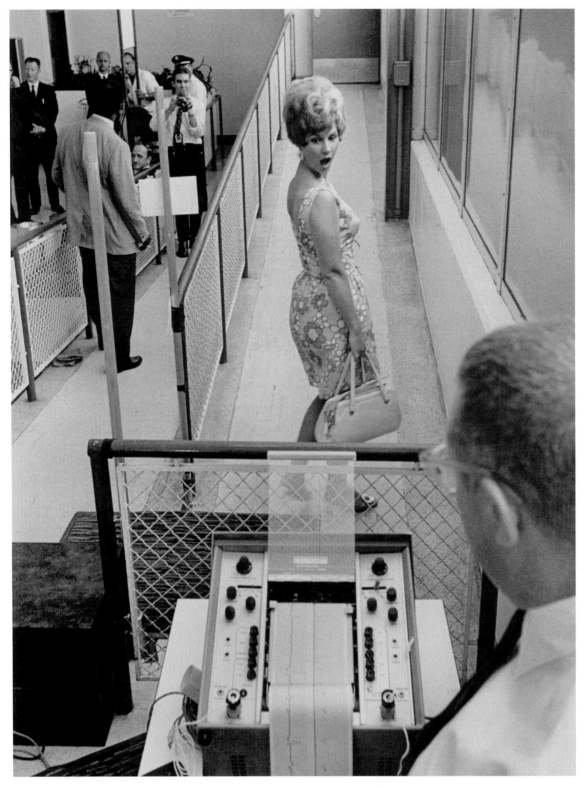

In the mid 1960s, the municipal airport installed the first airport security system, tested here by a surprised Linda Fay. The photograph was publicity for the new system. The airport's current terminal opened in 1980 and was named William B. Hartsfield Atlanta International Airport for the former mayor, who had promoted its founding and development. In 2003, the name was changed to Hartsfield-Jackson Atlanta International Airport to recognize Mayor Maynard Jackson.

In 1948, Rich's downtown department store began their longstanding tradition of lighting a giant Christmas tree on Thanksgiving night. Originally perched atop the store's roof, Rich's Giant Tree appeared for many years on the "Crystal Bridge" above Forsyth Street. In 1994, the tree lighting moved to Underground Atlanta until 2000, when it moved to its present location at Lenox Square. Another Rich's holiday tradition was the Pink Pig, a pig-faced monorail that carried children above the department store.

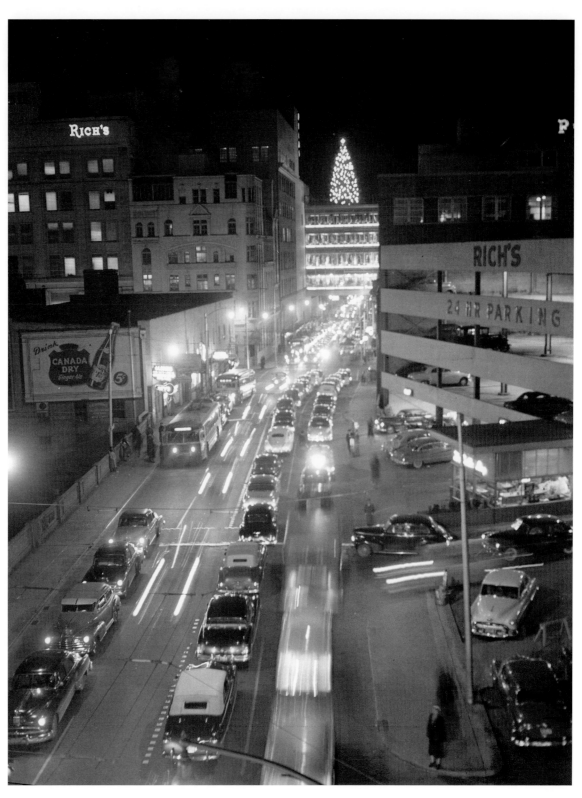

Civil rights leader Julian Bond is not standing with other members of the Georgia legislature, who are being sworn into office in 1966. Bond was one of eight African Americans elected to the house of representatives the previous year. When the legislature met in January, however, representatives voted 184-12 against seating him owing to his opposition to the Vietnam War. The U.S. Supreme Court later ruled that Bond had been denied his freedom of speech and required the legislature to seat him.

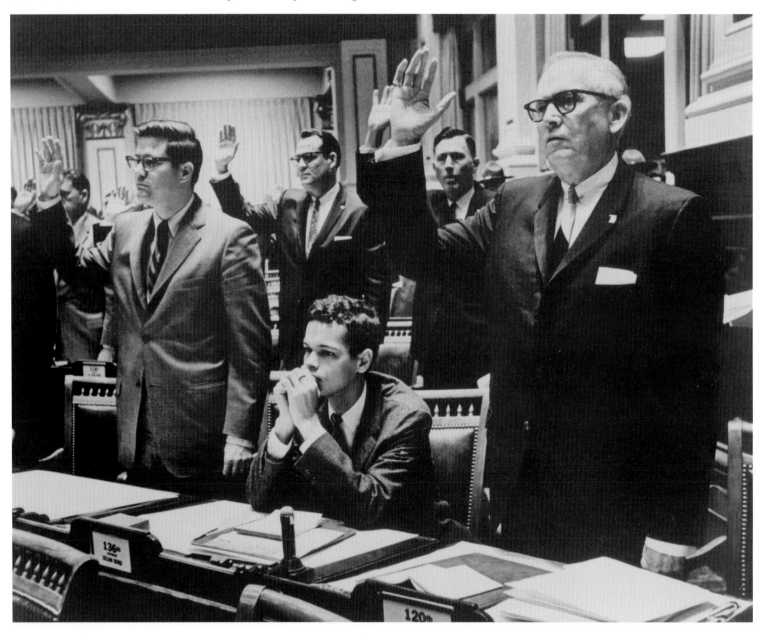

President Lyndon B. Johnson visits Atlanta on a campaign trip during the presidential election of 1964. To his right is musician Graham W. Jackson, best known for his relationship with President Franklin D. Roosevelt. Jackson frequently entertained Roosevelt at the Little White House in Warm Springs, Georgia, where the president sought treatment for paralysis, an outcome of his bout with polio or a similar disease. Jackson lived on White House Drive in Atlanta in a replica of Roosevelt's home.

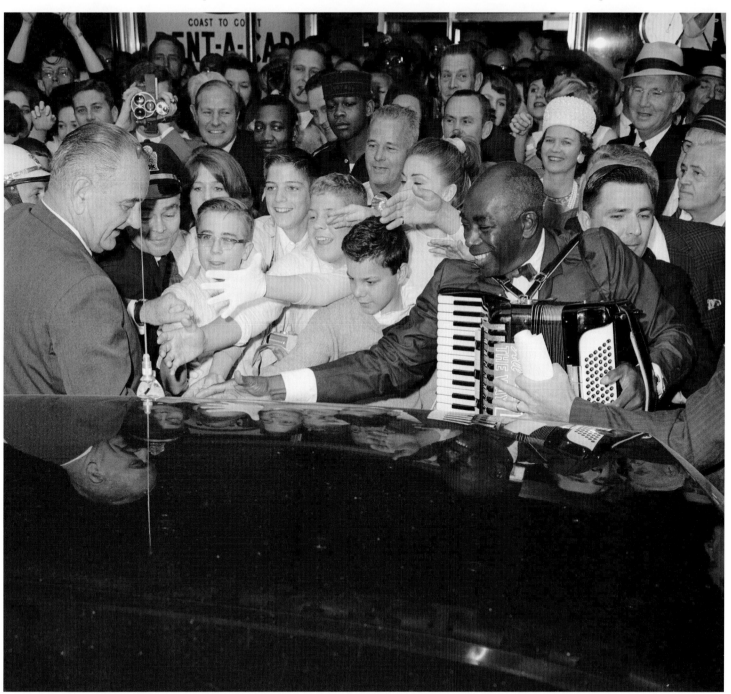

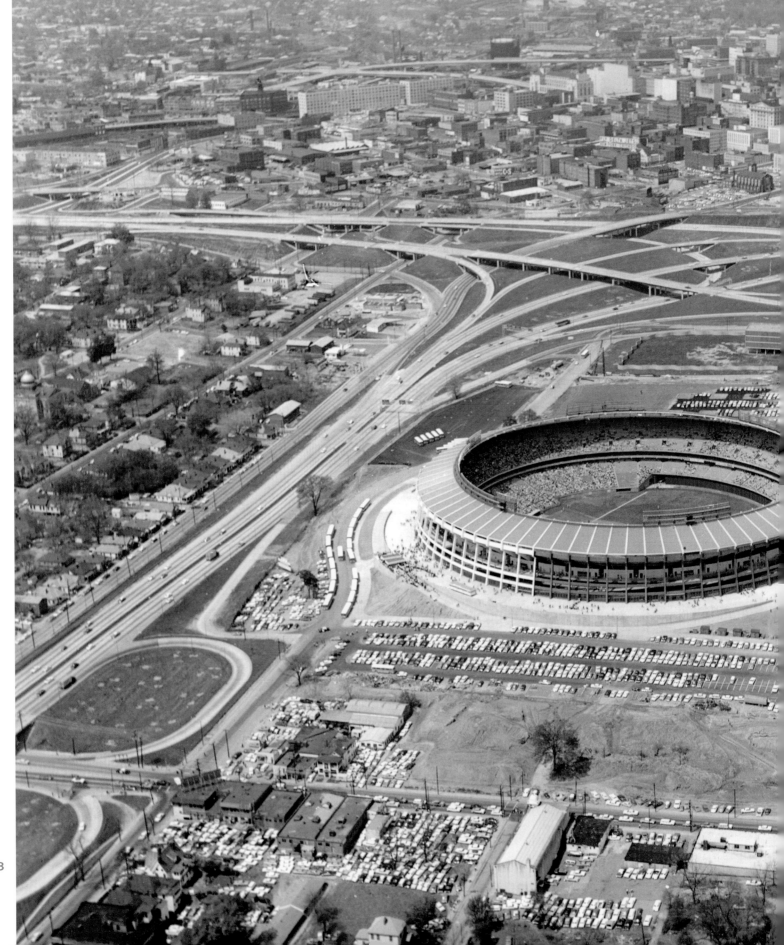

Mayor Ivan Allen, Jr., sought to bring major league sports teams to Atlanta and in anticipation of relocating the Milwaukee Braves, the city approved construction of Atlanta–Fulton County Stadium, completed in 1965. Allen later stated they had built a stadium on "land we didn't own, with money we didn't have, for teams that didn't exist." Home to the Atlanta Braves baseball team and the Atlanta Falcons football team, it was razed in 1997 following the Centennial Olympic Games.

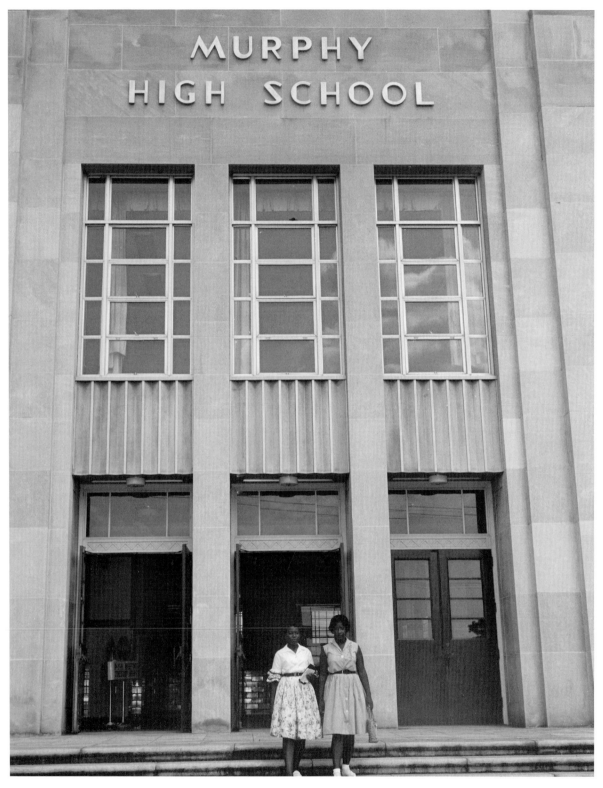

Murphy High School was one of the first Atlanta schools to desegregate, on August 30, 1961. During the 1950s, Mayor William B. Hartsfield had described Atlanta as "the City Too Busy To Hate" in an effort to preserve the city's business image. In 1961, with support from the Atlanta police department, nine African American students were selected from a pool of 133 to peacefully integrate four area schools—the others were Brown, Grady, and Northside.

Dr. Martin Luther King, Jr., was assassinated on the afternoon of April 4, 1968. A crowd of 300,000 attended his funeral at Ebenezer Baptist Church, where King had been co-pastor with his father, Martin Sr. Afterward, King's casket was placed on the flatbed wagon seen at bottom, which was then drawn by two mules through Atlanta to Morehouse College. The wagon bearing the casket was joined on its journey by nearly 50,000 followers.

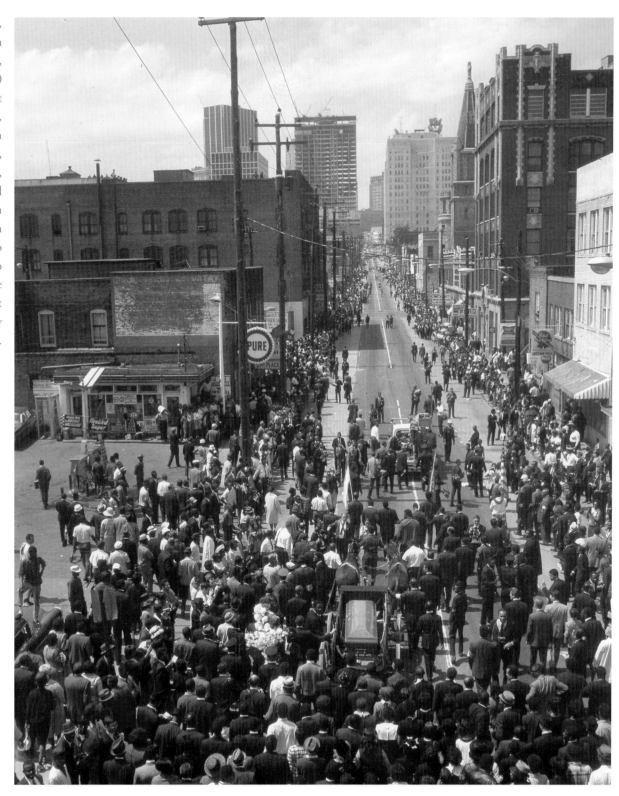

Midtown Atlanta was the center of the Hippie counterculture in the Southeast during the late 1960s and early 1970s, with the intersection of Peachtree and 10th streets the heart of the movement. Abandoned or inexpensive housing, including the one-time apartment home of Margaret Mitchell, provided a base for activists, wanderers, and runaways. Today, the section is full of restaurants, bars, and high-rise condominiums.

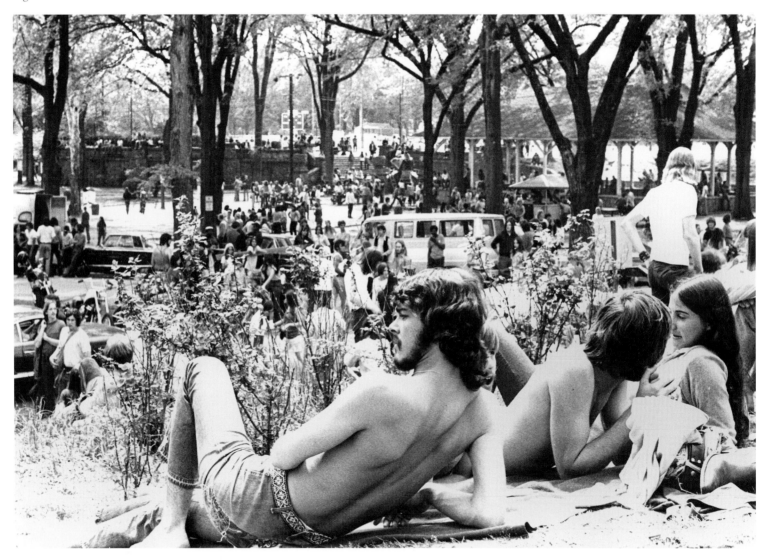

An aerial view of the Atlanta skyline in 1970 includes the Polaris Restaurant at upper-right, located on the Hyatt Regency Hotel. When it opened in 1967, the hotel's twenty-two-story atrium was an unprecedented design in modern hotels. Equally novel was the blue, spaceship-shaped restaurant atop the building; the rotating restaurant and lounge allowed a 360-degree view. The Polaris is still open, but is now surrounded by taller skyscrapers, limiting the view to downtown streets.

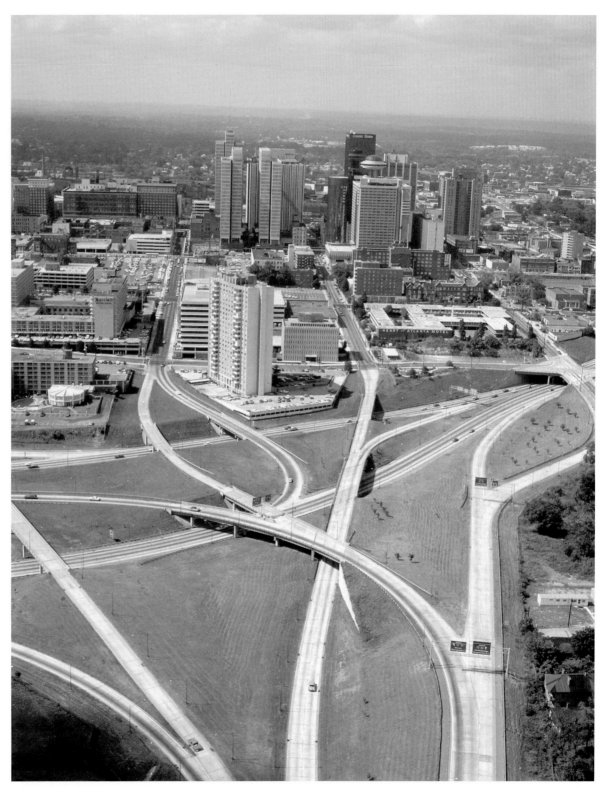

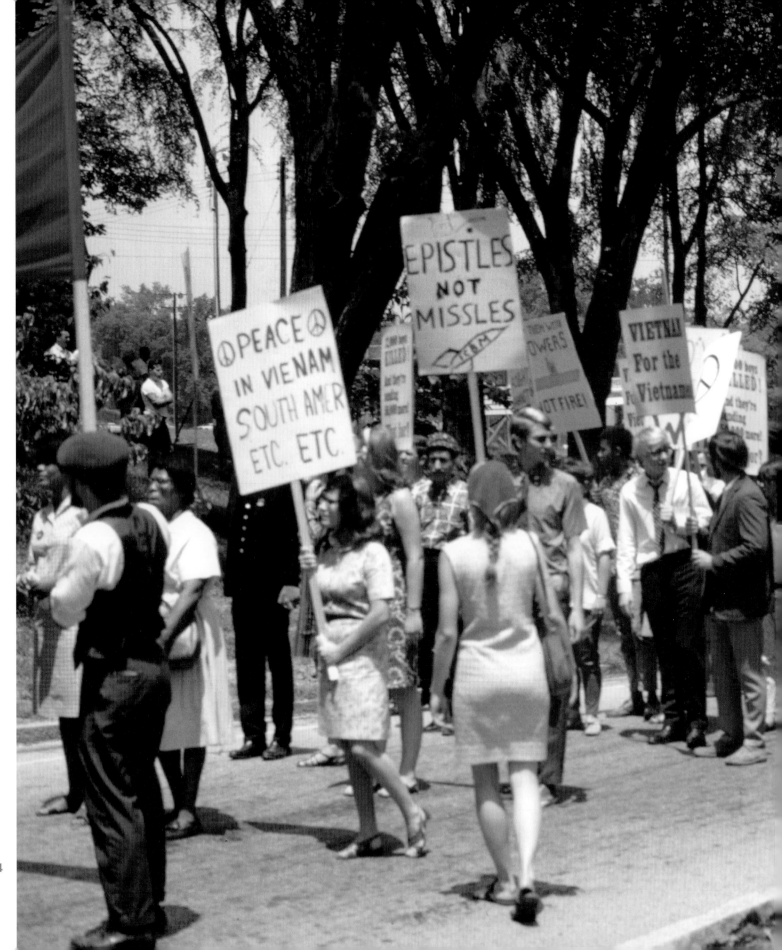

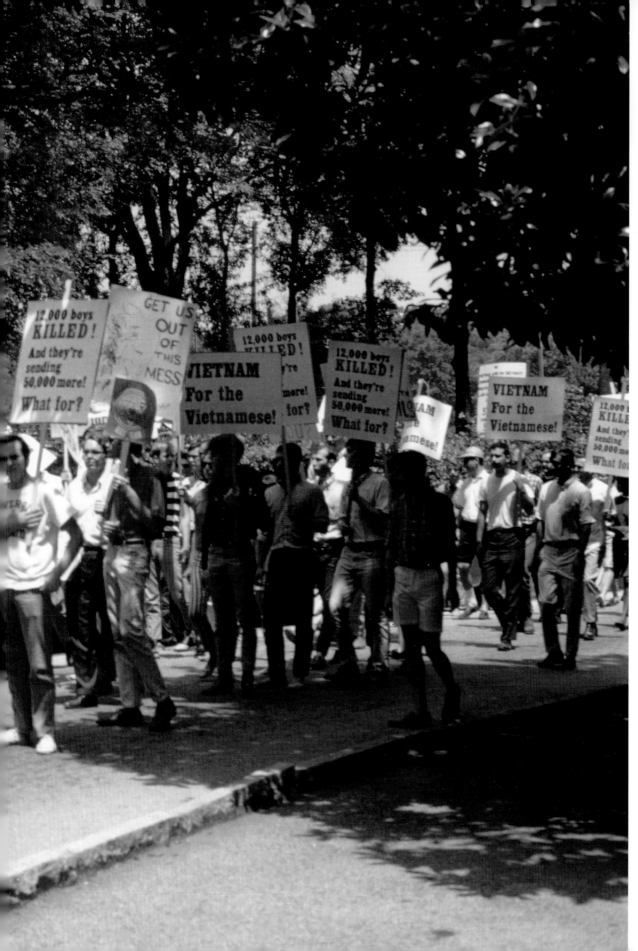

Like many cities during the period, Atlanta experienced protestors against the war in Vietnam, seen here marching through Piedmont Park. The antiwar movement had a supporter in Dr. Martin Luther King, Jr., who spoke out against America's involvement in a foreign war. As early as 1967, King asserted that the war distracted public attention from the civil rights movement and he contributed by giving speeches and participating in antiwar marches.

In 1996, Atlanta hosted the Centennial Olympic Games celebrating the 100th anniversary of the modern Olympics. The Atlanta-Fulton County Stadium at lower-right acted as a venue along with its successor, the present Turner Field, to its right. For seventeen days, Atlanta was the focus of the entire world, and the games accelerated the city's transformation from southern capital to international city. A record 197 nations took part in the Olympics, presenting 10,318 athletes who competed in 271 events.

In the early 1970s, the Atlanta Raft Race and the original Underground Atlanta made "Hotlanta" the place to be for recreation. Beginning in 1969, the raft race was held on the Chattahoochee River every Memorial Day Weekend, eventually drawing up to 300,000 participants. Unfortunately, its success led to its demise as the cost became prohibitive. The event was canceled after the last run in 1980.

Hank Aaron looks up as his 715th career home run heads skyward on April 8, 1974—the home run broke the existing record belonging to Babe Ruth, set 1914–1935. Aaron began his Major League baseball career in 1954, playing with the Milwaukee Braves and continuing with the team when the Braves moved to Atlanta. In 1976, Aaron hit his 755th home run, a record that stood until 2007.

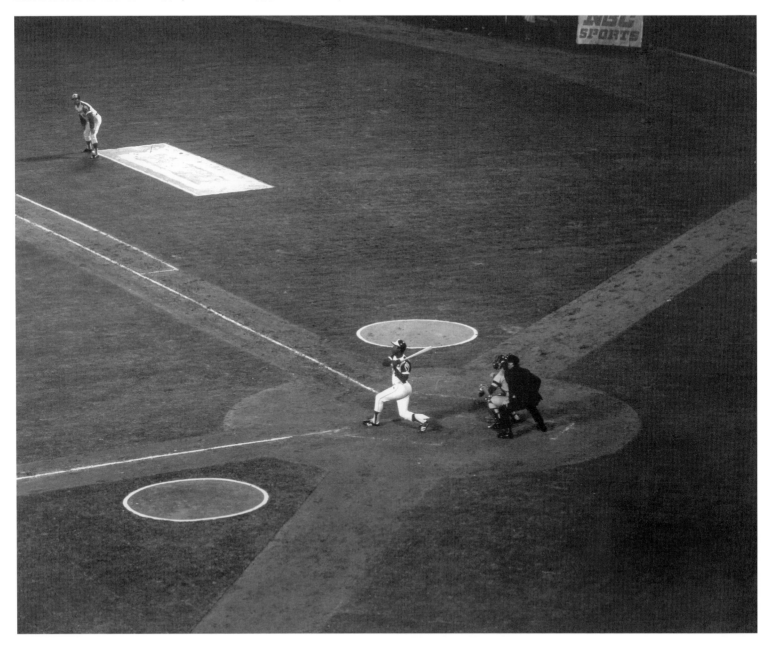

A nighttime view of Atlanta near the end of the twentieth century presents a city that had been a frontier wilderness in 1837. By the year 2000, the metropolitan area had a population of more than 4 million residents and was a name recognized around the globe.

NOTES ON THE PHOTOGRAPHS

All photographs are courtesy of the Kenan Research Center at the Atlanta History Center. These notes, listed by page number, attempt to include all aspects known of the photographs. Each of the photographs is identified by the page number, photograph's title or description, photographer and collection, archive, and call or box number when applicable. Although every attempt was made to collect all available data, in some cases complete data was unavailable due to the age and condition of some of the photographs and records.